Women TRAILBLAZERS *of* CALIFORNIA

Women
TRAILBLAZERS *of*
CALIFORNIA

❧ PIONEERS *to the* PRESENT ☙

GLORIA G. HARRIS *and* HANNAH S. COHEN

THE
History
PRESS

Published by The History Press
Charleston, SC 29403
www.historypress.net

Front Cover: Torrey Pines, courtesy of Dreamstime.
Back Cover: Postcard of Fifth Street, San Diego, courtesy of San Diego History Center.

First published 2012
Second printing 2012

Manufactured in the United States

ISBN 978.1.60949.675.3

Library of Congress CIP data applied for.

CONTENTS

PART III. WOMEN WHO CONTRIBUTED TO THE WORLD OF WORK

CONTENTS

PREFACE

Women's history is omnipresent in every major social and political issue that has taken place in the development of the United States. As settlers, suffragists, activists, architects, entertainers, community leaders and educators, women have made their mark on California's cultural, physical and social landscapes. In every walk of life, women have strengthened and contributed to the history of our nation's most populous state. However, many have never been acknowledged or remembered. This book introduces these remarkable trailblazers to help us better understand the daily challenges and barriers women faced when making career choices.

We chose these women because they personified a trailblazer, leader or pioneer who paved the way for others. In a historical context, many were a "first"; many accomplished something that previously had been denied to women. Undaunted by discrimination and closed doors, the inspiring stories of forty multicultural women in ten fields of endeavor are told. We have tried to include a variety of women who lived in diverse places and time periods. The introduction to each chapter presents an overview of the broad range of women's contributions to California history from the early pioneers to the present.

The authors are board members of the Women's Museum of California, whose mission is to educate and inspire future generations about the experiences and contributions of women by preserving and interpreting the evidence of that experience. The value of sharing women's history is to fill a gap in our communities' knowledge of female role models and women's achievements and to appreciate their willingness to take risks and break down barriers.

Many of the women, both past and present, represented in our book are responsible for shaping our current lives. Issues that concerned our foremothers continue today, and their determination to make a difference has benefited all of us. *Women Trailblazers of California* celebrates their tenacity and achievements and honors their contributions to our state.

PART I

Women of Early California

Chapter 1

PIONEERS

In the year 1510, Spanish author Garcia de Montalvo wrote *Las Sergas de Esplandian (The Deeds of Esplandian)*, an epic novel about Spanish chivalry. One of the fictional characters in the popular story was Queen Calafia, the courageous leader of a race of black Amazons. In the book, she is described as the most beautiful of a long line of queens who ruled over California, a mythical island. Calafia and her women warriors were said to wear gold armor adorned with many precious stones.

"At the right hand of the Indies very near the location of the Garden of Eden, there once was an island called California, which was inhabited by black women without any man being among them, so that their way of life was almost Amazon like," the popular tale began. "They had strong bodies and valiant, fervent hearts and had great courage."

De Montalvo's romantic tale captured the imagination of future explorers of the New World who hoped to discover a nation of women and riches. Twelve years after the novel was published, a party of Spanish explorers sent by Hernan Cortes anchored their ships on what appeared to be an island off western Mexico in the recently discovered Pacific Ocean. Elated that they had found the mythical island described in de Montalvo's story, the place was named "California." Given the exciting details of de Montalvo's tale, it was an understandable mistake to believe that Baja California, a peninsula, was the fictional island ruled by the beautiful warrior queen Calafia.

The actual discoverer of California, Juan Rodriguez Cabrillo, arrived in the future harbor of San Diego in 1542. Despite the legend of black Amazon queens, the Spanish made no effort to colonize the area until the eighteenth

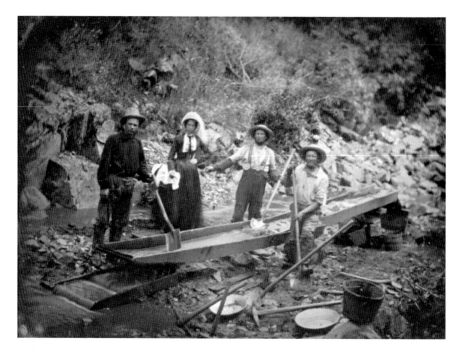

In Auburn Ravine. *Courtesy of the California History Room, California State Library.*

century. In preparation for settlement, the mainland region of California was granted to Franciscan missionaries in order to convert the native population to Catholicism. Between 1769 and 1823, Spanish friars established twenty-one missions, each a day's journey from the next, along the Pacific coastline. The first one was established by Father Serra in San Diego in 1769.

At the end of the eighteenth century, Spain experienced a series of international difficulties, and in 1822, the tattered flag of Spain was lowered for the last time at Monterey and the new banner of Mexico was raised in its place. In 1848, the Treaty of Guadalupe Hidalgo ended the Mexican-American War and resulted in Mexico ceding California to the United States. It was not until the 1840s that American families began heading west.

The 1848 discovery of gold on the American River in Northern California forever changed the state's history. When news of gold spread around the world, thousands of prospectors, dreaming they would strike it rich, traveled to the newly conquered territory. The sudden arrival of nationalities, races and ethnicities in one region was unprecedented in U.S. history. Until the mid-1850s, most women stayed behind, and the perilous overland journey to California was undertaken primarily by adventurous young men. The

gold-mining camps were viewed as unsafe for women, and female pioneers were in scarce supply.

This chapter tells the remarkable stories of Nancy Kelsey, a young pioneer who was the first white woman to travel to California; Luzena Wilson, an entrepreneurial frontier woman; Mary Ellen Pleasant, a black civil rights crusader; and Charlotte "Charley" Parkhurst, a strong, independent woman who courageously defied her gender's identity.

NANCY KELSEY (1823–1896)

FIRST WOMAN TO TRAVEL OVERLAND TO CALIFORNIA

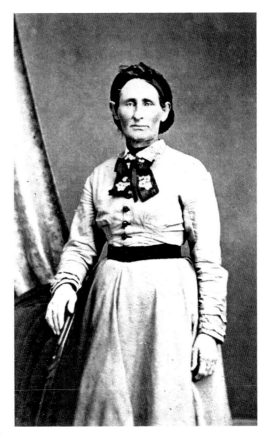

Nancy Kelsey was born in Kentucky in 1823, a few miles from the Missouri River that was the border of the settled United States. At the age of fifteen, she married a man twelve years her senior. During the 1840s, American families began heading for California to seek a better life, and her husband was a man with ambitious plans for their future. In 1841, the Kelseys and their infant daughter began a wagon train journey across the country that no white woman had ever made. Kelsey explained her reason for making the trip: "Where my husband goes I can go. I can better stand the hardships of the journey than the anxieties for an absent husband."

In 1841, several Missourians received a letter from Dr. John

Nancy Kelsey. *Courtesy of the California History Room, California State Library.*

Marsh praising California. In it he described "a wonderful fertile land with a sublime climate, meek Indians, and a lax local Mexican government." Paradise was located by the Pacific, waiting to be visited by enterprising people. One of the people who received the letter was a local farmer, John Bartleson, who passed the word on to the newspapers. After Kelsey read the letter to her husband, he became determined to join a group bound for the West Coast organized by John Bidwell.

Preparations for the trip included two farm wagons with wooden beds about ten feet long by four feet wide, sloping sides and a canvas cover that could be drawn closed to protect them from the rain. The wagons were to be pulled by oxen while Kelsey and her husband would ride their horses. John Bartleson, a man who had traveled farther west than the others, was chosen to be the party's leader. The group consisting of the Kelsey family and about thirty men departed from Missouri in the spring of 1841. They became known as the Bidwell-Bartleson party.

For the first twelve hundred miles, the group followed the Oregon Trail and all went well, but the party was ill prepared for the challenges that lay ahead. Members of the group had limited knowledge of western geography and lacked an adequate map or experienced guide. After the party reached Wyoming, problems began. Interviewed by the *San Francisco Examiner* in her later years, Kelsey told a reporter about the group's first mishap: "A young man named Dawson was captured by Indians and stripped of his clothing. They let him go then and then followed him so that without his knowing it, he acted as their guide to our camp. The redskins surrounded our camp and remained all night, but when daylight showed them our strength they went away."

Some men in the group decided to take a safer route and headed to Oregon. Others, including the Kelseys, were determined to reach California and continued on. By September, the Bidwell-Bartleson party was hopelessly lost. The weather got colder, food grew scarce and the oxen became too exhausted to pull the wagons. One by one the cattle were killed for food, and the wagons had to be abandoned. Kelsey described their desperate situation: "We left our wagons and finished our journey on horseback and drove our cattle. I carried my baby in front of me on the horse. At one place the Indians surrounded us, armed with their bows and arrows, but my husband leveled his gun at the chief and made him order his Indians out of arrow range."

Nancy Kelsey turned eighteen while camping at the summit of the Sierra Nevada Mountains. While the men searched for a safe route down through the jagged mountains, she was left alone with her baby for half a day. Fearing for her safety, Kelsey is quoted as commenting, "It seemed to me while I was

there alone that the moaning of the wind through the pines was the loneliest sound I had ever heard." During the treacherous descent, four pack animals fell over a cliff, and her husband came very near death. On November 25, 1841, after seven long months, the weary group arrived at Sutter's Fort, near the present-day city of Sacramento. Nancy Kelsey became the first white woman to cross the Sierra Nevada Mountains, and miraculously, her baby also survived the journey.

Joseph Chiles, one of the men who had traveled with the group, wrote about his experiences. Nancy Kelsey was described as a cheerful woman who "brought many a ray of sunshine through clouds that gathered around a company of so many weary travelers. She bore the fatigue of the journey with so much heroism, patience, and kindness that there still exists a warmth in every heart for the mother and child, that were always forming silver linings for every dark cloud that assailed them."

Kelsey remained in California only briefly before her husband decided to explore Oregon. In 1844, the couple traveled back to California with their two young daughters. En route, they were attacked by Indians. "While the arrows were flying into our camp," recalled Kelsey, "I took one babe and rolled it in a blanket and hid it in the brush and returned and took my other child and hid it also."

In 1859, Kelsey and her husband moved to Mexico, and in 1861, they went to Texas. Over the years, she gave birth to eleven children, and the family eventually returned to California. Despite her difficult life, she expressed no regrets. "I have enjoyed riches and suffered the pangs of poverty. I saw General Grant when he was little known. I baked bread for General Fremont and talked to Kit Carson. I have run from bear and killed all other kinds of game," she explained in later life. Her husband, Ben Kelsey, died in 1889, and seven years later, California's first woman emigrant passed away.

Luzena Wilson (1820–1902)

Pioneering Entrepreneur

When Luzena Wilson's husband learned that gold had been discovered in California, he became excited. Hoping to gain a fortune, he told his twenty-eight-year-old wife and mother of their two small children, "I'm bound for California. You stay home, and I'll send for you later." An independent woman, Luzena insisted on accompanying him. Her daughter, Correnah

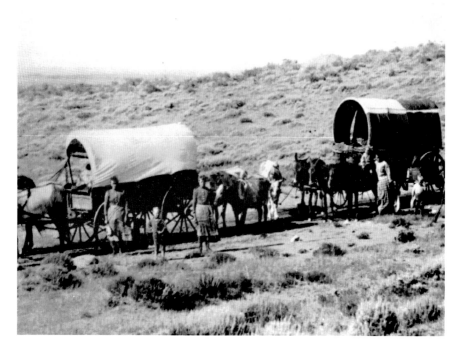

Overland journey. *Courtesy of the Utah State Historical Society.*

Wilson Wright, wrote about her mother's memories years later and included an explanation for this courageous decision:

> *My husband grew enthusiastic and wanted to start immediately, but I would not be left behind. I thought where he could go I could, and where I went I could take my two little toddling babies. Mother-like, my first thought was of my children. I little realized then the task I had undertaken. If I had, I think I should still be in my log cabin in Missouri.*

In 1849, the couple and their young sons began the 2,200-mile journey by wagon to California. Wilson's account of the family's overland journey and life in early America was published as a series of articles in the *Argonaut* of San Francisco in 1881. In the articles, "A Woman's Reminiscences of Early Days," she recalled the hardship of heading west: "Nothing but the actual experience will give one an idea of the plodding, unvarying monotony, the vexations, the exhaustive energy, the throbs of hope, the depths of despair, through which we lived."

Food and water for the oxen pulling their wagon were difficult to find, and the cattle grew thin. In order to lighten the load, wagon trains often discarded some of their possessions, and the trail west became littered with household items. The Wilsons' wagon, like many others, was overloaded. Her husband was concerned that their wagon might drop behind others in the caravan, and he wanted to spare the oxen. "Some things which I thought necessities when we started became burdensome luxuries, and before many days, I dropped by the road-side many unnecessary pots and kettles." Among the items Luzena Wilson refused to discard was her prized dirty calico apron.

At long last, after a tedious descent down the Sierras, the family arrived in Sacramento. Unable to afford a tent, they settled in their wagon, where Wilson set up their household. One evening while she was cooking supper over a campfire, a hungry man approached and offered her five dollars for a biscuit. Wilson hesitated, "and he repeated his offer to purchase and said that he would give ten dollars for bread made by a woman." Without further hesitation, the man's second offer was accepted.

During the gold rush, numerous opportunities to provide goods and services for the miners were possible, and Wilson was an enterprising woman. As a result of her profitable biscuit sale, she decided to put her culinary skills to work. She purchased supplies, set up a makeshift table and cooked meals for as many as twenty miners at a time. "Each man as he rose put a dollar in my hand and said I might count on him as a permanent customer," Wilson recalled. Since a married woman was a rarity in the gold-mining camps, she was able to reap the benefits. Wilson saved all the money she earned and successfully convinced her husband to invest their funds in a small hotel.

One afternoon in December 1849, after days of torrential rain, Wilson was preparing dinner when she heard a cry: "The levees broke!" As the floodwaters rose, the family ran for safety to the top floor of their hotel. For seventeen days, they remained in the hotel before returning to their tent. Although their property was damaged and the business ruined, Wilson hoped to begin again. After learning of a gold strike near Nevada City, she offered to pay a teamster $700 to transport her family there.

When the family arrived in Nevada City, a thriving hotel selling meals for one dollar already existed. Wilson was determined to set up a rival establishment. She bought two boards, chopped stakes with her own hands, drove them into the ground and set up a table. Wilson called her new hotel El Dorado, the name of a mythical "Lost City of Gold" sought by early explorers. Within six months, her establishment had earned thousands of dollars, more than enough to repay the teamster who agreed to bring her family to Nevada City.

Unfortunately, disaster struck again. "We had lived eighteen months in Nevada City when fire cut us adrift again, as water had done in Sacramento," she explained. It was believed that the fire was deliberately set by a suspected thief who had been whipped and driven out of town the day before, but the culprit was never found. The Wilsons decided not to participate in the rebuilding of Nevada City, and for the second time, the family was forced to move.

Uncertain about where to go next, the Wilsons returned to Sacramento. Since their departure after the flood of '49, the city had recovered and grown, and they decided to relocate in a less populated community. Eventually they settled in a valley called Vaca, where the city of Vacaville later developed. While her husband farmed to support the family, Wilson started another business. She etched "Wilson's Hotel" on a board and made chairs from stumps. Her guests had to sleep behind on a bale of hay. Once again, her hotel became profitable, and Wilson invested her earnings in property. Before long, they had a legal deed to seven hundred acres in the Vaca Valley.

Year after year, Wilson operated her hotel and watched the area grow from a frontier backwater into a thriving agricultural valley covered in vineyards that produced quality California wines. In 1872, her husband, Mason, abruptly left his family. Wilson remained in Vacaville until 1877. Five years later, she moved to San Francisco, where she lived in a hotel paid for by profits from her real estate investments. Luzena Wilson, a woman pioneer and successful entrepreneur of the California gold rush, overcame numerous hardships to make her dreams come true.

MARY ELLEN PLEASANT (1814–1904)

BLACK CIVIL RIGHTS CRUSADER

Mary Ellen Pleasant devoted her entire life to the cause of racial equality. Today she is called the "mother of the civil rights movement in the United States." Some historians have noted that she was born as a slave in 1814 on a Georgia plantation. In Pleasant's memoirs dictated to her goddaughter, she claimed to have been born to parents who were a voodoo priestess and the son of a Virginia governor. In the introduction to her book, *The Making of "Mammy" Pleasant*, biographer Lynn Hudson offers an explanation of the contradictory claims about Pleasant's early years: "Owning her past by providing her own version became very important to her at the end of her life."

It is believed that Pleasant did not remain with her parents very long. After living in several homes in different cities, she was sent to live with a Quaker family as an indentured servant on the island of Nantucket in Massachusetts. Pleasant wanted to have the opportunity to attend school, but there were no schools on the island that would admit black girls. "When my father sent me to live with the Husseys, he also gave them... plenty of money to have me educated, but they did not use it for that purpose and that's how I came to have no education," she later recalled. The Hussey family was actively involved with the abolitionist movement and shared their beliefs about human equality with their foster daughter.

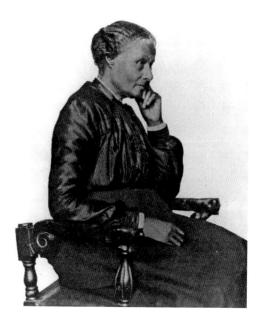

Mary Ellen Pleasant. *Courtesy of the Bancroft Library, University of California–Berkeley.*

While in her early twenties, Pleasant left Nantucket and moved to either Philadelphia or Boston. Like much of her history, there are conflicting accounts of the details of this time in her life. She was a biracial woman who often was able to pass as white. At the age of twenty-seven, Pleasant married James Smith, a wealthy contractor and plantation owner who also passed as white. Pleasant's light skin made her a valuable member of the freedom movement, and she and her husband worked as "slave stealers" on the Underground Railroad. They transported slaves to northern states and as far away as Canada. Pleasant traveled to the South and wrote stories for a radical abolitionist paper, *The Liberator*. In 1840, four years after their marriage, Smith died and left his wife a great deal of money for the purpose of continuing their abolitionist work.

In 1848, Pleasant married for the second time, and her involvement with the Underground Railroad continued. She frequently traveled south, where she crept onto plantations and provided slaves with information about how to escape and travel to safety. Eventually, her abolitionist activities resulted in a price being placed on her head, and she and her husband escaped to New

Orleans. After Pleasant made the acquaintance of Marie Laveau, the city's "voodoo queen," she became one of her students. Some accounts of her life state that Pleasant practiced voodoo in order to manipulate rich people for the benefit of the poor.

With the discovery of gold, many black forty-niners arrived in California, and in 1850, Pleasant's husband went alone to San Francisco and later wrote back that the city seemed promising. In 1852, after a four-month voyage by boat around the Cape of Good Hope to the West Coast, Pleasant joined him. She easily found employment as a housekeeper in the homes of wealthy residents, and her husband obtained work as a ship's cook. Although the Pleasants remained married for twenty years, they often lived apart.

Pleasant had no emancipation papers, and California law allowed for black people without them to be captured and returned to slavery in the South. She was forced to live a double life and always exercised discretion. In San Francisco, Pleasant briefly assumed an alias, Yerba Buena, and was able to pass as white. After leaving work as a domestic servant, she found employment in several exclusive men's eating establishments, where she met many of the wealthy city founders. Realizing that she was not white but biracial, the men she associated with started calling her "Mammy" or "Mammy Pleasant."

She benefited from these contacts and, with the assistance of Thomas Bell, a Bank of California employee, wisely invested the money inherited from her first husband. Thomas made money of his own, especially in quicksilver, and together they both invested in banking, real estate, mining and business enterprises. Pleasant believed that financial success was necessary to support her cause. By 1875, they had amassed a $30 million fortune between them.

Considered an outstanding hostess, Pleasant organized parties and invited the city's influential government and political leaders. Many of the prominent men who attended freely discussed San Francisco's events and businesses. Pleasant had other ways to acquire information from important civic leaders. One of her properties, Geneva Cottage, was located in the country and served as a retreat for guests who were lavishly entertained there. After dinner, the men were given an opportunity to associate with beautiful "special girls." These courtesans were instructed to also function as conduits of valuable information. Since Pleasant viewed slavery and racial discrimination as immoral, she probably believed that the ends justified her means. The information she obtained was also helpful to her and Thomas Bell in making their investments.

By the mid-1860s, Pleasant had become one of the richest women in California. A significant portion of her money was used to care for and support

freed or runaway slaves and to assist them in obtaining work. After the Civil War and the signing of the Emancipation Proclamation, Pleasant provided financial assistance for black people challenging California's Jim Crow laws and fought a legal battle to guarantee black Californians the right to testify in court. In 1868, she and two other black women were ejected from a city streetcar. Her lawsuit, *Pleasant v. North Beach and Mission Railroad Company*, successfully outlawed segregation in the city's public conveyances and set a precedent in the California Supreme Court that was employed in future civil rights cases.

By the late 1880s, Pleasant had backed several unsuccessful causes and made poor investments in the stock market, with the result that she lost a significant amount of her wealth. Despite her financial setback, she continued to provide assistance to better the lives of black people. In 1904 at the age of eighty-nine, Mary Ellen Pleasant died in San Francisco.

Charlotte "Charley" Parkhurst (1812–1879)

Stagecoach Driver

At a time when women were forbidden to assume such roles, Charlotte "Charley" drove a stagecoach for Wells Fargo. Her unusual life as a cross-dressing stagecoach driver and the likelihood that she was the first woman to vote in California qualify her as a true trailblazer.

Parkhurst was born in 1812 in Lebanon, New Hampshire. Abandoned by her parents and placed in an orphanage, at approximately the age of fifteen, she borrowed male attire and ran away. In the early 1800s, a girl would have had difficulty earning a living, but a boy could become an apprentice and learn a trade. Although males had more employment options available than females, the specific reason that Charlotte Parkhurst chose to be known as "Charley" and to live her life as a man is unknown.

After leaving the orphanage, Parkhurst found work as a stable boy cleaning stables, pitching hay and caring for horses in Worcester, Massachusetts. Her employer, Ebenezer Balch, observed that she had a natural ability to connect with horses, and he trained her to handle teams. Parkhurst became skilled in the art of driving first two-in-hand, then four-in-hand and later six-in-hand horse teams. Balch later purchased What Cheer Stables in Providence, Rhode Island, and took Parkhurst along to work for him. During the years she lived on the East Coast, Charley Parkhurst acquired a reputation for being an outstanding "sure handed driver."

Charlotte "Charley" Parkhurst. *Courtesy of the Wells Fargo Historical Collection.*

By 1849, the gold rush had begun, and two years later, Parkhurst traveled by ship to California, where she obtained work with the recently established California Stage Company. At the time that she arrived in San Francisco, Charley Parkhurst was nearly forty years old and described as a person of medium height (five feet, seven inches) with broad shoulders and a raspy voice. She is reputed to have smoked cigars, chewed tobacco and been a moderate drinker.

During the time Parkhurst worked for the California Stage Company, she drove coaches through all the gold-mining towns and nearly every route in California. Some days she would cover sixty miles on treacherous muddy roads and make the return trip as well. She also worked for the Pioneer line, which was taken over by Wells Fargo in 1866. The Pioneer line provided service between San Jose and Santa Cruz. Sometimes Wells Fargo entrusted Parkhurst with special missions that included sending her to New York with a quantity of gold, and she always returned safely.

Charley Parkhurst was proud of her skill in the extremely difficult job as "whip." A whip was a stagecoach driver who could manage six horses pulling at that many leads. The ability to use a whip while driving required the

combination of good judgment, dexterity and a great deal of strength. Those who were adept at it were well paid. A competent whip could earn as much as $125 a month plus room and board, which was a high salary for the era.

Throughout her career as a coachman in Northern California, Parkhurst wore blue jeans, pleated blousy shirts, a cap of buffalo hide and embroidered buckskin gloves to cover her small hands. She always carried a brace of pistols stuck in her belt and was never afraid to use one if needed. Because she had been kicked by a horse and wore a patch over one eye, she became known as "One-Eyed Charley." Fortunately, the eye injury never ended Parkhurst's love of horses or her goal to become "the best damn driver in California." By all accounts, she succeeded and became known as one of the old West's greatest stagecoach drivers.

Parkhurst drove stagecoaches until the late 1860s. Railroads were expanding, and she was suffering from rheumatism, a common problem for drivers. After retirement, she tried cattle ranching, lumbering and raising chickens in an area between Santa Cruz and Watsonville. In her later years, Parkhurst lived alone in a small cabin near Watsonville where, in 1879, at the age of sixty-seven, she died of cancer. After her death, neighbors who came to lay out her body for burial were shocked to discover that "Charley" was a woman.

On December 28, 1879, the *San Francisco Morning Call* reported on the death of Charley Parkhurst: "He was in his day one of the most dexterous and celebrated of the famous California drivers ranking with Foss, Hank Monk, and George Gordon, and it was an honor to be striven for to occupy the spare end of the driver's seat when the fearless Charley Parkhurst held the reins of a four or six-in-hand."

Fifty-two years before women won the right, legend claims that Parkhurst was the first woman to vote in the United States. While living in Soquel, she registered to vote in the 1868 election for presidential candidates Horatio Seymour of New York and Civil War general Ulysses S. Grant. Although there is a document on file proving Parkhurst registered, no evidence exists to prove that she actually voted.

There is, however, a plaque in a fire station located in Soquel that states:

> *The first ballot by a woman in an American presidential election was cast on this site November 3, 1868 by Charlotte Parkhurst who masqueraded as a man for much of her life. She was a stagecoach driver in the mother lode county during the gold rush days and shot and killed at least one bandit. In her later years she drove a stagecoach in this area. She died in 1879. Not until then was she found to be a woman. She is buried in Watsonville at the pioneer cemetery.*

Chapter 2

SETTLERS

After the hardship of their journey westward, everyone was grateful to end their nomadic existence and finally arrive in California. In the mid-nineteenth century, most eastern women had lived in houses with heat, soft beds and other amenities and were unprepared for life in the rough frontier communities. In the gold-mining camps of California, their first homes were likely to be tents or crude mining shacks with dirt floors and canvas ceilings. Only a few lucky women were able to move into log cabins. Those who landed in San Francisco did not find the city a pleasant place to live. Author Jo Ann Levy describes the city in 1849 as offering few comforts: "Streets far from being paved with gold had, excepting litter and discards, no paving at all."

In 1850, there was only one female for every thirty men, and it is estimated that half the women in San Francisco were prostitutes. Women continued to arrive and settle in San Francisco. Those who came by ship rather than overland tended to be wealthier, and respectable families separated themselves from contact with the bawdy women who worked in saloons, gambling halls and brothels. After 1854, a number of mansions in ornate architectural styles were built, while working-class women lived in cottages and boardinghouses. The city's working-class neighborhoods contained a wide range of ethnic groups, including a small black community.

Biddy Mason, a lifelong slave, arrived in Southern California in 1851. At that time, about 1,600 people lived in Los Angeles, and half of them were under twenty years old. About a dozen were blacks. Some accounts describe the city just after mid-century as a tough cow town that housed sixty-two saloons by 1872 with a record for violence that included shootings

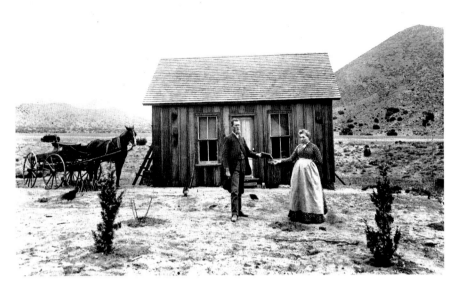

Homesteader receiving patent to her land. *Courtesy of the University of Southern California, USC Special Collections.*

and hangings. By the 1880s, Los Angeles increasingly attracted immigrants who wanted to settle down as homeowners and churchgoers.

As gold-seeking pioneers established towns in the early 1850s, Native Americans who had lived off the land suffered economic and cultural decline. Many were forced to travel to find work. While men turned to ranching or odd jobs, women became prostitutes or laundresses. The story of Toby "Winema" Riddle, a Modoc woman who married outside her tribe, illuminates the role of Native American women in California history. Through her marriage, she gained protection from the white community, something that most indigenous women could not obtain.

The lives of women settlers in mid-nineteenth-century California depended on their adaptability, ethnicity, skills and courage. In this chapter, you will learn about the experiences of Louise Amelia Knapp Smith Clappe, who documented life in the gold-mining camps; Bridget "Biddy" Mason, a philanthropist and founder of the first black church in Los Angeles; Toby "Winema" Riddle, a Modoc woman who worked for peace between her Modoc tribe and the U.S. government; and Elizabeth "Lillie" Hitchcock Coit, San Francisco's volunteer firefighter.

LOUISE AMELIA KNAPP SMITH CLAPPE (1819–1906)

DOCUMENTED LIFE IN GOLD-MINING CAMPS

Among the best records of day-to-day life in the gold-mining camps from a woman's perspective are letters written by Louise Clappe. Her vivid account of these camps consists of twenty-three letters written to her sister Molly back home in Massachusetts. They were subsequently published under the name "Dame Shirley" in 1854 as a series titled *California in 1851 and 1852: A Trip into the Mines*.

Louise Amelia Knapp Smith was born in Elizabethtown, New Jersey, in 1819. Her mother was dedicated to raising seven children, and her father, an academician, died when Louise was twelve. Louise left home at the age of fifteen to attend a female seminary in Keene, New Hampshire. Two years later, the school's founder died and the school closed. Louise returned home to care for her mother, who died after a long battle with tuberculosis. In 1838, Louise attended a female seminary in Massachusetts but later transferred to Amherst Academy to complete her education. In 1849, she married Fayette Clappe, five years her junior, who had just begun his medical apprenticeship.

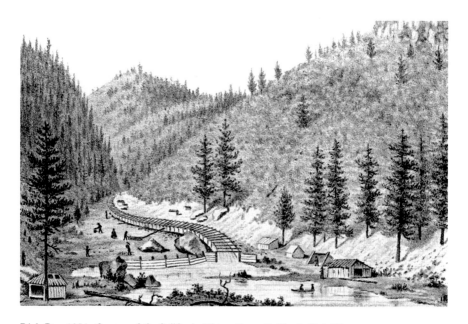

Rich Bar, 1851. *Courtesy of the California History Room, California State Library.*

Within three months of their marriage, the couple moved to San Francisco, and during the time they were there, the city was seriously damaged by three fires. Clappe wrote an essay that was later published in 1851 in which she described the city as "built one day and burnt the next." The San Francisco climate did not agree with them, and in the spring of 1851, the couple boarded a steamship for Marysville, located about 40 miles northeast of Sacramento in the foothills of the Sierra Nevada Mountains at the confluence of the Feather and Yuba Rivers.

While her husband explored the Feather River region, Louise remained in Marysville. About this time, she met the co-owner and editor of the *Marysville Herald*, a young man named Stephen Massett. After selecting the name "Dame Shirley," she submitted three essays and two poems describing the rolling Sacramento Valley countryside and the "quiet depths of the meadows and the mossy roots of ancient trees" to Massett, who published them in 1851.

By the time the Clappes arrived, a dusty gold-mining camp named Rich Bar had been established. More than two thousand miners, four women and a few children lived in the crowded community. The main street was lined with primitive huts on a narrow flat of land. Canvas tents with exterior kitchens, hovels made of wood planks and log cabins flanked the street. Since the mining camp had only one doctor, Fayette expected to have plenty of opportunities to practice medicine there. The couple moved into a one-room log cabin, and during the next fifteen months, Clappe wrote twenty-three letters to her sister describing life in the camp.

Clappe accurately recorded the camp's chaotic life and described everything from mining techniques to the drinking habits of the miners. As the winter months dragged by without newspapers, theaters or female companionship, the miners' only entertainment was an abundance of whiskey. Their worst bout of drinking began on Christmas Eve and continued for three days and nights. The lure of gold attracted not only young, ambitious men seeking to strike it rich in the gold fields but also a criminal element. In 1852, Clappe wrote, "We have had murders, fearful accidents, bloody deaths, a mob, whippings, a hanging, an attempt of suicide, and a fatal duel...I almost shrink from relating the gloomy news, but if I leave out the darker shades of our mountain life, the picture would be incomplete."

The couple later moved upriver to another mining camp, Indian Bar, where conditions were similar to those experienced in Rich Bar. As it turned out, Fayette spent less time practicing medicine than he had hoped. By the time he arrived, quite a few rival doctors had already opened offices.

Not immune to gold fever himself, Fayette often left his wife alone while he pursued a claim. Unfortunately, both as a doctor and prospector, he was unsuccessful, and after fifteen months in the mining camps, the Clappes returned to San Francisco.

On November 21, 1852, Dame Shirley composed her final letter:

> *My heart is heavy at the thought of departing forever from this place. I like the wild and barbarous life: I leave it with regret. The solemn fir trees, the watching hills, and the calmly beautiful river seem to gaze sorrowfully at me, as I stand in the moon-lighted midnight, to bid farewell. I quit your serene teaching for a restless and troubled future.*

Soon after the Clappes returned to San Francisco, the couple separated, and two years later, Louise filed for divorce. Fayette departed for Hawaii, where he obtained employment in the treatment of smallpox and vaccinations.

When a friend, Ferdinand C. Ewer, launched a new periodical, *The Pioneer*, California's first monthly magazine, Clappe gave him copies of the letters written to her sister. They appeared in each issue from January 1854 through December 1855, until the magazine ceased publication. In 1854, she began teaching in San Francisco public schools and continued her career for the next twenty-four years until retiring in 1878. She returned to her home state of New Jersey, where she died on February 9, 1906.

Bridget "Biddy" Mason (1818–1891)

From Slave to Humanitarian

Born into slavery on August 15, 1818, and named Bridget, this former slave came to be known as "Biddy" and retained that name throughout her life. She was separated from her parents as a young child, and the exact place of her birth is unknown. Although Mason received no formal education, she learned about midwifery and herbal medicines from other female slaves. By the end of her life, she was widely known as a successful real estate investor, businesswoman, philanthropist and founder of the first black church in Los Angeles.

In 1836, Mason was either given as a wedding present or sold to Robert and Rebecca Smith and taken to their plantation in Mississippi. At the age of twenty, Mason gave birth to her first child, a daughter named Ellen, and

by the age of thirty, she was the mother of two more daughters. Mason's owner, Robert Smith, is believed to have been the father of all three of her children.

Smith became a Mormon convert in 1847 and moved with his household and slaves to Utah to help build the Church of Latter-Day Saints in Salt Lake City. Mason exhibited an impressive range of skills on the almost two-thousand-mile wagon train journey across the country. She organized the group of fifty-six whites and thirty-four slaves, herded the cattle,

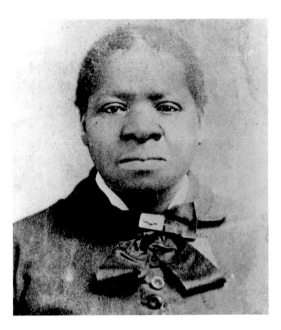

Bridget "Biddy" Mason. *Courtesy of Los Angeles Public Library Photo Collection.*

prepared meals and cared for her own children. In her groundbreaking book, *The Negro Trail Blazers of California*, author Delilah Beasley commented, "Think of this slave woman coming to California by ox-team which consisted of three hundred wagons, Biddy Mason driving the cattle across the plains, notwithstanding she had her own three little girls, Ellen, Ann, and Harriett, to care for en route!"

In 1851, Smith moved again to San Bernardino, California, where Brigham Young was starting another Mormon community. He may not have been aware that California had been admitted to the Union in 1850 as a free state and slavery was prohibited. Despite being a free state, the status of people of color who entered the state as slaves was ambiguous. Initially, slave owners were rarely challenged in court, but by 1855, the law was more strictly enforced, and Smith decided to move to Texas, a state that still allowed slavery.

Mason's eldest daughter, Ellen, had met a free black man, Charles Owens, who helped Biddy file a petition for her freedom in the Los Angeles County Court. Since California law did not allow blacks, mulattos or Native Americans to testify on their own behalf, Mason was required to remain silent during the court proceedings. After Robert Smith failed to appear in court, on January

19, 1856, Judge Benjamin Hayes granted Mason, her three daughters and thirteen other slaves their freedom. This landmark decision against slavery in her case provided important support for California's new constitution.

After emancipation, she chose to be legally known as Bridget Mason. Mason was the middle name of Amasa Lyman, a member of the Mormon Church and mayor of San Bernardino for whom she had done work. She and her daughters accepted an invitation to live with the Owens family in Los Angeles, and her daughter Ellen later married Charles. Soon after her relocation, Mason secured work as a nurse and midwife, and she eventually assisted in hundreds of births to mothers of all races. After a smallpox epidemic hit Los Angeles, Mason utilized her knowledge of herbal remedies and risked her own life to care for those who had contracted the illness.

Obtaining employment made it possible for Mason to not only support her family but also to give her financial independence. She lived frugally, saved her earnings and, in 1866, bought her first house and a large lot located on Spring Street for $250. At the time, the property was considered out of town, but it eventually became part of the city's central financial district. Biddy Mason became one of the first black women to own land in Los Angeles.

She had an intuitive sense of the financial value of property and believed in the future of Los Angeles. In 1884, Mason sold a parcel of her land for $1,500 and built a commercial building with rental spaces on the remainder. In another transaction, she sold a forty-foot lot for $12,000. As the city boomed, Mason continued to buy property and make wise real estate investments. Eventually, she accumulated approximately $300,000, a sum considered to be a small fortune at the time.

Author Beasley wrote:

> *Biddy Mason was a devoted mother. Her most remarkable trait of character was her ability to teach her children and grandchildren the value of money and property. So thorough were her teachings that her vast holdings have been retained by her children and grandchildren who have never sold a piece of property unless they were positively sure that they were making great gains by so doing. The greater part of her purchases of property in early days they have retained, and these have grown in value at least two hundred or more per cent since their first purchase by Biddy Mason.*

As Mason became wealthy, she generously donated money to numerous Los Angeles charities and nonprofit organizations, including both black and white churches. She visited jail inmates; established a day-care center

and nursery for working parents; founded a travelers' aid center; provided food and shelter to the poor of all races; and even ran an orphanage in her home. During severe flooding in Los Angeles in the 1880s, many people in the city lost their homes, and Mason reputedly opened accounts at grocery stores and paid for the flood victims' purchases. She became a widely recognized philanthropist in Los Angeles, where she was known as "Grandma Mason."

In addition to being a philanthropist, Mason was a deeply religious woman. Along with her son-in-law, Charles Owens, in 1872 she established and financed the Los Angeles branch of the First African Methodist Episcopal Church (AME), the first black church in the city. Organizing meetings were held in her home on Spring Street. She is also credited with helping to establish the first elementary school for black children in Los Angeles. According to Beasley, "Her home at No. 331 South Spring Street in later years became a refuge for her stranded and needy settlers. As she grew more feeble it became necessary for her grandson to stand at the gate each morning and turn away the line which had formed awaiting her assistance."

Mason died on January 15, 1891, at the age of seventy-three. Although beloved by many people, she was buried in an unmarked grave at Evergreen Cemetery in the Boyle Heights area of Los Angeles. The grave remained unmarked for nearly one hundred years. On March 27, 1988, her accomplishments were finally recognized, and an impressive tombstone was erected. The event was attended by the mayor of Los Angeles and approximately three thousand members of the First AME Church. The California Afro-American Museum included her in its "Black Angelenos" exhibit, and the following year, November 16, 1989, was declared "Biddy Mason Day."

TOBY "WINEMA" RIDDLE (1846–1920)

NATIVE AMERICAN PEACE NEGOTIATOR

The Modoc and Klamath were neighboring Native American tribes in the Cascade Range of what is now southern Oregon and Northern California. Although the area lacked water and had been circumvented during westward expansion, gold-seeking whites created an increased demand for land. As a result, the U.S. government pressured the two tribes to leave their homeland and move to a reservation near Klamath Lake, Oregon. Into this environment and difficult times, Winema, a Modoc woman, was born. She

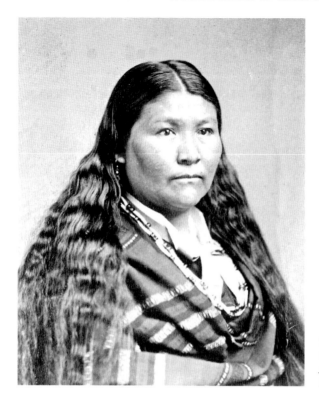

Toby "Winema" Riddle.
*Courtesy of the National
Anthropological Archives,
Smithsonian Institution.*

later acted as a mediator in negotiations between her tribe and the United States during the Modoc War.

Born in southern Oregon, little is known about her early childhood. She is believed to have had reddish-colored hair, an unusual characteristic for her native people, and was named Nannooktowa, which translates as "strange child." As a young teen, she courageously saved several children from drowning after their canoe was caught in the rapids and became known as "Winema" or "woman chief." Another example of her courageous nature was her refusal to marry a Modoc husband selected by her father. Instead, she fell in love with Frank Riddle, a white miner from Kentucky who came to California hoping to strike it rich in the gold mines.

Initially shunned by the tribe, the couple gained their approval after Frank fulfilled the obligations of a Modoc groom and gave a gift of several horses to his new father-in-law. The Riddles settled in the Lost River area of Oregon and had a son, Charka ("the handsome one"). Winema became known as Toby, learned English and served as an interpreter and mediator between the Modoc people and the white community.

In 1852, the Modocs were falsely blamed for an attack on a wagon train en route to California. As a result of the incident, a volunteer regiment sought revenge, and about forty members of the tribe were slaughtered. Toby's cousin Kintpuash, who lived in the village, witnessed his father's murder. He eventually became the tribal leader and was known as "Captain Jack" by the whites, who couldn't pronounce his name. Hostilities continued until 1864, when the Modocs signed a peace treaty and agreed to live on the reservation in Oregon. Unable to coexist with the Klamaths, the tribe left the reservation in 1865, returned briefly in 1869 but left again in 1870.

Two years later, President Ulysses S. Grant ordered American troops to force the tribe back to the reservation, and the Modoc War began. When the tribe fled, led by Captain Jack, they killed a number of settlers and retreated to a lava bed honeycombed with caves and caverns that formed a virtually impregnable fortress. As Captain Jack's cousin and interpreter, Toby was ensured safety and traveled through the lava beds carrying messages back and forth. After this method failed to convince the Modocs to peacefully return to a new reservation, a face-to-face meeting was scheduled with representatives of a government commission. In early 1873, as Toby was leaving the lava beds, she was informed by one of her cousin's men about a plot to kill the commissioners during the upcoming peace negotiation meeting.

Toby relayed this alarming information to two members of the commission, General Edward Canby and Reverend Alfred Meacham, and urged them to cancel the meeting. Unfortunately, her warning was ignored. At the meeting, Captain Jack tried one last time to negotiate more favorable terms for his people, but the commissioners simply wanted the Native Americans to surrender. As negotiations grew tense, the Modocs decided to proceed with their original assassination plan and opened fire. During the attack, Canby and another member of the commission were killed, and Meacham was severely wounded. Seeing the reverend in the process of being scalped, Riddle shouted that the soldiers were coming, and the Modoc warriors fled. Meacham's life was saved by her warning, and he was led to safety.

The peace commissioners' murder made national news, and after two more months of fighting, the soldiers were able to close in on the caves. The Modocs surrendered, and Captain Jack and other tribal leaders were captured. Hoping for leniency in their trial before a U.S. military court, Toby testified about the events surrounding the war and explained why the Modocs had acted as they did. She was unsuccessful, and after a hasty trial, Captain Jack and four members of the Modoc tribe were convicted and hanged.

The Modoc War cost over half a million dollars, the lives of some eighty-three whites and a total of seventeen Native Americans. After it ended, the lives of many Modocs changed dramatically. The remaining members of the tribe who had occupied the lava beds were moved to Indian Territory in present-day Oklahoma. A few Modocs, including the Riddle family, returned to the Klamath Reservation in Oregon. After their relocation, Toby and Frank decided that they could best serve all Native Americans by bringing attention to the Modocs' plight. With Meacham's encouragement, they embarked on a lecture tour and spoke throughout the United States about the events of the war and how Toby had saved Meacham's life.

In 1876, Meacham published an account of Riddle's life titled *Winema*, which he dedicated to her and wrote, "This book is written with the avowed purpose of doing honor to the heroic Wi-ne-ma who at the peril of her life sought to save the ill fated peace commission to the Modoc Indians in 1873. The woman to whom the writer is indebted, under God, for saving his life."

As a consequence of her role in attempting to save the lives of the peace commissioners and because of Meacham's deep regard for her, he petitioned the U.S. Congress to award Riddle a military pension, which she received until her death in 1920. Rebecca Bales, author of the article "Winema and the Modoc War: One Woman's Struggle for Peace," concludes, "Winema's death marked the closing of an era—she was one of the last Modoc War participants to die, and she was one of the first American women to be distinguished by congressional act for her actions in time of war."

ELIZABETH "LILLIE" HITCHCOCK COIT (1843–1929)

SAN FRANCISCO'S VOLUNTEER FIREFIGHTER

Lillie Hitchcock Coit was a true trailblazer who symbolized the new frontier of early California. In an era when women's conduct was constrained by rigid convention, she was bold and courageous. Lillie became a widely known volunteer firefighter and benefactor for the construction of San Francisco's Coit Tower located at the top of present-day Telegraph Hill.

Born Elizabeth Hitchcock, "Lillie" was the only child of her father, Charles, an army surgeon, and her mother, Martha. In 1851, when she was seven, Dr. Hitchcock received orders to move to California, and the family reluctantly left Kentucky for San Francisco. According to Lillie's biographer, Charles had been told that the city of San Francisco "was a veritable

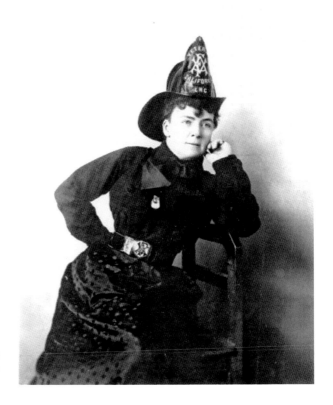

Elizabeth "Lillie" Hitchcock Coit. *Courtesy of the San Francisco History Center, San Francisco Public Library.*

nightmare of unleashed passions and diabolical deeds. One third of all the businesses there were gambling saloons and nearly everyone lived riotously and extravagantly." By the beginning of 1852, Dr. Hitchcock realized that he could not go on living in San Francisco on his army pay, and he resigned and went into private practice.

As a young girl, Lillie became fascinated by the red shirts and war-like helmets worn by firemen. She earned her place with the San Francisco fire department at the age of fifteen when she led bystanders to help pull a struggling Knickerbocker engine No. 5 up Telegraph Hill to beat other engine companies fighting a fire. One day on her way home from school, Lillie saw the plight of the Knickerbocker, tossed her books to the ground and ran to a vacant place on the rope. She began to pull while crying out to the numerous bystanders, "Come on, you men! Everybody pull and we'll beat 'em!" Others did come, helped to pull Knickerbocker No. 5 up the steep hill and succeeded in quenching the fire.

According to a description of the incident later published in the *San Francisco Chronicle*, "One afternoon the pioneer fire company had a short staff on the ropes as it raced to the fire. Because of the shortage of man power, the engine was falling behind. Then suddenly there came a diversion. It was the story of Jeanne d'Arc at Orleans, the Maid of Sargossa, and Molly Pitcher of Revolutionary Fame all over again."

After this experience, whenever an alarm was sounded, Dr. Hitchcock had difficulty preventing his daughter from rushing to the scene of the fire. In 1863, after Lillie was elected an honorary member of the Knickerbocker Company and given a gold badge, she sewed the number 5 on her clothing in needlepoint and wore the badge every day. Each year when the company celebrated the anniversary of its founding, Lillie would wear a red fireman's shirt atop a black silk dress and carry her shiny black fire helmet in one hand. When there was a parade or celebration in the city, she would appear seated atop Knickerbocker No. 5, surrounded by flags and flowers. Lillie Hitchcock became, literally, the mascot of San Francisco's firemen.

As years passed and Lillie Hitchcock grew older, she no longer followed Knickerbocker No. 5, but her relationship with the company remained as strong as ever. If one of the firemen became ill, she would enliven the sick room by her presence and care for his needs. When death claimed a member of the company, Hitchcock sent a floral tribute to express her condolences and sympathy. She even took to signing her name "Lillie Hitchcock 5."

The Hitchcocks became wealthy and influential members of San Francisco society. In 1860, Lillie attended a ball where she met and fell in love with Howard Coit, a stockbroker described as handsome and "elegant in dress and manner" but considered by her mother to be not good enough for her daughter. Martha decided to take Lillie to Paris for "a more finished education." Before departing, the editor of the *Evening Bulletin* of San Francisco asked Lillie to write some articles for his newspaper about her experiences. The first article written by Lillie as "Our Paris Correspondent" had "Number 5" placed to the right of her initials.

While living in Paris, Hitchcock's unique personality made her a favorite at the court of Napoleon III, and she received numerous invitations to attend social events. On one occasion, Lillie was introduced to a member of the royal family, Prince Grimaldi, who soon asked for her hand in marriage. Lillie found her noble suitor "altogether too calm and placid, so unlike Howard Coit with his exhilarating personality." According to historian Helen Holdredge, Lillie wrote in her diary, "Howard Coit is my secret love. He trails my affection for him in the dust as if I were a sabre he intends to

dull by being dragged along unnoticed. I do not understand him in the least but I seem to comprehend the Prince very well. He has two hobbies: what he is going to put outside of himself and what he is going to put inside."

In 1869, after her return to San Francisco, she eloped with Howard Coit. For a while, the couple lived in a country house in California's wine country. One summer, Lillie met and became a friend of the famous writer Robert Louis Stevenson, who was living nearby. The Coits traveled extensively in the eastern United States, Europe and Asia, but Lillie's love of California never wavered. Unfortunately, her marriage was not a happy one, and the couple separated in 1880. The marriage ended with Howard's death in 1885.

Although Martha had done her best to turn her daughter into a traditional southern belle, Lillie continued to be contemptuous of conformity. She has been described as one of the most eccentric personalities of her time. She once arranged a middleweight boxing match in her hotel room. A New York newspaper reported the incident:

> *Mrs. Lillie Coit has broken through another social tradition by having a slugging match in her drawing room. Blood flowed freely. The winning fighter asked her if he should finish off his opponent and she turned her thumbs down. Has the wealthy woman set an example, which other women will follow? This is a staggering shock to conservative New York. But it did not ruffle San Francisco one bit. They are used to her.*

Lillie Coit played poker, smoked cigars, polished off bottles of bourbon and wore trousers long before it was socially acceptable for women to do so. On one occasion, she attended a meeting of San Francisco's all-male Bohemian Club disguised as a gentleman. Although Coit was the originator of a new way of life for women, San Francisco society accepted her and her oddities. "This was because she was so picturesque that she was able to violate the many norms of behavior without suffering a loss of reputation," wrote a *Boston Globe* reporter.

After her husband's death, Lillie Coit moved into a suite in San Francisco's Palace Hotel. In 1904, while entertaining a guest, a former acquaintance broke into her room. A scuffle occurred, and the visitor was shot and later died. The murderer was arrested and served fifteen years for second-degree manslaughter. Terrified that the man would one day be released and kill her too, Lillie moved to Paris and remained there for the next twenty years. After learning of the assassin's death, Lillie returned to San Francisco but lived only one more year in her beloved city.

On July 22, 1929, at the age of eighty-six, Lillie Coit died and was cremated wearing the gold patch of Knickerbocker Engine Company No. 5. A family mausoleum holds her remains, and a khaki fire jacket, coiled fire hose and brass fire hose nozzle are placed beside the niche containing her ashes.

When Coit died, she left one-third of her estate to San Francisco "to be expanded in an appropriate manner for the purpose of adding to the beauty of the city which I have always loved." Several years after her death, the executors of her will decided to construct a memorial tower in her honor that would also serve as a tribute to the city's firemen. The novel 180-foot cylindrical tower now stands atop Telegraph Hill. In 1933, a second memorial was erected in the city's Washington Square, a sculptured block representing a life-sized group of three firemen, one of them carrying a woman in his arms.

PART II

Women Who Contributed to Social and Political Change

Chapter 3
SUFFRAGISTS

In the early twentieth century, the United States experienced an exciting and significant political triumph: women finally won the right to vote and achieved political independence. The battle for women's suffrage had been waging for decades, and long before the Civil War, women were seeking voting equality. As early as the 1870s, a group of pioneer suffragists demanded their own political voice and civil rights; they did not want men deciding their future. It was, however, not until 1911 that California women achieved suffrage, and not until 1920 were all women granted enfranchisement with the passage of the Nineteenth Amendment to the United States Constitution. There were hard-fought battles, devastating defeats, countless alliances and many divides, but they never wavered in their determination for women's suffrage. Women finally achieved the freedom men had since 1776: to choose for themselves what they believed was best for them.

During the 1870s and 1880s, the suffrage movement took different forms. Many women had little interest in politics and were content to help on social welfare issues that they regarded as an extension of home domestic duties. When assisting within an organization, they often referred to it as "advancing women's work." Others, such as Laura de Force Gordon, were Progressives and participated with a group of national firebrands including Susan B. Anthony and Elizabeth Cady Stanton. Gordon gave the first suffrage speech in California.

Following an evolving philosophical route, the Woman's Christian Temperance Union (WCTU) played an important role in the suffrage

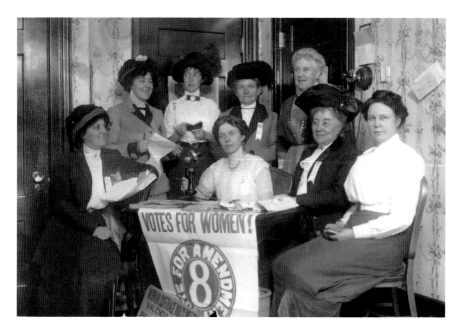

Suffrage committee meeting. *Courtesy of the California History Room, California State Library, Sacramento, California.*

process. Members believed that lobbying and political power could strengthen women's moral authority. Therefore, club members, professionals and the well educated participated in the suffrage fight through WCTU membership. They may have been following different ideological compasses, but when the campaigns of 1896 and 1911 were waged, the progressive, conservative and temperance blocs were all on the same side: to get the power of the vote. So many extraordinary women participated: Ellen Clark Sargent challenged disenfranchisement with the argument of "no taxes without representation," and Maud Younger, a Progressive, founded the waitress labor union and organized it in the fight for suffrage.

Throughout the years, suffrage organizations utilized a variety of tactics. They lobbied for the right to vote in the new state constitution; advocated through the legislative process; incorporated voting equality into the Republican platform; and petitioned the 1891 legislature for the right to vote in school board and bond elections. In 1896, they used the referendum process only to be defeated again. Unexpectedly, the campaign lost in the San Francisco Bay area, which at that time was the population center of the state. Surprisingly, it passed in the southern part of the state and was carried by working men. The results illustrated that class mattered but in an

unexpected way: the more affluent areas voted against suffrage in a higher proportion than working-class neighborhoods.

California women finally achieved suffrage in the astounding campaign of 1911. The younger suffragists worked with the experienced ones, the clubs, the unions and men's organizations all united to give women what they always deserved: the right to vote. Riding up and down the state in her automobile was the daring and brilliant pioneer suffragist Clara Shortridge Foltz. Along with the members of her Votes for Women Club, Foltz organized Los Angeles and other Southern California regions. Although the margin of victory was a mere 2 percent, Los Angeles and southern rural districts carried the vote. As in the 1896 election, the working class in both Southern and Northern California had the highest percentage of affirmative votes.

California was the sixth state to win the vote, and as arduous and dramatic as achieving victory was, it was a major advance for the suffragists and their supporters. An important and influential state, it set the stage for the other states. Nine more states achieved suffrage before the 1920 national referendum when finally, after so many campaigns and defeats, women were granted the right to vote.

In this chapter, the reader will learn about the remarkable women who devoted their lives to women's suffrage. They were brave and determined to attain what they believed was their inherent right. They set the path for political freedom and civil rights for womankind. Please meet Laura de Force Gordon, fierce fighter and orator; Ellen Clark Sargent, gracious and most respected rebel; Maud Younger, the incredible millionaire waitress and labor reformer; and last but very important, Clara Shortridge Foltz, the first woman lawyer and one of the most notable suffragists during the entire movement.

LAURA DE FORCE GORDON (1838–1907)

LADY OF THE PODIUM

Laura de Force Gordon was a suffragist, lobbyist, journalist, spiritualist, newspaper editor, attorney, farmer and more. Unquestionably, she was a trailblazer and outspoken feminist in every sense of the word. As a speaker, "she was Websterian in force and eloquence," and she used this talent to espouse her causes early in her life as a Spiritualist and then a staunch women's rights advocate. Her speech in 1868 launched the California suffrage movement and the founding of the California Women's Suffrage Society.

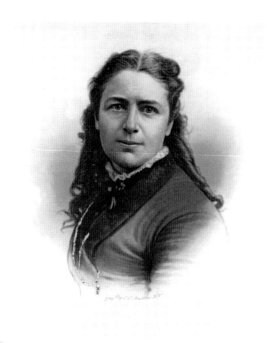

Laura de Force Gordon. *Courtesy of the Library of Congress.*

Born in Pennsylvania in August 1838, Gordon was one of nine children born to Catherine Allen and Abram de Force. Because of her father's poor health, the family suffered a lot of hardship, but Gordon and her sister were fortunate to have been well educated throughout their young years. Her mastery of English, both written and oral, was the basis of her exceptional oratory ability and success as a writer and publisher. Following her mother, Gordon became a Christian Spiritualist. Recognizing she had extraordinary communication skills, Gordon began traveling throughout the Northeast giving speeches on Spiritualism, a popular movement on the left of religious liberalism. Her reputation as a gifted orator grew quickly. During one such tour, she met Dr. Charles H. Gordon, a physician and captain in the Third Rhode Island Volunteer Cavalry. They married in 1862 and eventually settled in Lodi, California, a small farming community.

Gordon continued on the speaking circuit, but once she reached California, she devoted her time and energy to the suffrage movement. In 1868 in San Francisco, she delivered the first suffrage speech in the state. This was the beginning of numerous tours through California and other western states promoting women's suffrage and demanding more rights for women. She had a deep belief in human rights for everyone, and she instilled a militant individualism into the movement. In one of her speeches, she demanded that "the Constitution of the several States be amended so the white and black, red and yellow, of both sexes, can exercise their civil rights." She openly expressed her opinions in her writing and speeches. Her fame was quickly spreading, and to her amazement, she was nominated for state senator for the Independent Party of San Joaquin County. She even received two hundred votes—of course, all from men.

In addition to her love of speaking, Gordon was also an accomplished writer. She began her professional career in newspapers as editor of the women's department of the *Narrow Gauge*, a short-lived semi-weekly in Stockton. Gordon then went on to become editor and publisher of the *Stockton Weekly*, which was so well received that she turned it into a daily. In 1875, she moved the paper to Sacramento, changed its name to the *Weekly Reader* and sold it about a year later. Gordon used these papers as a vehicle to speak out for women's rights and the Democratic Party.

During this time, Gordon was involved with the "radical" faction of the women's movement and was connected with the Stanton-Anthony National Women's Suffrage Association, as opposed to the "conservative" side. Gordon, along with other California "radicals," was charged with espousing treacherous free thinking. However, the suffrage movement moved on with its ups and downs in California, and Gordon moved with it. She then entered another phase of her career, the legal profession, which was certainly a natural transition.

Working as a correspondent for the *Oakland Democrat* and the *Sacramento Bee*, Gordon strongly advocated for the Woman Lawyer's Bill, drafted by Clara Shortridge Foltz. The bill would allow women to practice law in California. Gordon played "a spirited and brilliant" part in lobbying for the bill, which was eventually adopted by the California legislature. It was at this time that she began to diligently study for the qualifying exams and, along with Foltz, applied for admission to the Hastings Law College, a division of the state university system. Much to their disappointment, they were denied admission.

They took the next logical step and argued their case before the Fourth District Court, which ruled in their favor, but Hastings appealed. Next was the California Supreme Court, where they successfully argued their case, thereby opening the way for women to study law at the state university. It was a continual struggle as men, even women, the press and others taunted her every step of the way. In spite of it all, she graduated with honors.

In December 1879, the California Supreme Court ruled that Gordon and Foltz be admitted to the state bar, the first women to have that privilege. While attending a state constitutional convention in that same year, Gordon persuaded the San Francisco delegation to support the clause that "no person shall, on account of sex, be disqualified from entering upon or pursuing any lawful business, vocation, or profession." This became Article 20 of the new state constitution.

Gordon opened her San Francisco law practice in 1880 and on weekends traveled home to her farm in Lodi. Her intelligence, writing and proficient

communication skills contributed to a very successful career. However, she still had some unfinished business. She wanted the opportunity to practice before the Supreme Court of the United States. She petitioned the court and on February 3, 1883, was admitted, thus making her the second woman in the country to have that opportunity. Although her practice was continually busy, she still had time to use her "golden" tongue to help the Democratic Party and advance feminist issues. The women's suffrage movement was at the core of her activist life from the early stages of her involvement. Always present was the knowledge that although women were able to practice medicine and law, they did not have the right to vote.

When the Republican state convention endorsed full women's suffrage in 1894, the movement was strengthened significantly. Gordon and Foltz led an impressive lobbying effort for the right to vote, and Gordon's essays and speeches received extensive coverage in the press. Along with other state radicals, she advocated for women's enfranchisement in the name of human rights and democracy and argued that the people should force the state to address economic injustice and inefficiency. She denounced restricting the right to vote to a privileged few and declared that the same men who deny women the vote could also "give the gentry the right to vote and shut out the laboring classes. It is a kind of political bondage." From this argument, she demanded that women be granted voting rights on the basis of "human rights." Unfortunately, the 1896 vote for women's suffrage was defeated at the ballot.

Not much has been written about Gordon's personal life. Records show that sometime around 1877 she divorced her husband on the basis of adultery, and around 1893, she adopted a young boy named Verne. In 1901, she officially retired from the legal profession, moved to Lodi to manage her twenty-five-acre farm and continued her advocacy activities. She died in April 1907 and is buried at Harmony Grove Cemetery in Lockeford. In an obituary published in the *Woman's Tribune* on May 25, 1907, Gordon's life was summarized as follows: "Hers was a genial, tender, loving soul, cast in heroic mold...The cause of women's rights both suffrage and in the profession owes much to Laura de Force Gordon's lifetime of work on behalf of American women."

In 1979, a time capsule was unearthed in San Francisco's Washington Square Park. It contained a copy of *The Great Geysers of California*, written by Gordon. On the book's flyleaf, she had written, "If this little book should see the light of day after 100 years' entombment, I should like the readers to know that the author was a lover of her own sex and devoted the best years of her life in striving for the political equality of women."

ELLEN CLARK SARGENT (1826–1911)
BELOVED SUFFRAGIST AND GRACIOUS REBEL

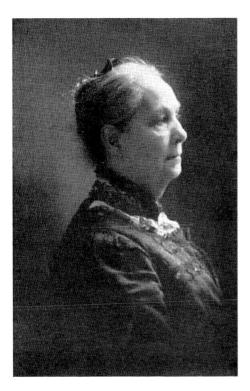

Ellen Clark Sargent. *Courtesy of the Bancroft Library, University of California–Berkeley.*

Ellen Clark Sargent was a combination of many things: devoted wife, caring mother, gracious hostess and involved community leader. Her life's commitment, however, was to ensure that all women had the right to vote. As a close friend of Susan B. Anthony and the wife of a United States senator, Sargent, a pioneer suffragist, was able to make her mark in the long fight for women's suffrage. She was persistent and tenacious and never faltered in her pursuit of voting rights for women.

Born in 1826 in Massachusetts, Ellen Clark met her future husband, Aaron Sargent, when they were teenagers and both were teaching Sunday school in a church in Newburyport, Massachusetts. Upon learning about the California gold rush, he left to follow the trail of gold to Nevada City in 1849, promising to return and marry her. After limited success in his gold search, he became a reporter and part owner of the *Nevada Journal*. Almost three years to the date after he left Massachusetts, he returned to Newburyport and married Ellen Clark in March 1852. The following October, they returned to Nevada City and moved into a small four-room house that Aaron Sargent had built for them. From all accounts, Sargent was very pleased with her new home with a ceiling covered by muslin. In her memoirs, however, she noted that her only apprehensions were the "rats that incessantly scampered on the fabric above her head." Today, this remodeled one-story abode is the lovely setting for Grandmere's Bed and Breakfast at the corner of Broad and Bennett Streets.

During the early years of married life, while her husband was involved in journalism, pursuing a law degree and beginning a political career, Sargent began to develop her own political interests. Her deep concern about the lack of women's voting rights inspired her to get involved in the suffrage movement. In 1869, she established the first women's suffrage group, the Nevada County Women's Suffrage Association. Sargent established herself as a respected and most influential suffrage leader in California, eventually becoming the first president of the state suffrage organization.

In the years that followed, Aaron Sargent was elected to Congress and, in 1872, to the United States Senate as a member of the new Republican Party. In 1878, Senator Sargent introduced the twenty-nine words that would eventually become the Nineteenth Amendment to the United States Constitution. Unbeknownst to many, this bill was unsuccessfully introduced each year for the next forty years. Aaron Sargent was the first senator to speak about women's suffrage in the United States Congress. At the risk of "the loss of personal and official prestige in the conservative court circles," Sargent and her husband spoke openly about their unwavering support of women's rights. Their home on Folsom Street was often used as a campaign center where many meetings were held to discuss the political issues of the day, especially women's suffrage.

During the time leading up to the 1896 ballot amendment to allow women the right the vote, many newspapers had very unflattering stories and editorials. Such was the case with a *New York Times* editorial, the essence of which stated that it was acceptable for women to use their charms and guile to get a proper husband but it was not all right to use their brains to vote and decide public issues. In a letter, Sargent wrote to a friend about the "great privileges and responsibilities of full American citizen." She asked, "Does not that apply to women as well as men: Why cannot women see their low estate in the scale of humanity! And to think they could change it if they would."

Sargent was a founding member of the Century Club, a group of elite women that provided vital support in the election to get women on local school boards. She became president of the Campaign Association, honorary president of the California Equal Suffrage Association and treasurer for six years of the National American Woman Suffrage Association, the most influential women's rights organization of its day. She was always there to assist her friends and colleagues for the women's movement. Even after the defeat of the bill in 1896, Sargent was one of the most vocal and influential leaders who led the rebuilding of the movement. In the fall of 1899, she

waged a very personal and public campaign for the ballot measure. She attempted to register to vote. Of course, not being a male, she was refused the right. This, however, did not stop her, and on Election Day she attempted to vote. Once again, she was denied the privilege.

Sargent would not give up the battle that she had been fighting for so many decades. When she received her property tax assessment in 1900, she developed a campaign to bring this injustice to the public's attention. Sargent dutifully paid it, and then—represented by her son, George Sargent, an attorney—she filed to reclaim the tax based on the theory that since she had not been given the right to vote it was "taxation without representation." George Sargent quoted the most eminent authorities to prove that taxation and representation are inseparable. The case wound through the courts, with the Sargents being defeated on every motion. However, Ellen Sargent's tactic worked, and the suffrage movement was quick to understand the importance of the scenario. Their numbers grew, and they declared the theme of the 1901 convention "Taxation Without Representation Is Tyranny." They took up her argument that the taxation issue was one of the causes of the Revolutionary War and reminded everyone that the Declaration of Independence states that all men are equal, and this included women.

For the next ten years, Sargent remained a moving force and inspiration to the suffrage movement. She gave her time, her money and every ounce of strength so that women would have the right to vote. Sargent died just days before the October 10, 1911 vote when women finally gained the right to vote in California. Her memorial service was held in Union Square, and for the first time in California history, the flags were at half-mast for a woman. One thousand people, including suffragists, elected officials, men and women who believed in equality, came to honor her memory. The Sargents were giants in the suffrage movement and contributed inestimable contributions to the cause. Ellen Sargent set the standard and never faltered. She was a gracious rebel and committed pioneer suffragist.

In a letter to her dear friend Susan B. Anthony, Sargent wrote about the pleasures of age: "I have learned to accept people as they are with limitations and frailties that belong to the human family…As for old age, I can say that to be free the carking cares which seems to belong to one's earlier years is itself happiness. Old age is the spirit freed from most of earthly follies."

MAUD YOUNGER (1870–1936)

MILLIONAIRE WAITRESS AND LABOR REFORMER

Suffragist Maud Younger, aggressive and passionate, was a significant figure in the women's movement in the early years of the twentieth century. A gifted leader and political activist, she was able to bridge the divide between women of disparate backgrounds, bring them together around common goals and shape social change. Her ebullient personality and charismatic style attracted others to the causes in which she believed very deeply, such as fair labor laws, the suffrage movement and the Equal Rights Amendment.

Younger was born in San Francisco on January 10, 1870, to William John Younger and Annie Lane Younger, pioneer settlers in that city. Her father, a prominent and very successful dental surgeon, was able to send his five daughters and son to the best schools and provide them with the finer things of life, to which they were accustomed. Additionally, when Younger

Maud Younger. *Courtesy of the Library of Congress.*

was twelve years old, her mother died and left her children a substantial inheritance, on which she could have spent the remainder of her life as a wealthy socialite with very few worries. Although the activities in her early years were of a traditional nature—such as going to elite private schools, attending church, moving in privileged circles in San Francisco and traveling throughout Europe and the United States—she soon broke away from the conventional lifestyle of her family and peers. Growing up, she developed a strong social conscience and personal empathy that were strengthened through her travels and the people she met.

On her way to Europe in 1901, she visited New York and requested permission to stay at the College Settlement House that had been established by a group of graduates from the emerging women's colleges. The concept behind the Settlement Houses that were established in the heart of poverty-stricken areas was to give wealthy people an opportunity to experience firsthand the depth of poverty and to study how it affects lives. The objective was hopefully for them to develop long-term solutions and improve the life conditions of these very poor individuals. Younger's intention was to stay for a week. However, she remained there for five years, and during this time, her convictions for social reform thrived and her belief in the grass-roots movement intensified. She emerged from this experience an ardent advocate for the poor, women's suffrage and protective legislation for women and labor unions. She later noted that her experience on New York's East Side led to her passion as a committed suffragist.

The more she involved herself in these nascent movements, the more she wanted to actually experience what other women were living. She did this by working as a waitress in New York restaurants and soon after joined the Waitresses' Union. Sometime later, she colorfully portrayed her experiences in *McClure's* magazine, a progressive publication of the day, in an article entitled "Diary of an Amateur Waitress: An Industrial Problem from the Worker's Point of View."

Upon her return to California in 1908, she took another job as a waitress with the intention of joining the labor union. Discovering that there was no labor union to join, she organized one. She had the skills and talents to organize, her spirit was contagious and she was driven. By this time, she had already been nicknamed the "millionaire waitress" by her colleagues. They had enormous trust and respect for her and elected her president of their local and a three-term delegate to the Central Trades and Labor Council. A natural leader, she skillfully worked the political system and helped facilitate the passage of California's eight-hour workday law for women. With her

union connections, she succeeded in getting the measure endorsed by the California State Federation of Labor and pushed it through the legislature by organizing testimony on the bill by factory workers, waitresses and laundry workers.

During the same year, the drive to obtain suffrage for women was once again gaining momentum, and many members of the movement understood that victory depended on securing at least some of labor's votes. Maud Younger played a significant role in obtaining labor's support for the cause. By this time in her life, Younger recognized that voting and working rights were on a similar plane and closely related. She felt strongly that suffrage for women was a vehicle to fix other social ills, and she traveled to all parts of the state speaking on behalf of the suffrage amendment. As a powerful speaker, she had a talent for imparting her message with authority and humor. Utilizing her strong writing skills, she published pamphlets aimed at male working-class voters, such as "Why Wage-Earning Women Should Vote." Among her most important contributions to the cause was organizing a Wage Earners' Equal Suffrage League, the working women's arm of the campaign.

Ever flamboyant, during the 1911 Labor Day Parade in San Francisco, she drove the Wage Earners Equal Suffrage League's float of six white horses to publicize the vote for the amendment. As the first woman to drive a float, she was able to attract an enormous amount of attention for the movement. Younger was then recruited by Alice Paul, one of the most famous figures in the national women's suffrage movement, to help with many other state campaigns. She went to New York to organize the International Ladies' Garment Workers' Union. From there, Paul made her a lieutenant, and she became involved in the newly formed Congressional Union of Woman Suffrage, a forerunner of the National Women's Party and a more militant wing of the movement. After the passage of the amendment, she continued her work advancing women's labor causes and assumed leadership positions in the National Women's Party campaign for the Equal Rights Amendment. For the next several years, Younger worked hard for the passage of the Nineteenth Amendment. As the party's congressional chair, she was influential in presenting the amendment to Congress in 1923. On the national level, she was a recognized orator and fearless lobbyist occupying many leadership positions.

Maud Younger died in June 1936 at her home in Los Gatos, California. The number of committees and organizations with which she was involved are too numerous to list, but they are of significant importance in all facets of the women and labor movements. Although born to wealth, Younger

chose not to spend her life as a socialite but to roll up her sleeves, work with ordinary people and use her money and talents to better the cause of working people. All women owe a debt of gratitude to this exuberant, selfless, charming and talented "millionaire waitress" who devoted her life to helping and empowering other women.

CLARA SHORTRIDGE FOLTZ (1849–1934)

PORTIA OF THE PACIFIC

There are many remarkable trailblazers in the California struggle for women's suffrage, but few were as dynamic and tenacious as Clara Shortridge Foltz. She was first among "firsts" in the California women's equality movement: the first female lawyer, the first female deputy district attorney and founder and champion of the public defender system. An intellectual with flair, élan and confidence, she knew how to promote not only her beliefs and

Clara Shortridge Foltz.
Courtesy of the Center for Bibliographical Studies and Research.

convictions but also herself through utilizing the power of the press and the courtroom. For many decades and through numerous political and legal challenges, she remained a celebrity, a woman to watch, follow and admire. As a progressive and scholarly thinker, she devoted her professional and personal life to working for women's suffrage and public defense, both of which were her ultimate triumphs.

Born in 1849 to Talitha Harwood and Elias Shortridge, she was the only daughter in a family with four boys. At the age of fifteen, she eloped with Jeremiah Foltz, had five children and divorced him in 1877. Faced with the responsibility of supporting her young family, Foltz looked to the legal profession to start her career. Although she had only a few years of formal education between the ages of eleven and fourteen, Foltz had a keen interest in law. Encouraged by her parents and brothers, she requested permission to read law with a local attorney in San Jose. He refused her because she was a woman. His answer was the first of many rejections and humiliations that Foltz would encounter throughout her career fighting for women's rights. This rebuff made it ever more challenging, and she "silently went about preparing to do battle against all comers who would deny to women any right or privilege that men enjoyed."

Determined to practice law, Foltz drafted an amendment to the California Code of Procedure, which at that time limited membership in the legal profession to white males. The legislation proposed to eliminate both gender and racial discrimination. Working with Laura de Force Gordon and other suffragists against fierce opposition, they successfully lobbied to get the amendment known as the Woman Lawyer's Bill passed. Later in her autobiography, Foltz noted, "The bill met with a storm of opposition such as had never been witnessed upon the floor of a California Senate." Up to the last moment, passage was uncertain. It was close to midnight, and the governor still had not signed the bill, so Foltz moved into the governor's chamber, defying the sergeant at arms, and personally asked him to endorse it. As the story goes, the governor pulled it from the discarded pile and signed it as the clock struck twelve midnight. On September 5, 1878, Clara Shortridge Foltz was sworn in as the first woman lawyer on the Pacific Coast. Newspapers from all over the country wrote fascinating stories about this amazing lawyer with five children who could study law and still care for her children and home. This was just the beginning of a long career that would bring her fame and notoriety. It is apparent that she very much enjoyed and encouraged the spotlight.

In the fall of 1878, she opened a small practice in San Jose and began working with Gordon on a suffrage platform at the state constitutional

convention, the first time a suffrage platform was seriously considered. Although Gordon was taking the lead on this issue, Foltz traveled to Sacramento to assist her. In December, the convention adjourned, and the fight was to start anew the next year. It was the first of many battles they would encounter in the coming decades working for the suffrage cause.

For her to advance professionally, Foltz realized she would need a more formal education. With three of her children, she moved to San Francisco and applied to the newly established Hastings Law School. She was admitted, but only for three days. The board of directors of Hastings denied her application. In those few days, however, she suffered harassment and loathsome behavior from the male students and professors. Gordon joined her on the third day but was also turned away. They sued the board of trustees, demanding their right to study law.

On the day of the decision, the courtroom was packed with women suffragists, male colleagues and many reporters. The papers reported about Foltz's and Gordon's stylish clothing, chic hats and fashionable hairdos. Not a word was written about the men's attire. Although the judge ruled in their favor, the case was appealed, and it was several months before women were granted the right to attend law school. He ordered Hastings to admit Foltz and Gordon. In his remarks, he referred to the Woman Lawyer's Act that both women had written. It would still be a few more months before the case was settled—too late for Foltz to realize her dream of a formal law school education. Her money ran out, and the semester was over. It may have been a personal loss, but it did not deter her from being a "great lady lawyer." Foltz's landmark achievement opened the way for millions of other women to study law.

While she was practicing law and in the midst of fighting for admission to law school, Foltz remained deeply involved in the suffrage movement. In 1879, she was appointed clerk to the California Assembly Judiciary Committee, the first woman to hold this position. The appointment was very beneficial for her activities at the 1880 legislature because it helped her advance the "war" for women's suffrage. She based her extremely technical arguments on the belief that the new state constitution gave women the right to vote. Although they were defeated in convincing the legislature, it was a victory for the amount of coverage they received and the interest the suffrage movement inspired in both women and men. It was a glorious time for Foltz. Helped by her dramatic language and remarkable oratory skills, she was definitely on the way to being a shining star in the suffrage movement.

As Foltz pursued her law career and her interest in social reform, she moved from San Jose to San Francisco, New York and Los Angeles, seeking

to expand her law practice, making her mark and earning sufficient money for her family. Wherever she resided, she joined the suffrage movement and usually rose to the top rung of the leadership. As early as 1872, she declared, "Leave women...to find their sphere. And do not tell us, before we are born even, that our province is to cook dinners, darn stockings, and sew on buttons." Newspapers and magazines such as the *Woman's Journal* followed her with great interest and wrote accounts of her latest activities. In 1888, she was noted as a "leader of woman suffrage on the Pacific Coast," and at the age of thirty-one, she was elected president of the California Woman Suffrage Association.

During her lifetime, Foltz's ideologies evolved, and she deftly would adopt the trend that had the most potential for achieving voting equality for women. An example was her involvement in the Woman's Christian Temperance Union. Throughout the decades, the WCTU movement was intertwined with women's suffrage, sometimes united and sometimes against it. In several campaigns, Foltz, like other suffragists, united with the Prohibitionists and then a few years later disengaged from them. She reasoned there was more power in numbers.

The late 1880s saw little progress for the movement, but another chance for victory arose in the 1896 presidential campaign. Foltz and several hundred women attended the Republican convention to urge a suffrage plank being included in the platform. Much to their intense disappointment, the Republicans included a very weak "women's plank," which did not receive any recognition. To add to the loss, the arduous campaign for women's suffrage on the same 1896 California ballot was defeated by a vote of 137,000 to 110,000. After these two losses, Foltz's involvement in the movement slowed, and during the next few years, she concentrated on her very successful law practice.

When the 1911 suffragist campaign started, Foltz was living in Los Angeles and once again was ready to participate. Much to her surprise and humiliation, the younger suffragists believed her style was dated and inappropriate for their new fight for equality, and they rejected her. Clara Foltz may have been ostracized, but her ego would not let these rebuffs stand in her way. She started the Votes for Women Club and proceeded with her "old-fashioned" way of campaigning. Her leadership skills helped build a group of several thousand women and men who distributed millions of buttons, signs, booklets, flyers and grocery bags; held meetings and rallies; and never looked back. They used automobiles to drive up and down the state and promote their cause. Seeing these women in their dresses and

chic hats waving and speaking from their cars was a natural attention getter and provided more visibility for the ballot measure. After so many years of grueling campaigns, victory was at hand. The amendment passed by a small margin of 3,587 votes out of 246,487, but it was a magnificent triumph. Foltz's club was just one of numerous organizations campaigning for the suffrage ballot amendment, but once again, the newspapers lauded her as the "leader of woman suffrage on the Pacific Coast."

Clara Foltz was a unique, accomplished woman who devoted her life to law, women's suffrage and the most original contribution to law reform, the public defender system. Foltz was a successful lawyer, businesswoman, journalist, political activist and wonderful mother; her contributions to womankind are immeasurable. Brave, optimistic and regal in nature, she would not give in to defeat. Foltz liked being first and spent her fifty years in law working to stay on top. As she approached the end of her brilliant career, she wrote of her achievements: "a leader in woman suffrage." Foltz died in 1934 after having lived a full and noteworthy life.

Chapter 4

REFORMERS AND ACTIVISTS

The women profiled in this chapter made significant contributions to California with their courage, tenacity and concern for the rights of others. They fought to overcome injustice for voiceless and marginalized people, including victims of the yellow slave trade and racial discrimination, children, sweatshop employees, immigrants and farm workers. Many of these women who ventured into nontraditional activities with vigor and determination perceived their relationship to public and private institutions differently from men and dedicated their lives to obtaining equality and justice for all.

Donaldina Cameron was a Presbyterian advocate for social justice who boldly charged into brothels and cribs to rescue more than three thousand Chinese slave girls and women in San Francisco. For nearly forty years, Cameron worked tirelessly to free illegally held women and girls and became known as "Lo Mo," the Mother.

In Los Angeles, reformer Katherine Philips Edson lobbied for the Industrial Welfare Commission (IWC) to establish standards for wages, hours and working conditions for women and children. She campaigned effectively for the right of women to participate meaningfully in electoral politics and fought for regulation of milk production to protect babies from disease.

Rose Pesotta, a member of the International Ladies' Garment Workers' Union (ILGWU), came to Los Angeles in 1933 to organize the mostly Latino dressmakers who made up a large percentage of the Southern California garment industry workforce. Despite facing anti-picketing injunctions and hired thugs, she spearheaded the Dressmakers General Strike in Los

Dolores Huerta speaks
to UFW union members.
Courtesy of the Walter P.
Reuther Library, Wayne State
University.

Angeles. Pesotta's visibility led to her election in 1934 as a vice-president of the ILGWU.

In 1962, Dolores Huerta co-founded the United Farm Workers union with Cesar Chavez. She helped to organize the strike of over five thousand grape workers and the following wine company boycott. In addition to organizing, she also fought against the use of harmful pesticides and for healthcare benefits for agricultural workers.

DONALDINA CAMERON (1869–1968)

ANGRY ANGEL OF CHINATOWN

Donaldina Cameron was an advocate for social justice. In early twentieth-century San Francisco, she rescued more than three thousand Chinese prostitutes kept against their will. Working on tips, she led the police to the

Donaldina Cameron with young Chinese women. *Courtesy of the San Francisco History Center, San Francisco Public Library.*

brothels and opium dens where the women led wretched existences. She discovered women hidden behind panels in secret alleyways and sometimes chopped down the doors herself. With support enlisted from church and civic groups, she is credited with breaking the back of the Chinese slave trade that flourished until the 1930s. Through her influence, lawyers and legislators changed and initiated state and federal statutes that freed Chinese people across the nation. It took Donaldina Cameron, a true trailblazer, more than forty years of personal risk, courage and fortitude to accomplish her goal.

Cameron was born in New Zealand. At the age of two, her family immigrated to California and settled in San Joaquin, California's great central valley. In 1895, Cameron was invited by Maggie Culbertson to work as a sewing teacher at the Presbyterian Mission Home for Girls, located near San Francisco's Chinatown. Two years after she arrived, Miss Culbertson became ill and died. Cameron, then twenty-five years old, became director of the Mission Home that had been established in 1874 to intervene on

behalf of Chinese girls and women who became vulnerable upon arrival in the United States.

The Exclusion Act of 1882 made it illegal for Chinese men who had come to California to work in the gold fields or on the railroads to send for their wives. Single men were not permitted to import wives from China or allowed to marry non-Chinese women. In 1895, Chinese men outnumbered Chinese women in America about twenty to one, and the small ratio of Chinese women to men created an enormous demand for prostitutes. In impoverished nineteenth-century China, a female child was considered to be a liability to her family, and one option was to offer her for sale. Many families sold their daughters to pay family debts. Others were misled into believing they were sending their daughters to the United States to be educated or married off to older, wealthy men. Sometimes girls as young as five were kidnapped and brought to San Francisco's Chinatown.

The girls and women were smuggled into the United States illegally. Forged papers often stated they were related to upper-class Chinese men already living in California. Bogus "contracts" were created to support a system known as the "yellow slave trade." Once in the country, the females were sold for one of two purposes. Young girls were sold to work as household servants called *mui tsais*. Many of these children were required to do heavy labor and endured frequent physical punishment. After they matured, they were often sold into prostitution.

The mui tsais and prostitutes were the main target of the Mission Home's efforts. Cameron became skilled at finding girls who had been hidden under trapdoors and behind false walls in brothels and cribs. The cribs were flimsy shacks, some only twelve feet wide, on the dimly lit, narrow streets and alleys of Chinatown. They were little more than jails with bars on the windows; some cribs had barred doors, too. Resistance was almost impossible. Some women were chained to their beds and drugged to keep them compliant. Others, because of their cultural training, simply resigned themselves to their dismal fate. Almost all Chinese prostitutes contracted venereal diseases from their clients. By the time they reached the age of twenty, many had died or committed suicide.

Rescues were conducted late at night in collaboration with axe- and sledgehammer-wielding policemen. Sometimes Cameron was unsuccessful in finding the girls she sought. A few police officers accepted bribes to betray her. Owners arranged with informers throughout Chinatown to warn them of impending raids and whisked the women into secret rooms, over rooftops or into cellars and underground tunnels.

Cameron became known as *Fahn Gwai*, "white devil," to the brothel owners, many of whom were members of tongs, groups of powerful Chinese gangsters who worked together to bribe officials. Workers in the Mission Home were often threatened by the tongs. On one occasion, a stick of explosives was found planted in the building. Had it been ignited, it might have destroyed the entire block.

After rescuing the girls and women from the hands of their captors, Cameron provided them with a home and became affectionately known as Lo Mo, "the Mother." Although the Mission Home was not intended for young children, Cameron could not bear to turn away infants or those born to girls who were pregnant when rescued. They were taught English, as well as cooking, cleaning and sewing. It is to Cameron's credit that many of those she rescued were able to return to China. Some of the older women, however, were too ashamed to return to their ancestral homes. Many of those who remained assisted Cameron in rescuing other women. Some even became teachers or nurses, found jobs or married, and one woman, Yoke Yeen, became the first Chinese woman to graduate from Stanford University in 1928.

In April 1906, the great San Francisco earthquake and fire forced Cameron and residents of the Mission Home to evacuate. Realizing that the girls' records had been left behind, Cameron braved the oncoming flames and retrieved the records that granted her guardianship rights. She then led her wards safely across the bay. Although the records were saved, the Mission Home itself was destroyed, and one of the many buildings had to be dynamited to prevent the fire from spreading. For two years, the refugees lived in temporary housing, first in San Rafael and later in Oakland. In 1908, the home was rebuilt, and it still stands, now known as Cameron House. Located in San Francisco's Chinatown, it has evolved into a center that helps low-income immigrants and families.

Cameron continued to fight for the rights of Chinese girls and women in the courts and to perform rescues until her retirement in 1934 after forty-seven years with the mission. Interviewed about her selfless and courageous ventures, Cameron commented, "Oh yes, there was that side of it. Things got into the newspaper. But it was the work that was important. I don't like epitaphs! The work is what I want people to know." Her legacy lives on in the Chinese American families for whom she devoted her life's work. She died at the age of ninety-eight and is interred in Evergreen Cemetery in Los Angeles.

KATHERINE PHILIPS EDSON (1870–1933)
PIONEER IN SOCIAL AND LABOR REFORM

Katherine Philips Edson helped lay the foundation for labor legislation both in California and the nation. Her efforts helped to transform California into a leading Progressive state and led to significant social legislation, including passage of a state law that improved milk quality standards and proposing a comprehensive wage and hour reform law. The law, passed by the legislature in 1913, established a minimum wage, reduced working hours and improved employment conditions for women and children.

Edson was born in 1870 in Ohio. After receiving her primary and secondary education, she studied operatic singing at a conservatory in Chicago where, at the age of twenty, she met Charles Edson, a music teacher. The couple married in 1890 and remained together for thirty-five years. (They divorced in 1925.) In 1891, the Edsons invested in a ranch in Southern California's

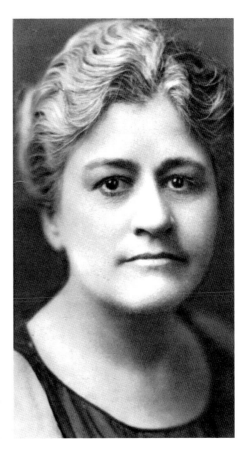

Katherine Philips Edson. *Courtesy of the San Francisco History Center, San Francisco Public Library.*

Antelope Valley and moved to the property. Edson became active in organizing support for the suffrage movement and initiated what she called "female round-ups" of women in her community to share their experiences.

Seeking a more profitable and creative life, the couple moved to Los Angeles in 1899. After relocating, Edson became a member of the Friday Morning Club, a prestigious women's club founded nine years earlier by Caroline Severance. An effective organizer and leader, she contributed

significantly to the club's evolution from an organization devoted to cultural and philanthropic issues to one that advocated for reform of municipal and state agencies, public health, labor legislation, consumer awareness and numerous other social issues.

While serving as chair of the club's Committee on Public Health, she grew increasingly alarmed over the high rate of infant deaths in the nation. Statistics indicated that mortality among infants fed cow's milk was significantly higher than those who were breastfed. Representing the Friday Morning Club, Edson began investigating production techniques in Southern California dairies and was appointed to serve as the only non–medically licensed member of the Los Angeles County Medical Milk Commission. Her findings concluded that at least 10 percent of the cows providing milk to the city were carriers of bovine tuberculosis. At the annual convention of the Federation of Women's Clubs, Edson convinced the gathering to pass a resolution endorsing state and federal legislation to eliminate bovine tuberculosis in dairy herds. Her tireless campaigning resulted in the passage of a state law that made tuberculin tests for cows mandatory.

In 1912, Edson served as deputy inspector in the California Bureau of Labor Statistics for Southern California. In her role as inspector, she studied the working conditions of women and children and discovered the unhealthful conditions, especially in the canning industry, under which they labored. During the canning season, fruit, fish and vegetable canneries employed approximately twenty-two thousand women, more than were employed in any other industry. After becoming aware of women's low wages and the long hours they endured, Edson set out to improve their working conditions.

In 1913, she received encouragement from Governor Hiram Johnson to draft a bill establishing a minimum wage that provided "for the comfort, health, safety, and general welfare of any and all employees." Establishment of a minimum wage was opposed by many business concerns on the grounds that "salaries would be drawn, politics would be played, and all the time taxes would have to be levied and collected to pay for the extravagance." Others, like Senator William Brown, were supportive and declared, "If any industry in California employing women cannot pay its employees a wage sufficiently large to permit them to live decently, the State is better off without such industry." The bill successfully passed and authorized the government to create an Industrial Welfare Commission (IWC) to establish and enforce wages, hours and working conditions for women and children.

The new law also included a requirement to appoint at least one woman to the five-member commission, and Governor Johnson selected Edson.

Her appointment was a significant accomplishment, particularly because he disapproved of women serving in the government and had difficulty adjusting to women's suffrage. Edson viewed the IWC as a regulatory agency whose most important goal was to inform big business that the state would no longer approve the idea that "any man's method of conducting his own business, as it touches the lives of others, is his own affair." As a result of her influence, the IWC established a minimum wage in the fish canning, fruit and vegetable canning, packing, manufacturing and laundry industries. Edson eventually administered policies regulating workers' hours in the hotel, restaurant and motion picture industries.

After the United States entered World War I in 1917, Edson was concerned that war would destroy the protective legislation that had been achieved, including the eight-hour day for women. She argued that there was still an adequate supply of labor for all the factories in California to maintain an eight-hour day, "if necessary on two shifts." In 1916, the federal government created the Council of National Defense and a Civilian Advisory Commission that was to represent labor among other groups. The following year, Edson was appointed chair of the Committee on Women in Industry for California.

Edson continued to serve on the IWC for eighteen years under five governors and was its chief executive from 1927 to 1931. A prominent businessman from Santa Cruz praised her administration of the IWC and commented that "Mrs. Edson played a proud part in the political regeneration of California" and was "a pioneer in dedicating our government to human needs, more than any one person, she brought hope to unorganized toiling women, and into the lives of those who had little, she brought a bit of God's sunlight."

During and after the war, Edson worked on behalf of a national suffrage amendment and represented Southern California women at the 1921 St. Louis Convention of the National American Suffrage Association. After returning home, she established a California branch of the League of Women Voters. By 1933, health problems forced her to cancel many engagements before she died in August of that year. The California League of Women Voters dedicated a redwood grove in Humboldt Redwoods State Park in her honor. According to her biographer, "Her work stands as a milestone in the movement to raise women from their subordinate position in the labor force and in public life."

ROSE PESOTTA (1896–1965)
TRADE UNION ORGANIZER

Rose Pesotta, a Jewish immigrant, worked in various shirtwaist factories organized by the International Ladies' Garment Workers' Union (ILGWU). She became a general organizer for the union and was elected vice-president, the first woman to hold such a high position. In 1933, she organized the mostly Latino dressmakers who made up a large percentage of the Southern California garment industry workers and spearheaded a Dressmakers General Strike in Los Angeles. Between 1934 and 1944, Pesotta became known as one of the most effective union organizers in the United States, and she dedicated her life to improving working conditions and promoting the advancement of women in the union.

Rose Pesotta. *Courtesy of the ILGWU Archives, Kheel Center, Cornell University.*

The second of eight children, Pesotta was born in the Russian Ukraine in 1896. Her father was a grain merchant, and her mother was active in the family business. In order to avoid an arranged marriage to a local village boy at the age of seventeen, she immigrated to the United States. After moving to the Lower East Side of New York City, she lived with her older sister, who found her a job as a seamstress in a factory that manufactured shirtwaists, a type of women's blouse with buttons down the front. Pesotta soon joined the ILGWU, a union founded in New York in 1900 by Jewish immigrants who escaped the pogroms in pre-

revolutionary Russia. By World War I, the ILGWU had ninety thousand members and was the largest and most influential labor union in which women constituted a majority of the workforce.

Pesotta quickly became a union leader and, in 1915, helped to establish the ILGWU's first education department. By the 1920s, she had established a strong friendship with the radical leader Emma Goldman, a forceful advocate of workers' and women's rights. During this period, Pesotta was a member of the Sacco-Vanzetti Defense Committee that defended two Italian anarchists charged with murder and armed robbery. After a controversial trial, the two immigrants were executed. She also became active in the anarchist movement and served as editor of the *Road to Freedom*, an anarchist paper. Her sister Esther described Pesotta as "buxom and effervescent, marching through the streets in boots and carrying a knapsack, on her way to yet another political meeting." Twice in the 1920s and later in the 1950s, she lived with men in relationships that were never formalized.

In 1933, Pesotta was sent to Los Angeles to organize union shops. The majority of garment workers employed in sweatshops or garment factories in downtown Los Angeles were semi-skilled Latino women. As a growing garment center, at the height of the season the Los Angeles industry employed 7,500 workers. Some of the women were American-born, but a larger number were recent immigrants from Mexico. A smaller number of other workers were native-born white and African American women. Most of the manufacturers in the industry ignored the California minimum wage for women, and dressmakers were paid only for hours they actually worked, not for the total time spent. Work was often distributed unevenly, and foremen played favorites with some women while ignoring others. According to Elaine Leeder, her biographer, Pesotta learned that Los Angeles manufacturers preferred Latinos to white or black women because they would "work for a pittance and could endure any sort of treatment." When the dressmakers attempted to unionize, they were fired and blacklisted.

Outraged at the bigoted views of the male leaders, she organized a campaign among the workers. In order to accomplish her goal, Pesotta visited women workers in their homes, set up social get-togethers and arranged for a daily Spanish-language broadcast on a local radio station about her organizing campaign. Pesotta also made a sincere effort to understand the Latino culture and traditions. In her efforts to reorganize the union's dressmaking office, she hired Bill Busick, a journalist who had served as Norman Thomas's campaign manager in his bid for the presidency. With her encouragement, Busick published a four-page weekly called *The Organizer.*

Before long, Pesotta gained enough support from Los Angeles dressmakers that they were prepared to strike for improved conditions.

Pesotta arranged a meeting of dressmakers at which their demands were set forth. These included union recognition, a thirty-five-hour workweek, a minimum wage and no home work. The workers additionally demanded that future disputes be mediated by a committee composed of the shop chairperson, a representative of the employers and an impartial arbitrator. Several hundred women workers attended the meeting and endorsed the idea of a citywide strike beginning on October 12, 1933. The Los Angeles Central Labor Council lent its support to the work stoppage, while the strongly anti-union Merchants and Manufacturers Association was opposed. Siding with the manufacturers, the police protected those dressmakers who remained at work and arrested approximately fifty picketers. An arbitrated settlement ended the strike on November 6.

Pesotta's rhetorical skills and support for the workers won her many loyal followers, and the following year, she was elected vice-president of the ILGWU board. Her union activities eventually took her to places as far apart as Boston and Puerto Rico. In 1936, Pesotta was sent to Akron, Ohio, to aid striking workers at the Goodyear Rubber factory. She made a point of visiting strikers, singing union songs with them and ultimately convincing them to approve a negotiated settlement. In Cleveland in 1937, Pesotta was slashed and beaten by anti-union thugs. An altercation in Flint, Michigan, later caused a permanent hearing loss in one ear. In 1942, she returned to her old shop as a sewing machine operator and refused to seek a fourth term as vice-president two years later. At the convention, she explained that her decision to resign was related to the union's policy of having only one woman on its executive board despite the fact that 85 percent of its 305,000 members were women: "Some day I hope the membership will take this so-called rule and throw it out the window."

Following her resignation, Pesotta published two memoirs: *Bread upon the Waters* (1945), devoted to her years as an organizer, and *Days of Our Lives* (1958), which recalled her childhood. In the fall of 1965, Pesotta was diagnosed with terminal cancer, and she died in a Miami hospital on December 4, 1965. As a result of her tireless efforts, she left behind a stronger union for the thousands of members she brought to it. In her eulogy, Gus Tyler, a leading American labor intellectual and author of a history of the ILGWU, wrote, "She was born to lead. She was fated to rise from the machine and to guide her fellow workers in the age old struggle for human dignity."

DOLORES HUERTA (1930–PRESENT)

CO-FOUNDER OF UNITED FARM WORKERS OF AMERICA

Dolores Huerta fought discrimination and worked to improve social and economic conditions for farm workers. She co-founded the United Farm Workers (UFW) union with Cesar Chavez in 1962 and directed the UFW's national boycott during the Delano Grape Strike, taking the plight of the farm workers to the consumers. The boycott resulted in the entire California table grape industry signing a three-year collective bargaining agreement with the UFW in 1970. Many of her activities focused on lobbying for the passing and repealing of various legislative measures, including the 1960 bill to permit people to take the California driver's examination in Spanish; 1963 legislation to extend Aid to Families with Dependent Children to California farm workers; and the 1975 California Agricultural Labor Relations Act.

Dolores Huerta. *Courtesy of the Walter P. Reuther Library, Wayne State University.*

Huerta was born Dolores Fernandez in New Mexico. Her parents divorced when she was three years old, and along with two brothers and two sisters, the family moved to the central San Joaquin Valley farm community of Stockton, California. Dolores and her siblings were raised by her mother, a successful entrepreneur who provided her children with opportunities to participate in cultural activities. According to historian Richard Garcia, Huerta later explained that her mother, who was independent and ambitious, "a Mexican American Horatio Alger type," served as her role model. From her she learned to be generous and to care for others.

While in high school, Huerta became increasingly aware of the disparity in treatment between those who were rich and those who were poor and first experienced racial discrimination. She specifically recalled being upset when her teacher questioned the legitimacy of her high school essays because they were so well written. After graduating from high school, Huerta attended the University of Pacific's Delta Community College and earned a teaching credential.

Huerta briefly taught elementary school but left the job because, in her words, "I couldn't stand seeing kids come to class hungry and needing shoes. I thought I could do more by organizing farm workers than by trying to teach their hungry children." Receiving a high school and community college education made her more highly educated than many women of the 1950s and certainly most Mexican women. Seeking an avenue to help the poor, in 1955 she became a founding member of the Stockton chapter of the Community Services Organization (CSO), a grass-roots organization that fought segregation and police brutality, led voter registration drives, campaigned for improved public services and worked to enact new legislation.

Driven by a strong belief that people can change their lives and the lives of others, she became an organizer and negotiator. Huerta viewed the world of the CSO no differently than any other business sector. Both needed well-organized managers who wanted to succeed. To further her cause, Huerta organized and founded the Agricultural Workers Association in 1960. Through the organization, she lobbied politicians on many issues, including allowing migrant workers without United States citizenship to receive public assistance and pensions. She was also instrumental in securing passage of legislation allowing voters the right to vote in Spanish and to take the test for their driver's license in their native language.

Through her work for these organizations, Huerta met fellow labor leader and activist Cesar Chavez. In 1962, when the CSO refused to make the unionization of farm workers a high priority, they both left and created a

workers' union, later known as the United Farm Workers. Together they made a great team. Chavez was the dynamic speaker, and Huerta was a skilled organizer and tough negotiator. One account describes their relationship as "symbiotic." Chavez was the more visible leader, while Huerta was the "hidden" one. He invited her to join him as co-founder of the Farm Workers Association because he recognized her self-confidence, leadership and communication skills. According to author Mario Garcia, "Farm workers listened to her; young Chicanos followed her."

By 1965, they had recruited farm workers and their families throughout the San Joaquin Valley. In the same year, the Filipino grape pickers demanded higher wages and went on strike. Huerta and Chavez would not ignore their fellow workers, and on September 16, 1965, the union voted to join them. Over five thousand grape workers walked off their jobs in what became known as the five-year Delano Grape Strike. In 1966, Huerta successfully negotiated a contract with the Schenley Wine Company. Her achievement marked the first time in U.S. history that a negotiating committee consisting of farm workers achieved a collective bargaining agreement with an agricultural corporation.

She later negotiated additional contracts that established health and benefit plans for the workers, set up hiring halls and farm worker ranch committees and conducted over one hundred grievance procedures on behalf of the workers. Huerta spoke out early and often against toxic pesticides that threatened workers, consumers and the environment. She lobbied in Sacramento and Washington, D.C., organized field strikes and led farm workers' campaigns for political candidates.

During two divorces and a third live-in relationship, Huerta gave birth to eleven children. In an article titled "Traditional and Nontraditional Patterns of Female Activism in the United Farm Workers of America," historian Margaret Rose observes that Huerta's strong personality resulted in constant conflict with both her husbands. For example, she urged her second husband to quit his job and work with her in union activities. He disagreed with her insistence that the family come second to her work in the union. Even her father was opposed to her "unconventional family and personal life." Huerta behaved quite differently than the accepted traditional role of the Mexican woman. Rose writes, "She rebelled against the conventional constraints upon women's full participation in trade union activism, competing directly with male colleagues in the UFW."

In 1973, Huerta led a consumer boycott that resulted in the California Agricultural Labor Relations Act of 1975, the first law of its kind in the

United States. It allowed farm workers to form unions and bargain for better wages and working conditions. In 1975, she lobbied against federal guest worker programs and spearheaded legislation granting amnesty for farm workers who had lived, worked and paid taxes in the United States for many years but were denied citizenship. Her efforts led to the Immigration Act of 1985.

Huerta remained loyal to Chavez and a trusted advisor for thirty years until his death in 1993. Together, they established the Robert F. Kennedy Medical Plan, the Juan De La Cruz Farm Worker Pension Fund and the Farm Workers Credit Union. They also formed the National Farm Workers Service Center, a community-based affordable housing and Spanish-language radio communications organization. Although Huerta stepped down from her position at the UFW in 1999, she continued her work to improve the lives of workers, immigrants and women. In recognition of her achievements, Huerta has received many honors. In 1984, the California State Senate gave her the Outstanding Labor Leader award. In 1993, she was inducted into the National Women's Hall of Fame and received the Ellis Island Medal of Freedom Award.

Chapter 5

ENVIRONMENTALISTS AND CONSERVATIONISTS

W omen traditionally have been responsible for the care and welfare of families and are especially sensitive to the importance of a healthy and sustainable environment. American women throughout history wanted clean air and water, healthy food and a safe setting for their children. As mothers, they know their bodies provide the first environment for a child and they will be primarily responsible for the sustenance, safety and health of their children.

Decades before the first Earth Day in 1970, women were on the forefront to protect the environment. From the early Women's Clubs to the numerous current-day efforts of the United Nations Commission on the Status of Women, they would organize and show up at city council meetings and board meetings or organize on the local, state and national levels to speak up to save the trees, demand fresh water and clean air and wipe out pesticides.

Women and the status of the environment are inextricably linked. In many cases, it is women in the United States and across the globe who primarily feel the effects of ecological change and the manufacture of toxic substances by humans. The Feminist Majority Foundation has even coined a new vocabulary term, ecofeminism, to describe the relationship between women and the environment. While there is no central definition of ecofeminism, it is generally regarded as a feminist approach to environmental ethics. Ecofeminists see the oppression of women and the domination of nature as interconnected. As a movement, ecofeminist theorists use a framework that confronts issues of gender, race, class and nature.

Minerva Hoyt mural, Joshua Tree National Park Visitors' Center. *Courtesy of Diana Shay Diehl, Mojave Light; mural artist: Cory Ench.*

Although this chapter is dedicated to California environmentalists, the authors would be remiss if we did not acknowledge the impact women have on a global scale. The United Nations Environment Programme book *Women and the Environment* underlines how women are the unsung heroes of conservation, often outpacing men in their knowledge and nurturing of domestic and wild plants and animals. As this chapter illustrates, women are the true voice of the environment. Read about Josephine McCrackin, the first person to advocate for the preservation of the grandiose redwood trees of the Santa Cruz Mountains; Minerva Hoyt, who almost single-handedly was responsible for saving the Joshua tree forest in the California desert; Lupe Anguiano, a former nun who founded Stewards of the Earth; and finally Alice Waters, the world-famous chef and the mother of the Slow Food movement. Learn about these remarkable women, all recognized for devoting their lives to save some small part of the planet.

JOSEPHINE CLIFFORD MCCRACKIN (1839–1921)
SAVIOR OF THE REDWOODS

Distraught after fire destroyed the grand redwood trees that surrounded her ranch, Josephine McCrackin, a distinguished writer and conservationist, wrote that the worst enemy of the redwoods was not fire but the "greed, rapacity, the vandalism that would hack and cut and mutilate the grandest, most magnificent forest that can be found on the face of the globe." It was this terrifying fire in 1899 that sparked a movement committed to saving these trees and other similar forests from logging. McCrackin was the first to implore "Save the Redwoods!" Many well-known writers found inspiration in the splendor of the Santa Cruz Mountains, but Josephine McCrackin was the first to settle there permanently after purchasing a twenty-six-acre ranch at the summit in 1880. She was drawn to the beauty of the area and was the motivation for many literary giants—including Samuel Clemens (Mark

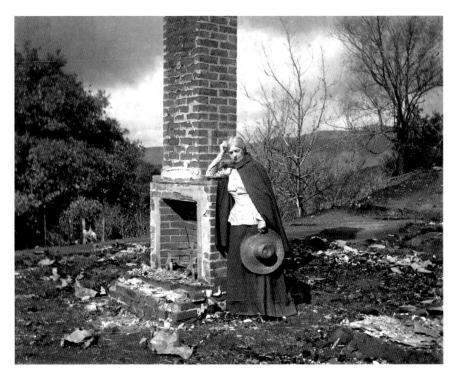

Josephine Clifford McCrackin. *Courtesy of the Department of Special Collections and University Archives, Stanford University Libraries.*

77

Twain), Ambrose Bierce, Bret Harte and others—of the late 1800s to visit and work in these exceptionally lovely mountains. Although she was a renowned writer whose articles were published by some of the most prestigious newspapers and magazines, McCrackin would mostly be remembered for her legacy as an environmentalist and conservationist. She was among a group of pioneer women whose contributions to the development of the Santa Cruz Mountains area were important though often overlooked and in many cases forgotten.

Josephine Clifford McCrackin was born in 1838 in Prussia to Charlotte and Ernst Wompner. McCrackin's father moved the family to the United States, settling in St. Louis, Missouri, in 1846. Near the close of the Civil War, McCrackin met and married Lieutenant James A. Clifford of the United States Army's Third Cavalry Regimen. They were stationed in Washington, D.C., and supposedly were part of an elite group that socialized with such legendary figures as Generals Grant and Sherman and even President Lincoln. After the close of the war, Lieutenant Clifford was assigned to the Southwest to protect settlers during the Indian wars. McCrackin was excited about the prospect of settling in the Southwest and looked forward to her life as a pioneer. During the journey, she took copious notes that were the basis of many of her future short stories and articles. One article, "Marching with a Command," recounted the arduous trek from Fort Leavenworth, Kansas, to Fort Union, New Mexico. She noted that the entire command consisted of eight hundred foot soldiers, two hundred army wagons, one or two dozen carriages, fourteen hundred mules and horses for officers. She was the only woman among one thousand soldiers.

Soon after they arrived, Lieutenant Clifford was sent to Fort Bayard, New Mexico. It was at this point that McCrackin's life started to unravel. Her husband was developing symptoms of paranoia. He confessed to McCrackin that when he was a civilian in Texas, he had killed a man in self-defense but he was charged with homicide. After telling McCrackin this story, he became convinced that she would betray him, and he threatened her life numerous times. With the assistance of army personnel who recognized his mental illness and detained him, she left for San Francisco, where her mother, brother and sister had settled.

McCrackin supported herself by teaching German until she learned of a new magazine, *Overland Monthly*, published by Bret Harte. McCrackin sent him an article titled "Down Among Dead Letters" outlining her experiences in wartime Washington, D.C, and to her delight, he accepted the story and published it in December 1869. With the encouragement of Harte and her

friends, she continued writing about her experiences in the Southwest. She even traveled to New York and visited the Harper Brothers publishing firm, which accepted one of her stories and paid her forty-five dollars, the first time she received payment as a writer. During the next fifty-two years, many of her articles appeared in *Overland, Harper's Magazine* and other periodicals. Many of the themes reflect her own experiences as a victim of an abusive husband. Over the years, she developed a following of San Francisco readers who enjoyed her tales. As her reputation grew, she befriended many other writers, including the famous Twain, Joaquin Miller and Bierce.

From her earnings, McCrackin purchased a twenty-six-acre ranch that she named Monte Paraiso at the summit of the Santa Cruz Mountains in 1880. On a visit to Arizona in 1881, she met Jackson McCrackin, owner of a mine in Arizona and the speaker of Arizona's first territorial legislature. They married in 1892, settled at the ranch and opened their home as a vacation hideaway for writers and artists.

It was in this setting that McCrackin developed a deep love and respect for the environment. Her stories shifted from military life and her personal experiences to environmental topics. In the short story "La Graciosa," McCrackin's love of nature emerges in a memorable picture of Salinas Valley. She wrote, "And oh! the charm of these mountains. In the Valley there might be the fog and the chill of the North, but on the mountains lay the warmth and the dreaminess of the South." She was enamored of the mountains and everything that grew and lived on them, but then her paradise was destroyed. In October 1899, a devastating fire swept through the mountainside, ravaging everything in its path, including Monte Paraiso. A poet friend of McCrackin's took a poignant photograph of McCrackin, her clothes torn and full of soot, standing next to the chimney of her home, the only remnant left standing after the fire. It was soon determined that the cause of the fire was careless, apathetic lumber companies that did not care about the natural resources or the wildlife of the region.

A heartbroken and furious McCrackin was determined to prevent this from happening to other centuries-old redwoods. She enlisted the help of Andrew Hill to photograph the area after the fire. Hill, so angry over the destruction of such beautiful environs, wrote a letter to McCrackin that she published in the *Santa Cruz Sentinel*, along with a scathing article about the lumber practices beseeching people to rally around the cause to save the redwoods.

In an article in the *Overland Monthly*, she referred to the lumbermen as aborigines and savages. She wrote about how the young redwoods are "reduced to cinders and pitifully-looking black stumps." Her articles were

reprinted in other newspapers, and nature lovers throughout the state took up the cause, joined the crusade and formed the Sempervirens Club of California. The club, the forerunner of the Save the Redwoods League, focused on preserving the last of the old-growth redwoods. McCrackin was appointed vice-president-at-large, and by 1902, the club was able to initiate legislation to save 3,800 acres that became what we know today as Big Basin State Park, the oldest state park in California.

McCrackin's work as an environmentalist and her love of nature spurred her interest in the unfortunate mass destruction of songbirds. Subsequently, she founded and became president of the Ladies' Forest and Song Birds Protection Association, the first bird-protection society of California. She was honorary vice-president of the California Humane Association and an honorary vice-president of the Audubon Society. McCrackin was interested in the women's movement and was one of the original members of the Women's Pacific Coast President Association.

After her husband died in 1904, McCrackin moved to a small bungalow in Santa Cruz that was given to her by the Santa Cruz Women's Club. She edited and managed her own news publication, the *Santa Cruz Sentinel*, but her declining years were not especially happy. She struggled financially, and although she was almost totally blind, she had to work to the day of her death at the age of eighty-one. Just before her death, she wrote to her friend, the renowned poet Ina Coolbirth: "The world has not used us well, Ina. California has been ungrateful to us. Of all the hundred thousands the state pays out in pension of one kind and another, don't you think you should be at the head of the pensioners, and I somewhere down below?"

MINERVA HAMILTON HOYT (1866–1945)

APOSTLE OF THE CACTI

Many Southern Californians share a love of the desert with Minerva Hamilton Hoyt, a wealthy socialite and civic activist from South Pasadena. Hoyt waged a persistent campaign to preserve the Southern California desert, earning her international recognition as the "Apostle of the Cacti" and a place in history for her part in founding Joshua Tree National Park. If she had not undertaken the leadership to preserve the desert terrain, Joshua Tree National Park may never have become part of the National Park System. How a transplanted southern belle born on a Mississippi plantation

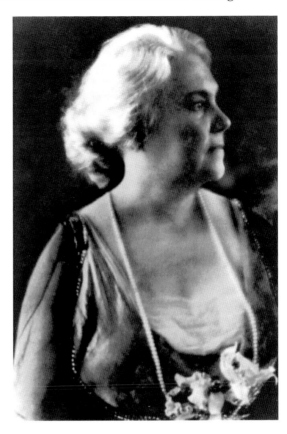

Minerva Hamilton Hoyt.
Courtesy of the Pasadena Museum
of History.

became a staunch backer of the protection of desert landscapes is perhaps one of the most unusual tales in the history of our country's national parks.

Born into what some consider "American royalty," Hoyt was born on a plantation near Durant, Mississippi, to a genteel southern family. After attending finishing schools and music conservatories, Minerva Hamilton married Dr. Albert Sherman Hoyt, a New York surgeon. They moved to Pasadena, where Hoyt devoted much of her time to the cultural and civic causes of Southern California. She developed a talent for organizing charitable events and at the same time involved herself in gardening clubs. As she became more involved in gardening, her interest and love of native desert vegetation grew, leading her to become a staunch advocate for desert landscape. After the deaths of her infant son and then her husband, she turned more frequently to the desert for peace and consolation.

With improved roads, more people traveled to the desert, threatening the beauty of the region. Motorists exacerbated the erosion already

started by miners, homesteaders and ranchers who had already discovered how the peaceful desert calmed the mind and the body. The area grew quickly, and in the 1920s Palm Springs—which had been a small haven for artists—expanded into a small town and a vibrant weekend resort. New settlers homesteaded desert tracts previously known to only a few prospectors and miners.

It was becoming evident to desert lovers like Hoyt that irrevocable change was occurring. Desert gardens filled with cacti were becoming the rage in the 1920s, and many people were digging up the plants and replanting them in their gardens back home in the cities. It was heartbreaking for Hoyt to see the senseless destruction of the plants by people who dug up, burned and otherwise razed so many of the cacti and Joshua trees. Writer Conner Sorensen wrote, "Desert lovers, alarmed at the practice of transplanting full-grown palms, barrel cacti, and Joshua trees to urban patios and cactus gardens, feared that indiscriminate collecting would destroy the desert vegetation…It was in response to these dangers that Mrs. Hoyt began her work for desert preservation."

She organized exhibitions of desert plants in Boston, New York and London. Her first project was a desert conservation exhibit displayed at the 1928 Garden Club of America's flower show in New York. The exhibit was composed of a live habitat group including stuffed birds and animals and was intended to communicate a sense of the total desert environment. It was so successful that the following year at the Centennial Flower Show, she mounted a replica of the Mojave Desert, Death Valley and the California redwoods. Her most intricate exhibit in England was later given to the Royal Botanic Gardens.

In March 1930, Hoyt organized the International Deserts Conservation League with the intention of creating a desert park to preserve the landscapes. She had two goals in mind. As Sorensen writes, "First, there was the need to protect desert plants and animals. Equally important for Mrs. Hoyt was the value of the desert as a retreat, which she described in terms of its 'calm' and 'silence.' Through the establishment of desert parks Mrs. Hoyt wished to preserve this 'unique desert atmosphere [of] silence and mystery.'"

The California State Park Commission appointed Frederick Olmsted Jr., a landscape architect, to survey areas and recommend proposals for new state parks. Olmsted asked Hoyt to serve on the commission and contribute information on four desert counties. She prepared the commission's report on desert parks and recommended large parks be created at Death Valley, the Anza-Borrego Desert and in the Joshua tree forests of the Little San

Bernardino Mountains. Olmsted's final report outlined nine desert projects, including the Joshua tree forests near Barstow and Victorville.

Hoyt strongly favored the area to be a national rather than a state park. She began her own personal campaign to have the Joshua tree region preserved through the National Park Service by hiring respected desert ecologists and botanists to prepare special reports. She was even able to get an introduction to President Franklin Roosevelt and develop a solid relationship with Harold Ickes, the secretary of the interior. Her reputation as a persistent preservationist of desert regions led to an invitation from the president of Mexico, Ortiz Rubio, to make recommendations about a border desert park near La Paz. Hoyt then wrote an article lauding the development of an international desert park along the U.S.-Mexican border. President Rubio designated a ten-thousand-acre forest near Tehuacan in honor of Hoyt and her International Deserts Conservation League, and he aptly named her the "Apostle of the Cacti."

Soon after, Roosevelt ordered the National Park Service to prepare a recommendation for one million acres he had recently designated as a preservation area. The Park Service proposed a smaller 138,000-acre park composed of the Wonderland of Rocks and the best of the Joshua tree stands. Hoyt registered her disappointment with Ickes, who ordered further studies. In August 1936, FDR signed the proclamation establishing Joshua Tree National Monument, an area encompassing over 825,000 acres. "Mrs. Hoyt's dream had become a reality…The reserve had monument rather than park status, but this mattered little because the monument— over 100 miles long and 50 miles wide—was still larger than many national parks," writes Sorensen. A lobby effort was undertaken to name the park after Hoyt, but the Park Service policy does not allow naming projects for living persons.

In 1994, President Bill Clinton signed the Desert Protection Act that added 234,000 acres to Joshua Tree National Monument, thus delegating the region as national park status. The Joshua Tree National Park is the only place in the world where these trees stand, once derided as "the most repulsive tree in the vegetable kingdom" and now acclaimed as the "Sentinel of the Desert," grow wild. Hoyt's dream of a national park was finally realized almost fifty years after her death in 1945. Her perseverance created Joshua Tree and Anza Borrego, two exceptionally beautiful areas that will be perpetually preserved.

LUPE ANGUIANO (1929–PRESENT)

A QUIET REBEL

Lupe Anguiano. *Courtesy of the UCLA Chicano Studies Center.*

Lupe Anguiano, an indefatigable champion of social justice, is widely known as an advocate for women's rights, the rights of the poor and the protection of the environment. A former nun and lifelong educator, she has worked for the equality of all people throughout her lifetime. Anguiano is passionate in all her undertakings and especially when volunteering to protect Mother Earth from global warming and devastating environmental conditions. Her life has been a fascinating one, from devout nun to passionate activist to advisor of presidents in both the Democratic and Republican Parties.

Born in La Junta, Colorado, in March 1929 to Rosario and Jose Anguiano, she was one of six children. Her mother was a schoolteacher, and her father worked for the Santa Fe Railroad. As was common then, the family lived in railroad housing, and Anguiano and her siblings attended segregated schools for children of Mexican workers. The students had class in the morning and were then sent into the fields to pick fruit. Exceptionally bright and confident, she recalls her teacher telling her "she had leadership skills."

Anguiano worked for a year after she graduated from high school but soon realized she wanted to devote her life to the Catholic Church and be a religious education teacher. She entered the Indiana order of Our Lady of Victory Missionary Sisters, known for being great advocates for the poor, in 1949. Nine years later, she took her vows with her name as Sister Mary Consuelo. Her first assignment was in East Los Angeles at Garfield High

School. Anguiano dedicated herself to the church and its teachings, but she also felt compelled to get involved with social justice issues.

In 1963, the California legislature passed the Rumford Fair Housing Act that banned racial discrimination by landlords. Anguiano actively supported the law because she had seen how Latinos and blacks were prevented from attending some Los Angeles schools. A year later, the California Association of Realtors attempted to reverse the law with a statewide initiative. Racial discrimination was contrary to Anguiano's upbringing and vows, and she made her feelings known by writing letters to newspapers and joining picket lines. The Los Angeles diocese was not pleased with an activist nun, and in a letter instructing her to cease her activities, she was reprimanded for disobedience. It was then that Anguiano decided to leave the convent. "It took me a year to decide to actually leave," she said. "I had taken perpetual vows and was very close to the Lord. But I decided I could still do as a civilian what I would have done as a nun," she said in a *Los Angeles Times* article.

Free to undertake any activist project to improve the social, educational and economic conditions of those in poverty, Anguiano traveled throughout the United States to wherever she was needed. In 1965, as a United Farm Workers volunteer working directly under the direction of Cesar Chavez, she went to Michigan to organize the grape boycotts. For a salary of just five dollars per week, she successfully led the boycott for the entire state.

For many years, she devoted her time to helping female single parents move from hardship and dependence to become self-sufficient and employed. In 1973, she moved to San Antonio, Texas, and founded the National Women's Employment and Education Model Program (NWEE). She was able to assist five hundred women in getting employment and no longer having to rely on welfare. Through NWEE, she secured grants and moved to East Los Angeles, where she successfully implemented the program and worked on youth training and employment programs with poor single mothers on welfare.

President Johnson, in 1965, recruited her as an education specialist in the Department of Health, Education and Welfare. She was also asked to help write the nation's first bilingual education bill. When Richard Nixon became president, Anguiano again worked as an advisor on Latino and women's issues. She also was an advisor on private sector initiatives for the Reagan administration.

While working to transform the national welfare policy, Anguiano became involved with the women's liberation movement. Along with Gloria Steinem and other feminists, she founded the National Women's Political Caucus and helped to bring Catholic support to the Equal Rights Amendment. She was

elected to serve as a delegate to the First National Women's Conference, where, along with Jean Stapleton and Coretta Scott King, she read the "Declaration of American Women."

In her later years, Anguiano set her sights on the environmental challenges facing California. In 2006, she founded Stewards of the Earth in Oxnard to protect West Coast communities and the environment through education and research programs and to advocate for regional sustainable clean energy solutions.

In 2007, she received an Individual Consultant Grant from the Women's Foundation in San Francisco to work with several state and national environmental organizations in California, Oregon and Washington State. With this grant, she successfully led the effort to defeat the installation of BHP Billiton's Cabrillo Port LNG (Liquefied Natural Gas) facility off the Oxnard, Malibu, Ventura County coastlines. The California Wellness Foundation funded the Stewards in 2008 to help them continue their work protecting Ventura, Santa Barbara, San Luis Obispo and Los Angeles County from several other LNG projects.

The University of California–Los Angeles paid tribute to Anguiano's service to human rights, women's rights and the protection of the environment with the opening of her archives at the launching of the school's Mujeres Initiative at the Chicano Studies Research Center. The program seeks to preserve and make accessible to scholars the history of Latinas in the United States. Anguiano was chosen as the ideal figure to celebrate the opening of the initiative. At a celebration to mark the event in 2007, Steinem and former Clinton administration housing secretary Henry Cisneros praised Anguiano as an unsung civil rights heroine. Cisneros worked with Anguiano when she was in San Antonio and he was mayor of the city. He lauded her "low-key, gentle demeanor that belied an underlying persistence." "She is not going to take 'no' for an answer," Cisneros said. "She never raises her voice, but there is a core of steel that is irreducible. She just wears you down with sweetness."

Anguiano has received many humanitarian awards throughout her life, but a very special one was from the Ventura County Women's Political Caucus, of which she was a founding member. From her childhood, she has been motivated for the quest for equality for all, especially women. In an interview, she noted, "Society as a whole continues to struggle with the reality of women's equality…the issue for me is women's equality is a God-given right."

Anguiano volunteers on a daily basis and enjoys the challenge of protecting Mother Earth. She said, "One of the things I enjoy most about living in California is our people's strong solving skills—we jump to the challenge

with solutions." She believes these issues are important because the world is faced with major human relations, economic, environmental and educational challenges that need to be addressed through the common good of all people. Her other work priorities include helping indigenous women in Mexico to obtain gainful employment and education in the form of technology skills so they are not compelled to seek jobs in the United States.

"We just need to work together to do what we know how to do best: create clean energy, create green jobs that will resolve our economy and improve education by placing dollars in the classroom."

ALICE WATERS (1944–PRESENT)

MOTHER OF THE SLOW FOOD MOVEMENT

Green chef Alice Waters is a national superstar, a shrine to the New American cuisine and an idol of the culinary world. Her professional training, however, was in education, not cooking. As an advocate of locally grown organic food, sustainable agriculture and refined dining, Waters is one of America's most influential cultural symbols. In the late 1960s and early 1970s, she led a group of political anti-corporate protestors to found a food chain that operated unlike any before it. The outcome was the creation of a major organic food movement that has taken the country and world by storm. Chef and owner of Chez Panisse, a fountainhead of California cuisine, Waters is often acknowledged with revolutionizing the eating habits of Americans and recognized as the founder of modern American cooking. Realizing how proper nutrition transforms the individual and society, she moved on to her next venture: to teach children proper eating habits

Alice Waters. *Courtesy of Chez Panisse.*

through an innovative schoolyard garden and cooking program. As noted on her website, she is a pioneer of a culinary philosophy that maintains that cooking should be based on the finest and freshest seasonal ingredients that are produced sustainably and locally.

Alice Waters was born in 1944 in Chatham, New Jersey, to Margaret and Charles Waters. At an early age, she was introduced to the concept of fresh vegetables from the World War II "victory garden" in her backyard. Waters not only enjoyed the garden for the luscious fresh food but also used her creativity to make a Halloween costume with flowering produce and to use asparagus stalks as a crown.

Waters attended the University of California–Santa Barbara before transferring to the University of California–Berkeley. Majoring in French cultural studies, she spent her junior year abroad and studied at the University of Paris. It was there that she became enamored with French food and intrigued as to how Europeans seemed to take such pleasure in preparing and eating their meals. She began researching and learning more about the preparation of French food. Speaking about her experiences, she notes:

> *My family never dined at restaurants. I didn't know anything about them until I traveled to France in 1964 in my junior year of college. That's when my whole world opened up. Everything was so beautiful there. I even remember my first French meal: a brothy root-vegetable soup with lots of parsley and garlic. It was amazing.*

After her graduation, she went to London to study at the Montessori school and then traveled to Turkey. In his book *Alice Waters and Chez Panisse*, Thomas McNamee writes about Waters's experience in Turkey when a young shepherd left tea and cheese for her and her friends, even though it was obvious he had little to share. This small act of generosity had a lasting effect on how she created the ambience of hospitality and openness in her restaurant. She also credits Richard Olney, an American authority on French food, as a great influence on developing her connection between food and the earth. She was drawn to the simplicity of the cooking styles and using fresh, locally grown foods and began to make a conscious connection with food and the importance of families eating together. In France, "I lived at the bottom of a market street, and I took everything in by osmosis," she said.

Upon returning to the United States, Waters taught at a Montessori school and cooked for her friends in the evening. She liked having her friends to dinner every night, and the only way to do that was to open a restaurant. She took

out a loan for $10,000 from her father, and she and her friend Lindsey Shere opened Chez Panisse in an old house in Berkeley in 1971. It is named after Honoré Panisse, a character in Marcel Pagnol's 1930s movie trilogy about waterfront life in Marseille. Her principles were simple: fresh, local ingredients used at the height of their season. Chez Panisse served a daily-changing, fixed-price menu, making the very most of California's readily available agriculture and seafood. When Waters opened Chez Panisse, it was difficult to find the kind of food that was so easily available during her time at the French farmers' markets. Therefore, she established relationships with local farmers and ranchers, encouraging them to grow healthy, ideally organic foods.

The first four years were very financially difficult because she did not know anything about running a restaurant. Business started to improve, and after a few profitable years, she expanded the dining space by opening the upstairs Chez Panisse Café, which serves an a la carte menu for lunch and dinner. Following in 1984, Café Fanny opened, named after her daughter, a few blocks from the restaurant. This was her last expansion. She was not one to capitalize on her fame with a television show, her own cookware line or even to replicate Chez Panisse. She strongly believed that the chef had to be on site. Waters, however, did use her status to advance some of her core beliefs. She campaigned for local farmers' markets, as well as organic foods grown without synthetic fertilizers, pesticides or hormones.

Waters was on a mission. A *New York Times* article on August 6, 1996, stated: "She believed that if all Americans sat down with their families to eat dinner every night, if all Americans had access to fresh, organic food, if all Americans worried as much about the environment as they do about their potato chips, the world would be a better place." Soon she was acclaimed as the pioneer who founded California cuisine: simple food straight from the garden. Renowned *New York Times* food critic Craig Claiborne wrote that she was "a chef of international repute who was born in the United States... Even rarer is such a celebrated chef who is a woman."

To continue her commitment to local farmers and the importance of organic food to the health of the environment, Waters founded the Chez Panisse Foundation, a nonprofit organization with the sole purpose of educating children about food, health and the environment. "We started [the foundation] largely out of concern that young people increasingly are isolated from the land and deprived of the joys and responsibilities it teaches," Waters notes. The primary work of the Chez Panisse Foundation has been to establish and sustain the Edible Schoolyard program at Berkeley's Martin Luther King Jr. Middle School. The Edible Schoolyard was established in

1995 and is a one-acre organic garden and kitchen classroom. Students at the middle school are involved in growing, harvesting and preparing the foods from the garden and for promoting the environmental and social well-being of the school community. As she noted in an interview, "I didn't want just a garden…I wanted it to be a garden that relates to what the children are eating at lunch. For me, the most neglected schoolroom is the lunch-room."

Waters's work at the Edible Schoolyard has also developed into her School Lunch Initiative, which has the broader goal of bringing schoolchildren into a new relationship with food by making a healthy, fresh, sustainable meal a part of the school day. The School Lunch Initiative is a collaborative project with the Center for Ecoliteracy and is also the topic of a series of studies through the Center for Weight and Health at UC–Berkeley. There are five other affiliate Edible Schoolyard programs around the country in New Orleans, New York City, Los Angeles, San Francisco and Greensboro, North Carolina.

Since 2002, Waters has served as a vice-president of Slow Food International, an organization dedicated to preserving local food traditions, protecting biodiversity and promoting small-scale quality products around the world. In 2003, Waters helped create the Yale Sustainable Food Project, which aims to make sustainable food an important part of university-level education. The project maintains an on-campus organic farm and integrates organic, local products into the university's dining program. Currently, she is working on national policy to extend free school meals to all public schools in the United States and to expand the Edible Schoolyard and School Lunch Initiative in schools across the United States.

In addition to writing more than a dozen bestselling books, Waters has been the recipient of numerous national and international honors. She is a passionate advocate for a food economy that is "good, clean, and fair." She is determined to bring fresh, wholesome, healthy foods into all schools and sees "democratizing healthy eating" in schools across America as the number-one goal in the battle to end childhood obesity. Waters is committed to the idea that if we take the time and care to put nourishing food on our plates, we will in turn renew our communities, our world and ourselves. "Eat junk and you demean yourself and destroy the environment. Eat natural, organic ingredients grown nearby and produced in season and you will improve yourself, the community and the world."

PART III

Women Who Contributed to the World of Work

Chapter 6
DOCTORS AND DENTISTS

A s with many pioneer trailblazers, women doctors and dentists were greeted with skepticism and prejudice. They were denied acceptance into schools and had to battle for admission. When they finally were accepted at the schools, their professors and other students consistently publicly embarrassed them. It was not uncommon for women to be subjected to a barrage of derision and slander and told they were intellectually inferior. The early women doctors even had to face intolerance by members of their own sex who did not have faith that they could actually understand medicine and cure them of their ailments. Dr. Harriet Hunt, an early medical practitioner, noted in 1835, "If I had cholera, hydrophobia, smallpox or any malignant disease, I could not have been more avoided than I was."

Women were not allowed to study medicine in California as long as the medical schools were privately owned, and it was not until the Toland Medical College became part of the University of California in 1874 that women were accepted as students. The university had a coeducational policy that mandated the medical school to accept them. The women who were first denied admission were not deterred and did not wait around for acceptance. All possessed great determination and high spirit and were remarkably resilient. They founded their own medical institutions, clinics, dispensaries, hospitals and nursing schools to provide practical training for themselves and other women. The manner in which they integrated into the medical societies is a fascinating saga in itself. Critical to their success was the steadfast support of their families,

Young women at work in the Histology Department. *Courtesy of the Legacy Center, Archives and Special Collections, Drexel University College of Medicine.*

friends, mentors and community partners that grew as their achievements became legendary.

It was only thirty years after Elizabeth Blackwell, the first woman to receive a medical degree in the United States in New York in 1849, that these early physicians were practicing medicine in the western part of the United States. There is a long list of women who made a significant difference in medicine and dentistry in California history and who paved the way and made the road easier for those who came after them. This chapter will give the reader an insight into the challenges and achievements of a few of these extraordinary women: Lucy Maria Field Wanzer, the first woman to graduate from Toland Medical College; June McCarroll, the first woman doctor to care for hundreds of thousands of Indians and inventor of stripes down the middle of roads; Nellie Pooler Chapman, the first woman dentist; and Margaret Chung, the amazing first Asian American woman doctor and "mom" to thousands of military men during World War II. They all made history, and they all have a story to tell.

LUCY MARIA FIELD WANZER (1841–1933)

FIRST WOMAN GRADUATE OF A CALIFORNIA MEDICAL SCHOOL

To appreciate the spirit and determination of Lucy M.F. Wanzer, one just has to read the retort she gave to a professor who told her the field of medicine was no place for a woman to work and "if she does, she ought to have her ovaries removed." To which Wanzer softly responded, "If that is true, the men students ought also to have their testicles removed!" Yes, she was a feisty and bright young woman who realized early in life that she wanted to be a doctor. As ambitious as she was, she was also realistic and understood the challenges she would have to overcome to achieve her dream. It would be many years and a long struggle before in 1874, at the age of thirty-three, she was finally admitted to the Toland Medical College, which had just come under the administration of the University of California.

Wanzer was born in 1841 in Madison, Wisconsin, where her father became a pioneer settler. Both her parents were from Massachusetts, so after several exciting years in the "wild west," her family left Wisconsin and moved back east to return to civility. She was fortunate to have parents who valued education and encouraged her to get a high school education. In 1858, after graduation at the age of seventeen, her family moved from Connecticut to California via the Isthmus of Panama, the route many pioneers took in that period. Soon after they arrived in California, Wanzer passed the examination that certified her to teach school. She taught elementary grades

Lucy M.F. Wanzer. *Courtesy of the Archives and Special Collections, Library and Center for Knowledge Management, University of California–San Francisco.*

through high school in Alameda County and, at the same time, became a competent dressmaker so that she could help support her family.

In 1865, at the age of twenty-three, she met and married James Wanzer, a county clerk whom she divorced three years later. To achieve her goal of becoming a physician, she needed money and more education. She decided to master telegraphy and then set up a telegraph office in a corner of the post office in Santa Cruz, where her father was the postmaster and the first mayor. For the next six years, she continued telegraphy and teaching and saved enough money for medical school. At the same time, she studied Latin, French, literature and algebra to give her a wider base of knowledge and enhance her chance of acceptance into medical school.

Wanzer understood the prejudice she would encounter in applying to medical school in California, so she decided to take one more step before applying. She had saved enough money to attend the Trawl Institute in New York City, where she attended lectures and clinics and within one year completed the coursework to graduate and receive the doctor of medicine degree. Before leaving New York, she married, and with her new husband, she moved to San Francisco, where she once again taught school. Finally, she applied to the Toland Medical College that was by then part of the University of California. However, she was rejected because of her gender. Wanzer was told women did not have the intellect or stamina required to be a physician, and in no way were women able to compete with men. Women belonged at home. Fortunately for Wanzer, a renowned doctor, Beverly Cole, was so taken with her ability and feistiness that he offered to help her gain admission, and four months later, she was admitted to the medical school. The dean and the regents conceded they could not prohibit her from entrance because the California law that established the university recognized that both men and women were entitled to the same education. This did not stop them from trying to make her life miserable. They encouraged her male classmates to haze her and make life at school so intolerable that she would eventually drop out. As the story goes, however, her male classmates came to respect her, and many formed genuine and lifelong friendships.

Wanzer realized her dream in November 1876. She graduated from the University of California Medical School and acquired the distinction of being the first woman graduate of medicine west of the Rocky Mountains. Dr. Cole nominated her for membership in the San Francisco Medical Society, prompting an immediate threat to blackball her. He refused to withdraw her name, and thus, she was permitted to join and became the first female member of that society.

Specializing in gynecology and obstetrics, Wanzer opened her first office in San Francisco above a small plumbing repair office. She was also a practicing pediatrician and treated children of the wealthy and noted patrons of the city. Dr. Wanzer was extremely active in the medical community in California and was a member of the California State Medical Society, the San Francisco Medical Society, the American Medical Society and the Women's National Medical Association. One of her favorite affiliations was being a life member of the San Francisco Academy of Science. She was extremely proud to be a founding member of Children's Hospital, the first hospital built to care for children and women.

Wanzer had the desire and toughness it takes to open the doors to a traditional men-only occupation. When Lucy Wanzer passed away in 1933, she was a much beloved physician to many residents of San Francisco. Until the end, she was a feisty and admirable member of her community and was especially respected by her medical colleagues. She set a trend and overcame the barriers and misconceptions about women being leaders in medicine in the new West of the country.

June Hill Robertson McCarroll (1867–1954)

Credited for Drawing Lines for Safe Highways

If you have any doubts that one person can really make a difference, you may not have heard about June McCarroll, nurse, gun-toting physician and inventor who is credited with inventing the striped lines that run down the center of all our roads, streets and highways—the lines that prevent thousands of accidents and save an untold number of lives each year. When living in Coachella Valley, California, McCarroll had some harrowing experiences that led her to devise a method to make roads safer for those newfangled automobiles.

June McCarroll was born in 1867 in the Adirondack Mountains in New York. Unlike most young women of her age, she attended college in Chicago and then went on to study at the Allopathic Medical College, where she received a medical degree. With her studies completed in 1888, she moved to Nebraska and worked as a doctor for the Nebraska State Schools. She married John Robertson, and several years later, when he became ill with tuberculosis, she insisted that they move to a desert climate in Southern

June McCarroll.
*Courtesy of Billy
Holcomb, Chapter 1069
of ECV.*

California to speed his recovery. Initially they were planning to move to Los Angeles. However, much to their good fortune, they happened upon a tuberculosis camp in Indio, a very sparsely populated part of the state. The owner of the camp was looking for someone to manage the sixty-acre farm that was part of the health camp. He was impressed with John Robertson's credentials and offered him the position. The plan was for McCarroll to retire, become a homemaker and be active in community affairs.

Shortly thereafter, McCarroll was solicited to step in and temporarily care for the residents of the camp. Dr. McCarroll, as she quickly became known, was so competent and likeable that the other residents on the ranch and the railroad families pleaded with her to be their personal doctor. She needed a California license to practice in the state, so she requested an expedited permit from the California Board of Medical Examiners, and within a few weeks after her arrival, she was once again practicing medicine.

Her dedication to her practice and community and her reputation as a skilled physician attracted the Bureau of Indian Affairs, and in 1907, it appointed her the first Indian doctor, "white medicine man" for the tribes. McCarroll was responsible for hundreds of thousands of Cahuilla Indians living on five tribal reservations. This responsibility was not without challenges. How could she, a woman, compete with the medicine men and hundreds of years of tradition? Her presence was an irritant to the powerful

medicine men, and they resented her "white medicine." Eventually, with diplomacy, a good amount of patience and excellent doctoring skills, she was able to win their confidence.

In 1908, a severe measles epidemic spread throughout the Imperial and Coachella Valleys. At that time, it was the custom to send most of the Cahuilla children off the reservation to attend school. Unfortunately, many succumbed to the disease and were coming home very ill and dying. The conditions were extremely primitive, and the only helpful resource was running water. Working endless hours, Dr. McCarroll was able to win the confidence of many of the Indians, including Ambrosio Costillo, the tribal shaman. She taught him the importance of quarantining infected children and showed him how to incorporate proper sanitation methods into the treatment. To demonstrate how appreciative he was of McCarroll's skills and her commitment to the Indian tribes, he ceased using his tribal medicinal rituals and followed her orders so health could be restored on the reservations. Ambrosio was so dedicated to her that he warned her about a few medicine men who still resented her and were talking of an uprising. Apparently, not much could faze petite Dr. McCarroll. She was loaded with courage and, along with her loaded six-shooter strapped on her hip, went about her business caring for the tribes. No one seems to have doubted her boldness or her ability to shoot, and the Indians grew to admire this wonderful white savior.

In that part of the state, there was very limited transportation infrastructure. The area was so vast and rugged from the Salton Sea to Palm Springs that it sometimes took her several days to get to her patients traveling by horse and buggy, a train and even pumping her way along the train rails in a handcar. She always traveled with her surgical equipment and, therefore, was always prepared for whatever challenges would come her way. When surgery was required, Dr. June, as they preferred to call her, transformed kitchen tables in the homes into operating tables. She tied the patients down, boiled water, administered the anesthetic and operated. Her caseload increased when the physician for the Southern Pacific Railroad left his job. The management of the railroad knew about this feisty and compassionate woman and asked her to be the company doctor. Imagine the challenge of working with tuberculosis patients, railroad workers and their families and all those Indians under very primitive conditions. What a great testament to her professional and personal skills and inexhaustible energy.

McCarroll was always trying to improve the lives of her tubercular patients and prevent them from suffering from boredom. There was not much for them to do on the farm, and the best treatment was a great deal of

rest and taking advantage of the warm sunshine and balmy climate. Aware that good reading material was an antidote to monotony, she decided to establish a library in her home. She applied for an application for a branch library from Sacramento, and in September 1905, McCarroll founded the first library in Coachella Valley. The library was open three afternoons a week and consisted of fifty to one hundred books that she changed every three months to ensure the patients had a variety of reading materials.

In 1914, McCarroll's husband passed away, and two years later, she married Frank McCarroll, a station agent for Southern Pacific Railroad. As more physicians started moving into the region, work became less harrowing for McCarroll. Not long after, she went into semi-retirement and decided to volunteer in the community and participate in the various clubs that were forming.

One evening in 1917, after visiting a patient and driving home in her Model-T Ford, a large truck roared toward McCarroll in the center of the pavement and forced her off the road into the sand. In her own words: "My Model T Ford and I found ourselves face to face with a truck on the paved highway. It did not take me long to choose between a sandy berth to the right and a ten-ton truck to the left!" This was not McCarroll's first experience of narrow escapes with cars and trucks, especially while riding her horse and buggy. She was also seeing many more patients who were suffering from injuries that resulted from automobile accidents. On a later trip on a newer portion of the road, she noticed a joint ridge in the middle of the highway that indicated on which side of the road drivers should stay. Thus was born her idea of a painted stripe down the middle of the road as the answer to fewer accidents. With as much determination as she applied to everything she did, McCarroll made presentations to the Riverside County Board of Supervisors and the Chamber of Commerce. They were polite and listened to her every word, but they courteously rebuffed her idea and quietly shelved it.

McCarroll, however, knew how to win a fight. In her long dress, she got down on her hands and knees and "painted" a four-inch-wide stripe down the middle of U.S. Highway 99 that ran in front of her home to create two separate lanes. There are varying accounts of how she did this; the most noted one is that she painted a two-mile-long strip. Another version is that she used baking flour and striped a mile-long white line down the middle of the road. This most likely was the first stripe in Riverside County, the state and probably in the United States. She then launched a letter-writing campaign and distributed petitions to the state and county to incorporate the use of lines down all county and state highways. This effort continued

for seven years without any success until McCarroll organized an Indio Women's Club. The club then received support from the County, District and State Federations of Women's Clubs. She petitioned the California state legislature to ratify a law authorizing the California Highway Commission to stripe all state roads. The legislators recognized that thousands of women club members backed this legislation, and in 1924, they voted to mandate that all roads and highways be painted with dividing stripes. This amazing doctor added inventor after her name and has been credited with saving thousands of lives and improving the safety of the roads.

After her retirement, June McCarroll remained active in the civic organization in Coachella Valley. There are no records that indicate how long she remained in Indio or where she went from there. The date of her death is supposedly March 30, 1954, at the age of eighty-four, but the residents in the valley have no recall of her death, her funeral or her burial site. Most unusual is that the medical records from the decades she practiced have not been found. However, the community of Coachella Valley has honored her in a touching way. They requested that a portion of Interstate 10 between Jefferson Street and Indio Boulevard be dedicated as the Dr. June McCarroll Memorial Freeway. The legislation was passed in 2000, and the dedication took place on April 24, 2002. In addition, a bronze plaque attached to a six-foot-high concrete pillar in Indio was erected in her honor and dedicated in October 2003 by the Billy Holcomb Chapter of E Clampus Vitus, an organization dedicated to the study and preservation of western heritage, in cooperation with the City of Indio. What a wonderful honor for a remarkable woman who helped saved tens of thousands of lives through medicine and invention.

NELLIE E. POOLER CHAPMAN (1847–1906)

FIRST WOMAN DENTIST IN CALIFORNIA

Nellie E. Pooler Chapman truly learned by practicing. Without any formal education, she became a dentist under the guidance of her husband, Allen Chapman. After they married in Nevada City, California, Dr. Chapman trained his wife to become his assistant. When she was just at the tender age of fourteen, he taught her how to use the dental tools and help with the patients. She was a competent young woman and learned quickly. With her dainty hands and calm manner, she easily won the confidence of the patients,

Nellie Pooler Chapman. *Courtesy of the Searls Historical Library.*

many of them miners drawn to the West during the gold rush. It was quite a contrast to see these brawny and weatherworn men sitting in a big red velvet chair being helped by a smartly dressed petite woman with her "modern" dental equipment.

Chapman was born in 1847 in Norridgewock, Maine. Her family, following in the footsteps of hundreds of others, acquired gold fever and traveled west in 1854 to seek riches in the gold mines. Nellie Pooler met Dr. Chapman, who was about thirty-five years old, and they were married in March 1861 in a lovely and unique house named the Red Castle. Today, this home, a preserved historic lodging landmark, is a bed-and-breakfast inn. Allen Chapman had a new practice in Nevada City, and he encouraged Chapman to work as his apprentice. He was an excellent teacher, and Chapman was a very clever student who had the temperament for this type of work. Initially, her duties were simple tasks such as giving patients pain relievers, applying iodine and learning how to sterilize equipment. She was soon able to assist him with patients and very quickly realized she enjoyed the work.

During the next eighteen years, Chapman worked and learned almost everything about dentistry and oral hygiene. Although she had two sons, she continued working as they were growing up. After ten years in their office building, the Chapmans purchased a home and used the parlor as their office. The Nevada City area was a perfect location for them. It was one of the richest mining sites in the state and was overflowing with people seeking their fortunes. As the population grew, their dental services were in great demand, and the Chapmans were financially secure.

Unfortunately, their financial status took a turn for the worse because of Allen Chapman's generosity and kindness. He helped a few of his friends by cosigning loans that later went unpaid. They owed a total of approximately $80,000, and instead of declaring bankruptcy, the couple decided to sell everything except their home. After liquidating their possessions, they still owed $16,000. The Chapmans recognized their value as dentists, and they decided that Allen Chapman would start a new practice in Virginia City, Nevada, and Nellie Chapman would remain in Nevada City and run that office. This worked out well because he also was seeking his fortune and laid claim to a piece of land to mine.

Chapman, more confident than ever, assumed total control of the office and, in 1879, registered to be the first woman dentist in the old West. To her credit, she also was running the family and helping with the everyday business needs. The family once again became financially stable, and her dental practice was expanding very rapidly. Her office decor reflected her feminine side. Chapman instinctively knew how to furnish an office to make it appealing to her clients. Imagine the sight of this small and slender woman in her long dress among the large equipment and tall pieces of furniture. Chapman purchased the most modern equipment available, including a drill powered by a treadle that operated a flywheel to produce the energy needed. Her patients were treated as royalty as they sat in a marvelous soft red velvet chair embroidered in gold script with the words "Imperial Columbia." The chair had a porcelain bowl sitting on a stand, an aspirator and even a place for a crystal water glass. It also had levers so Chapman could tilt it to the level she needed. She had the comfort of sitting on a red-and-white cut velvet round stool. In the parlor stood a grand cabinet with drawers filled with tools and shelves of books and other attractive sundries.

There was another side to Chapman. She had a delightful demeanor, was very sociable and had other interests she pursued. Chapman enjoyed poetry and music and was a talented writer and composer. She was in much demand to read her poetry at the Elks Lodge and was active in the Shakespeare Club. She was also recognized as an accomplished musician and had some of her well-known musical pieces published.

Life was good for Chapman, her husband and their two sons. He continued his dental practice in Nevada, and although it was an arduous trip between the two cities, the family thrived and remained very close. Letters went back and forth, and some of those that remain indicate things were well. This continued for many years as the boys grew up until 1885, when Allen Chapman was hurt in an accident. To complicate his injuries, he appeared to

be suffering from influenza. This combination proved to be debilitating, and he returned to Nevada City hoping to regain his health. Less than two years later, he passed away at the age of seventy-one. One of Nellie Chapman's musical pieces, "Weep Not for Me," was played at his funeral.

The dainty but strong Chapman continued to practice dentistry in her lovely parlor until she died in 1906 at the age of fifty-nine. May it be noted that her obituary in the *Daily Union* praised her talents as a musician, writer and elocutionist. Her professional success as the first woman licensed as a dentist in the West and the only female dentist in the area were not mentioned. One line noted that she "had practiced dentistry for many years in the city."

However, history does celebrate Nellie Pooler Chapman. The home where she practiced her dentistry in the parlor is still standing on the hillside above Deer Creek not far from the gold mines. Her great-granddaughter Deborah Chapman Luckinbill, who was also married in the Red Castle, lives in the historic home. Both of her sons became dentists, and Chester, her youngest son, was most generous in donating most of Chapman's dental things to the School of Dentistry in San Francisco. Many of the technical and medical books she had shelved in her office are on display in a glass cabinet at the school. Nellie Pooler Chapman was a truly talented and remarkable woman who made it easier for those women who came after her to become dentists in the old West.

Margaret "Mom" Chung (1889–1959)

First Chinese American Physician in California

When we think of trailblazing women physicians in the history of California, the image that one most often envisions is a serious and dedicated person intent on healing and changing lives. In addition, they are probably tenacious, strong-minded and confident. Margaret Chung had all of these desirable traits and more. She lived an electrifying life in a diversity of worlds, and she took the opportunity to re-create her persona as she moved through the different phases of her life. Her creative spirit, inquisitive mind and boundless energy help to define this remarkable woman. She was a healer, a patriot, a political activist, a humanitarian, a socialite and a "mom" to hundreds of pilots who served during the wars in the 1930s and 1940s. These young men were her adopted "sons."

Margaret Chung, born in Santa Barbara in 1889, was the oldest of eleven children of Chinese parents who immigrated to the United States in the 1870s. They were a devout Christian family, and Chung dreamed of becoming a medical missionary in China. In her early childhood, she lived with her family on a vast ranch in Ventura County, where her father worked as the ranch supervisor. The years on the farm instilled in her a fondness for the outdoors and nature. Unfortunately, her parents became ill, and the family

Margaret "Mom" Chung. *Courtesy of the Chinese Overseas Ethnic Studies Library, University of California–Berkley.*

became her responsibility. Determined to continue her education, Chung worked many hours a day and attended school while also caring for her siblings and mother who was dying of tuberculosis. Poverty was a natural way of life for them. The anti-Chinese fury that was so prevalent and the accompanying segregation and discrimination made life for the Chung family extremely challenging.

By being resourceful and working hard, Chung was able to earn scholarships to college and medical school. She sold subscriptions to the *Los Angeles Times*, gave speeches about China and sold medical supplies. In 1916, she graduated from the University of Southern California College of Physicians and Surgeons to become the first Chinese American doctor in the United States. It was in medical school that Chung first experimented changing her persona by dressing in men's clothing and referring to herself as Mickey. After medical school, her first position was as staff resident for the State Hospital for the Insane in Kankakee, Illinois. The State of Illinois then appointed her as a criminologist. Shortly thereafter, her father died, and she returned to California to tend to her younger siblings and work as the staff surgeon at the Santa Fe Railroad Hospital, where she was able to fine-tune her expertise as a surgeon. With all this experience on her résumé, she knew

it was time to open her own office. Success came quickly, and the practice grew and included scores of Hollywood celebrities, many of whom were to remain lifelong friends.

In 1922, Chung moved to San Francisco and opened the first western medicine clinic in Chinatown. Not only was she the first woman doctor, but she was also the first American doctor to have a practice in Chinatown. She fulfilled her dream to help the Chinese people as a medical missionary through this clinic.

Chung was able to easily move among different milieus and adapt her character to each in a comfortable manner. She did not conform to the social norms; she made them. Her world consisted of her Chinese and American patients; social elites; celebrities; enlisted men; gay, lesbian and transgender persons; and almost anyone who was famous in San Francisco and Hollywood. Her delightful personality and colorful flair attracted seventy-five to one hundred individuals to her home for dinner every Sunday. Her elegant entertaining, including homemade cooking, was a natural enticement, and Chung developed a strong sense of belonging to the diverse worlds she transcended. She had rules, however, for her guests. She cooked and the men, including top-tier officers, washed the dishes and mopped the floors.

When the Sino-Japanese War broke out in 1932, Chung, a strong supporter of China, petitioned the State Department to travel there to assist the people. Authorities believed she would be of more help supporting the effort from the United States, so they denied her request. About that time, she met an aviator from Berkeley, and he and several of his Navy Air Reserve friends became frequent visitors to Chung's home. Chung had a fondness for aviation, and they formed a close bond. From this friendship developed a club that during World War II numbered 1,500 flyers who became Chung's adopted "sons" and she became their "mom." This amazing "family" organization of aviators, known as the Fair Haired Bastards, expanded to include the Golden Dolphins, the submarine men and the Kiwis who neither flew nor went to sea. The members included women, high-ranking officers and even elected officials. Chung corresponded with all of them through letters and care packages, plus four thousand hand-written Christmas cards. As an expression of her appreciation and love for her "sons," she gave a small carved jade Buddha to each one. Boxes of papers from Chung's personal collection included military publications and materials, numerous photographs, letters, telegrams, invitations, announcements and stories sent to her from many of her "sons." Her personal papers have very affectionate

notes and letters that reveal she may have had lesbian romantic relationships with entertainer Sophie Tucker and other women. The papers also reveal a broad range of friendships, from Madame Chiang Kai-shek to Tallulah Bankhead. After the war, there was speculation that the government secretly blacklisted Chung because they suspected that she was a lesbian.

Chung was a zealous and prominent patriot and a supporter of equal rights for women long before the movement took hold. Extremely resourceful, she took advantage of her respected status and urged the passage of a congressional bill to allow women to join the military service. Brigadier General Melvin Maas, senator from Minnesota, "adopted son #447," sponsored the bill creating the Women's Naval Reserve (WAVES).

Margaret Chung was a trailblazer in the truest sense of the word as it relates to her professional and political activities. People of all lifestyles admired and respected her. This admiration gave her a sense of empowerment to do things most people would not dare try. She could change from masculine clothing into sophisticated feminine dress and move effortlessly through the gender, racial and sexual limits of the social structure. For example, she would dine in public with a caged parakeet dangling from her wrist and was well known for her very elegant furs.

Chung died in 1959 at the age of sixty-nine after a long illness. Her pallbearers included Admiral Chester W. Nimitz, Mayor George Christopher and famed conductor Andre Kostelanetz. Although this vibrant woman led a privileged life and made major contributions as a doctor and a patriot during challenging times for the United States, there was little written about her until Judy Tzu-Chun Wu, historian and author, decided to shine the spotlight on her. She wrote a wonderful account of Margaret "Mom" Chung's life titled *Doctor Mom Chung of the Fair-Haired Bastards: The Life of a Wartime Celebrity.*

Chapter 7
LAWYERS

U p until the late nineteenth century, the law was solely a man's world. In 1872, Myra Bradwell appeared before the U.S. Supreme Court after the Illinois high court twice denied her application to the state bar. The Supreme Court backed Illinois. In a concurrent opinion, one justice wrote that the "paramount destiny and mission" of women is "to fulfill the noble and benign offices of wife and mother: This is the law of the Creator."

In California, Nellie Tator passed the bar examination in 1872 but was refused admission because only "white male citizens" were allowed to join. In an effort to overcome her rejection, Tator drafted a Woman Lawyer's Bill, but it died in the Senate, and she never appealed the court's adverse decision. In 1878, suffragist Clara Shortridge Foltz wanted to become a lawyer and drafted a revised Woman Lawyer's Bill that simply replaced the words "white male citizen" with "any citizen or person." Despite widespread opposition, the Woman Lawyer's Bill passed the legislature and was signed by the governor in 1878. As a result of the new statute, the state requirement to practice law changed from "white male" to "person" and stands as a landmark in the history of women's professional progress in California. In 1879, Foltz and suffragist Laura de Force Gordon became the first two women licensed to practice law in California.

Despite her legislative success, Foltz was still denied admission to the state's Hastings College of Law on the grounds that women would "distract the attention of male students." The first woman, Mary McHenry, did not graduate from Hastings until 1882. When they sought employment, few of the first women lawyers were welcomed into their

The Supreme Court of California (1978–79). *Courtesy of the California Judicial Center Library.*

chosen profession. Unlike male law school graduates, women with outstanding records were not interviewed by elite firms that sought to hire the most talented attorneys.

Even as late as 1958, a U.S. government publication advised women lawyers seeking employment to concentrate on "real estate and domestic relations work, women's and juvenile legal problems, probate work, and patent law." The year 1972 marked a turning point for women's equality in education. Title IX of the Educational Amendment Act made it illegal to discriminate on the basis of sex in all public and undergraduate institutions and in most private and public graduate schools receiving federal funding. Title IX applied to all major law schools and impacted not only the enrollment of women students but also the availability of scholarship aid to them. Today, women are no longer barred from law schools or face quotas that once limited their enrollment, and women lawyers may argue a case in a courtroom presided over by a woman judge.

This chapter tells the stories of Annette Abbott Adams, a true trailblazer who was the first woman to be appointed assistant U.S. attorney general; Georgia Bullock, first female Superior Court judge in California; Gladys Towles Root, famous criminal defense lawyer; and Rose Bird, the first woman chief justice of the California Supreme Court.

ANNETTE ABBOTT ADAMS (1877–1956)

FIRST WOMAN ASSISTANT ATTORNEY GENERAL

In 1920, Attorney General A. Mitchell Palmer invited Annette Abbott Adams to become an assistant attorney general in Washington, D.C. She accepted, and three days later, President Woodrow Wilson presented her nomination to the Senate. Adams was immediately confirmed and became the first woman to hold the post in the United States.

Born in Prattville, California, Annette learned the frustrations of an educated woman from her mother, a Maine schoolteacher who could not serve on the board of education because of her sex. When the first suffrage amendment failed in 1896, Annette Adams was a junior at Chico State Normal School. At the time, teaching was the only appropriate profession for a young woman. After graduation, she obtained her first job, teaching grammar school in her home county of Plumas. In 1906, Adams broke tradition by marrying and continuing her teaching career. While saving money for law school, Adams eventually became one of the first women high school principals in California.

In 1910, Adams realized her dream: acceptance by Boalt Hall, the law school at the University of California–Berkeley. Two years later, Adams, the only woman in her graduating class, received her juris doctor (JD). When Western Pacific Railway asked the dean of the law school to recommend the "best man" in the class for a position as house counsel, he suggested Adams. Unfortunately, the railway was not ready to employ a woman lawyer. Unable to find any law firm in the San Francisco area that was willing to hire her, Adams returned to Plumas County and opened an office.

Annette Abbott Adams. *Courtesy of the Library of Congress.*

When, in 1912, the Democratic State Central Committee chairman invited Adams to organize women for Woodrow Wilson's presidential campaign, she eagerly accepted and moved back to San Francisco, leaving her husband behind. Adams became president of the Women's State Democratic Club and actively promoted Wilson's candidacy because of his support for women's rights. The following year, she attended Wilson's inauguration, where she was introduced as a promising young California lawyer and an asset to the Democratic Party. As a reward for her political support, Adams was sworn in as assistant United States attorney for Northern California in 1914. Prior to her appointment, no woman had ever represented the federal government in court or been awarded a high federal office.

Knowing of Adams's success in California, Attorney General A. Mitchell Palmer, candidate for the Democratic presidential nomination in 1920, invited Adams to become an assistant attorney general in Washington, D.C. Her first duties were at the Democratic National Convention in San Francisco gathering support from women for Palmer. At the same time, she began her own bid for the vice presidential position. A 1916 article in the *San Francisco Chronicle* stated, "In some circles the candidacy of a woman for vice-president is being strenuously urged. This particularly among the Democratic women who believe that a woman with the second place on the ticket would add great strength to the Democratic cause at the November election in the states where women have already been given suffrage." Palmer failed to gain the nomination, and as a consequence, Adams lost the possibility of becoming the nation's first female vice presidential candidate.

In August 1921, President Warren G. Harding replaced Adams with another California woman, Republican Mabel Wille-Brandt, and Adams returned to San Francisco and again started a private practice. Despite her defeat, Adams continued to participate in state and national Democratic politics. Although she had campaigned for others in the past, in 1923, she tested her own appeal to voters as a candidate for the San Francisco Board of Supervisors.

Senator Phelan actively supported her campaign and commented, "A woman member of the Board of Supervisors would bring a refining leaven to that body of decorum and intuition." After Adams spoke at luncheons, churches and Democratic rallies, newspapers began to predict her election. Since 1921, registration statistics in San Francisco showed that the number of women registered to vote had declined, and prohibition had become a controversial issue. Although Adams never stated her position, newspapers classified her as a "dry." The Labor-Union Party failed to endorse her, and Adams lost the election.

In 1932, she campaigned for Franklin D. Roosevelt, and the Women's Division of the Democratic National Committee counted on her organizational skills for support in Northern California. Once again she was offered a political reward. In 1933, Roosevelt wanted to appoint her to the Federal Board of Tax Appeals, but Adams declined because she preferred to remain in California.

In 1942, the Democratic governor of California appointed Adams presiding justice of the District Court of Appeals for the Third District of California. In 1950, she was assigned for a single case to the California Supreme Court and became the first woman to sit on the court. After 1947, Adams suffered from arteriosclerosis, and she retired in 1952. Annette Adams died in her Sacramento home four years later.

According to her biographer, Joan Jensen:

> *Mrs. Adams was one of the few women prepared to work for political influence with traditional male tools: a legal career, training as a specialist, and a basically conservative rather than reform outlook on life. Yet her career as politician proved that neither American women nor the American public were ready to accept women who wanted to compete as equals. In a sense the California woman suffrage amendment of 1911 ended one phase of the fight for political equality and began another. The fight for political suffrage had ended, but the fight for political office had just begun.*

GEORGIA BULLOCK (1874–1957)

FIRST WOMAN CALIFORNIA SUPERIOR COURT JUDGE

The first women to be promoted to judgeships were often appointed to part-time positions as token representatives of their sex. When Georgia Bullock took the bench as a Superior Court judge, the bailiff announced, "For the first time in Los Angeles in Superior Court, and the first time in California, Her Honor the judge—Hats off." Bullock's career had been one of many "firsts," and it was not surprising that as the first woman member of the Los Angeles Bar Association, she would also break this additional barrier.

Georgia Bullock was born in 1878 in Chicago, Illinois. She early exhibited intellectual curiosity and creative ability. "As a child, I was always fascinated by the unknown, the mysterious or the unusual. When I finally met algebra,

I was simply carried away with it. To me the unknown quality was the interesting part of it. It seemed to follow as a natural sequence that I became profoundly interested in the psychology of criminals and in the solving of mysterious crimes," she explained.

Bullock married in 1899 and attended the University of Southern California Law School from 1910 to 1914. In 1911, she and four other students formed Phi Delta Delta, the nation's first women's student law society. Bullock early recognized the importance of a professional network

Georgia Bullock. *Courtesy of the University of Southern California, USC Special Collections.*

of women lawyers. Together with a group of other USC Law School graduates, she later founded the Women Lawyer's Club of Los Angeles. The stated purpose of the club was to assist other women entering the profession.

After law school, Bullock worked as a volunteer juvenile probation officer in Los Angeles and in 1914 became a "referee" for women's cases before the Police Court, a position she held for approximately two years. Bullock was in charge of a court segregated by sex where "she would serve as a model of Victorian ideals of womanhood for female misdemeanants." Bullock believed that women would be better served by a woman judge who could tell the "good girls" from the bad and help them to change their behavior.

The Los Angeles Women's Court emphasized privacy and closed its doors to the public so that the female defendants could tell their stories without inhibition. A 1916 article in a national lawyers' magazine stated, "Women and girls from all walks of life; those who have committed crimes; those who are suspected of having committed crimes; and those who have got into trouble through no fault of their own, will be treated in the same kindly manner. They will bear their hearts—not to a courtroom full of curious, leering men—but to a few women who understand."

When interviewed about her favorite offender story, Bullock described a mother who shoplifted a ten-cent toy for her child. The woman was initially sentenced to sixty days in jail, but Bullock suspended the sentence on the condition that the woman avoid shopping in department stores. She believed that many female defendants were simply victims of impoverished conditions and initiated a program in which female inmates were paid a dollar a day during the terms of their sentences. The purpose of the program was to make it possible for the woman, upon her release, to pay for a hotel room until she obtained employment.

Bullock left the Women's Court in 1917 and joined the prosecutor's office as deputy district attorney. Believing she could contribute more toward women's causes in private practice, she resigned two years later. In 1924, the position of full-fledged police judge for the Women's Court became available, and the Los Angeles Board of Supervisors unanimously selected Bullock for the job. According to the *Los Angeles Times*, "The selection of Mrs. Bullock was in response to a veritable flood of requests for the appointment of a member of their sex by club and society women throughout the city."

Bullock's prominence was recognized throughout the legal community, and by the time she was named municipal judge in 1926, she had received a great deal of press coverage. For example, a nationally syndicated article quoted her as saying, "Women offenders against the law are glad to appear before a woman judge. Though they have a right to ask to be heard in other courts, they seldom ever, exercise it." She also commented on the difficulty she faced teaching women offenders to address "Her Honor." "The hardest job of my three years on the bench has been to persuade women prisoners that 'Dearie' is not the correct way to address the Court. I correct them again and again, but they just cannot seem to help getting familiar and out comes the 'Dearie' again."

Unfortunately, Bullock's role as a Municipal Court judge placed her in a position of danger. In August 1927, a man going by the name of "Black Hand Boston" threatened her life. He sent multiple death threats commanding Bullock to leave California. One of his letters depicted a revolver with the words "You will get this." Throughout her ordeal, Bullock courageously held court sessions every day. Her record on the bench was flawless. Only one appeal was ever made, and on appeal, Bullock's decision was upheld.

Bullock's track record as a proven judge made her a good choice to run for a Los Angeles Superior Court judgeship in 1928, a position to which a woman had never been elected. Her barrier-breaking opportunity was described by a local columnist: "It seemed peculiarly appropriate that the new city of Los Angeles should, as part of its bid for prominence, set a new

standard for female achievement. Georgia Bullock's career could feature as an important part of the judiciary history of the US." A supportive letter from the Women Lawyers Association stated, "We have a chance to elect a judge who has already proved herself on the municipal bench, a lawyer who fought her way through private practice…and mother who by her own efforts has reared a boy to manhood and a girl to womanhood."

Bullock's qualifications as a jurist were not questioned. A *Los Angeles Times* editorial stated, "Her fitness for a promotion to a higher court is not a factor." Throughout a physically demanding campaign schedule, Bullock continued to hear her usual calendar of cases. Despite her hard work and that of her numerous supporters, the incumbent, William Doran, prevailed at the polls by a vote of nearly two to one.

Fortunately, Bullock eventually achieved her ultimate goal. On August 14, 1931, Governor James Roph Jr. appointed her judge of the Superior Court, the first female judge of the Los Angeles Superior Court and California's first woman Superior Court judge. In her response to the governor's announcement, Bullock declared, "My appreciation and gratitude for your splendid tribute to the women of California in appointing a woman to the Superior Court of Los Angeles County cannot be measured in words."

Bullock used her appointment as an occasion to remember the women who had come before her. After receiving a handwritten letter of congratulations from Clara Shortridge Foltz, Bullock replied, "You have always known that above all women in my profession I admire you, and I doubt if the day will ever dawn when we will have the privilege and honor of knowing a greater woman lawyer than yourself, therefore, you must understand that your approval of whatever I do is of the highest value."

Bullock remained in her position as a Superior Court judge until retiring in 1955. She belonged to a transitional generation. In the first half of the twentieth century, there were still few women in the legal profession. Two years after her retirement, Georgia Bullock died at the age of eighty-three.

GLADYS TOWLES ROOT (1905–1982)

FAMOUS CRIMINAL DEFENSE LAWYER

One of the most famous female criminal defense lawyers of the twentieth century, Gladys Root won more sex crime cases than any other lawyer in her era. Since no other employment was available to her, after graduation from

Gladys Towles Root. *Courtesy of the Los Angeles Public Library Photo Collection.*

the USC Law School in 1930, she began accepting rape and murder cases. Her biographer, Cy Rice, observed, "In the turbulent pull-and-tug of the criminal courts, to be represented by Gladys Towles Root is to be certain that you have in your corner a brilliant battler who can influence the odds for acquittal." A trailblazer in the legal system, her regal bearing, unconventional outfits and outstanding legal skills packed courtrooms in Los Angeles for fifty-two years.

Root was born in Los Angeles on September 9, 1905. She was the second daughter of Charles and Clara Towles and grew up in comfortable surroundings. Early in her life, dramatics and colorful costumes played an important role. In the beginning, she staged amateur shows in her family's barn, later graduating to the Community Players of Hollywood. According to her biographer, Root was a college freshman when her father told her, "Gladys, you ought to be on the stage—not the theater, but life's real stage: the courtroom."

Immediately after obtaining her JD, Root opened an office four blocks from the Skid Row section of Los Angeles. One of her first clients, Louis Osuana, sought her assistance in obtaining a quick divorce from his unfaithful wife. Impatient for the wheels of justice to turn, the next day he shot and killed her. During the trial, Root successfully convinced the jury to convict her client of manslaughter rather than first-degree murder. After her former client told others about his lawyer, a familiar request made by numerous inmates was "Get me Gladys."

Root became famous for wearing flamboyant clothing and large hats in the courtroom. In one appearance before the U.S. Supreme Court, she wore a tight-fitting bronze taffeta dress hemmed with brown velvet, bronze ankle-

strap shoes, a topaz ring the size of a silver dollar and a topaz pin of 190 carats. Over the dress was a white monkey-fur cape. Her huge hat was made of the same fabric as the dress, and her hair was also dyed the color of topaz. This may be the only time in U.S. Supreme Court history that a lawyer refused to wear traditional attire.

Root developed a reputation as a highly skilled lawyer, and young attorneys often gathered to observe her cross-examination of the prosecution's witnesses. She defended many clients who were accused of murder but never lost one to the death penalty. Since California's gas chamber was quite busy during the era in which she practiced, Root's record was quite remarkable.

In 1931, Root won one of the most important cases in her entire law career. A young Filipino man sought her assistance because the law did not allow him to marry his pregnant Caucasian girlfriend. A 1906 decision handed down by a Los Angeles Superior Court judge stated, "Filipinos are Mongolians and thereby cannot marry with Caucasians." Root's research determined that the law prohibiting the marriage of these parties did not construe that the Malay race was included in the category of Mongolian. Root took the issue to a higher court, where she successfully contended that the Filipino race is a race by itself, distinct and entirely apart. The law was declared unconstitutional, and as a consequence of her victory, all restrictions were eliminated. This case, together with a number of acquittals in sensational rape cases, brought Root to the attention of the press and the public.

She also spoke out on behalf of racial equality, humane treatment for sex offenders and increased opportunities for woman lawyers. "The chief critics of woman lawyers are from the old school…old timers. Many a male lawyer when defeated by a woman will blame it on the mystic factor that they call feminine intuition. This is his excuse in plain language, he faced too much perception and intelligence and logical thinking," she told a *New York Times* reporter in 1964.

Root's compassion for the sick, poor and lonely was unwavering. She had a deep conviction that professed rapists and murderers deserved a fair trial and often would work pro bono for those who were unable to afford her services. She believed that a lawyer is obligated to do her job to the best of her ability, whether or not the job was pleasant. In addition to Root's average of seventy-five monthly court appearances, she frequently met with her clients in prisons and visited them in their homes. At one time, Root's office was handling as many as 1,600 cases a year, more criminal cases than any other private American law firm.

In 1964, three men kidnapped Frank Sinatra's son and collected $240,000 in ransom money. Root was retained to defend John Irwin, one of the men charged with the crime, and defended him zealously. Unfortunately, the federal grand jury issued an indictment against her in connection with her defense. She was accused of fabricating a story that Sinatra Jr. made up the kidnapping for publicity reasons and was indicted on charges of conspiracy, perjury and obstruction of justice. Root maintained her innocence, and four years later, the charges were dropped.

Gladys Towles Root married Sheriff's Deputy Frank Root in 1929 and gave birth to a son. The marriage lasted eleven years and ended in divorce. Two years later, she wedded John C. Geiger, with whom she had a daughter. The couple appeared to be devoted to each other, and both enjoyed wearing colorful clothing. Geiger was reputed to always have a green parrot named Pablo perched on his mink-covered lapels that once bit a judge Root disliked. Their marriage continued until 1958, when her husband died after a prolonged illness.

In December 1982 at the age of seventy-seven, Root was in a Pomona courtroom defending two brothers accused of rape when she asked the judge, "Give me a few minutes…I'm having trouble breathing." Then she collapsed and died two hours later. Root was buried in Forest Lawn Cemetery in Glendale, California, in a gold dress with sequins. An assortment of over four thousand friends, clients, attorneys and judges attended her media-covered funeral.

ROSE ELIZABETH BIRD (1936–1999)

FIRST WOMAN CHIEF JUSTICE OF THE CALIFORNIA SUPREME COURT

Rose Bird told a reporter in 1986, "I've always said when you're the first of your sex or race in a position, three things apply to you. One—you're always placed under a microscope. Two—you're allowed no margin for error. And three—the assumption is always that you achieved your position on something other than merit." Throughout her career, Bird achieved "first woman" status numerous times. She was the first woman to serve as a law clerk for the Nevada Supreme Court, the first woman deputy public defender in Santa Clara County and the first woman to teach at Stanford Law School. Other "firsts" include serving in a cabinet position in California, being appointed

to the California Supreme Court and becoming the court's chief justice.

Bird was born on a farm outside Tucson, Arizona, in 1936. Her father was a salesman who died when she was five. After his death, Bird's mother moved her daughter and two sons to New York, where she found employment in a plastics factory. While in high school, Bird served as representative to the Interschool World Relations Council and worked on presidential candidate Adlai Stevenson's campaign. She graduated from Long Island University in 1958 and went on to study political science at the University of California–

Rose Elizabeth Bird. *Courtesy of the California Judicial Center Library.*

Berkeley, where she was awarded a prestigious Ford Foundation grant. The award enabled her to spend a year as an intern in the California legislature. After completing her public policy experience, Bird decided to study law and transferred to the UC Berkeley School of Law, known as Boalt Hall.

While in law school, Bird was featured in a 1965 issue of *Mademoiselle* that highlighted the experiences of female law students in schools around the country. She told the interviewer, "If you want to have an impact, law is the key." Rose wanted to get back into government but this time in trial work. She was determined to work in something like the California public defender's office, arguing cases on behalf of indigent defendants. "This kind of work is not lucrative, but it does provide a chance to get seasoned fast in trial work—a fairly remote possibility for a woman in private practice," she explained.

After earning her JD in 1965, Bird clerked for the Nevada Supreme Court and then went on to pursue her goal of becoming a public defender. She initially applied to the Sacramento public defender's office but was told that it did not hire women. Her interviewer explained that he had only known one good female trial attorney, and she turned out to be an alcoholic.

Bird next applied to the Santa Clara County public defender's office and succeeded in obtaining employment. She eventually organized that office's first appellate division and argued a number of landmark cases before the California Supreme Court.

While working in the public defender's office, Bird taught a clinical course in criminal defense at Stanford Law School. She used her position at the public defender's office to provide students with direct experience in criminal defense. Bird selected cases that her colleagues viewed as hopeless and assigned them to her students. Many of her students succeeded in winning a number of these "hopeless" cases. In 1974, Bird declined a faculty position at Stanford and left the public defender's office for private practice.

Bird's eventual rise to the California Supreme Court began in 1974, when she volunteered on Jerry Brown's gubernatorial campaign and served as his driver when he was in San Mateo. Following Brown's election, he included her in his transition team and appointed her as secretary of agriculture and services, the largest government agency in California. Bird became the first woman to hold a cabinet position in California. Despite her lack of agricultural experience, Bird was committed to her job. One of her major accomplishments as secretary of agriculture was to outlaw the short hoe, a tool that caused farm workers serious health and physical problems. She also helped to pass the Agricultural Labor Relations Act that guaranteed farm workers the right to organize and negotiate labor contracts.

In 1977, at the age of forty and despite no judicial experience, Governor Jerry Brown appointed Bird to the California Supreme Court. At the time of her appointment, Gene Blake, legal affairs reporter for the *Los Angeles Times*, wrote:

> *Those who have been intimately associated with Ms. Bird in her capacities as law clerk, public defender, law school teacher, and Secretary of Agriculture and Services in Governor Brown's cabinet are enthusiastic in their praise. The qualities these people repeatedly mention are intelligence, a solid background in criminal law at both the trial and appellate level, an analytical mind, organizational ability and a prodigious capacity for hard work. But above all, they say, is her sensitivity to the problems of people as individual persons, particularly the underprivileged and the underdogs.*

Although opposed by almost all Republican politicians in the state, it was the vote of Attorney General Evelle Younger that provided the 2–1 vote from the Commission on Judicial Appointments. California Supreme Court

justices are normally elected for twelve-year terms. However, when a justice is appointed to replace a retired or deceased justice, he or she must first stand for reconfirmation by the electorate at the next statewide gubernatorial election held after the appointment. For Bird, this was the 1978 elections. Despite a well-financed campaign to defeat her by conservatives and law-and-order supporters who charged that she was "soft on crime," Bird narrowly won confirmation and was later sworn in as the California Supreme Court's first female chief justice.

During her tenure on the Supreme Court, Bird faced numerous attempts to unseat her. Most of the attacks against her were related to her position on the death penalty. She reviewed a total of sixty-four capital cases that were appealed to the court. In each case, she issued a decision overturning the death penalty that had been imposed at trial. Attempts to remove her from office continued through the election of 1986.

In 1986, the end of the term of her predecessor, Chief Justice Wright, Bird had to face reelection. Crime Victims for Crime Reform was one of the major organizations that led the fight against Bird. In San Diego, Sheriff John Duffy ordered his two hundred deputies to distribute postcards to the public actively opposing her reelection. Advertisements paid for by anti-Bird groups described brutal crimes, claiming that "Bird let the killers go free." Republican governor George Deukmejian, who was running for reelection in November, also campaigned vigorously against her.

As a result of the campaign citing her opposition to the death penalty, Bird became the first chief justice of the California Supreme Court to be removed from that office by a majority of the state's voters. Future political campaigns frequently used her name to associate candidates with being soft on crime or too liberal. Bird's reputation made it difficult for her to find legal work. She did, however, make a few appearances on television in the role of a family court judge. Eventually, she retreated to a private life and lived with her mother in Palo Alto. Bird never married.

On December 4, 1999, at the age of sixty-three, Rose Bird died from breast cancer, which she had battled on and off since 1976. She requested a private cremation and no funeral. Bird was memorialized in two services, and awards were established in her honor by the California Public Defender's Association and the California Women Lawyers.

Chapter 8

EDUCATORS

Early California settlers were not convinced of the need for schools. Until the settlers became more established, education was viewed as a luxury, and the importance of being able to read and write was not recognized until the mid-1800s. Initially, girls were not believed to need an education as much as boys. Once communities were established, the first schoolhouses were built. The first American school in California was established in December 1846 on the grounds of the Santa Clara Mission.

In December 1847, a public schoolhouse built of redwood was completed in San Francisco. The following year, a small number of voters elected a board of school trustees consisting of five members, and a male teacher was hired. The school finally opened in April 1848 with six pupils, and the number later increased to thirty-seven. Although parents had to pay tuition, education was free to indigent children. As a result of the discovery of gold, the attendance dropped to eight. Nearly everyone rushed to the gold fields, including the teacher, who closed the school to seek his fortune in the mines.

As school systems grew, a shortage of teachers developed for primary and secondary schools. Most of the first schoolteachers were male, but because there were many other opportunities for them, recruiting male teachers became increasingly more difficult. Although there was some opposition, it became clear that hiring female teachers was the only solution to the shortage. Many people believed that a woman's place was in the home, and there was concern that a female teacher would be unable to control boisterous male students. Female teachers were paid as little as one-third of what male teachers earned, and superintendents who hired

1890 Lexington School class. *Courtesy of Los Gatos Library & History Museum Project.*

them could more than double the number of teachers without having to increase their budgets.

During the 1870s, the California school system gradually became feminized. Women filled the majority of primary school positions, while males obtained the better-paying high school and administrative jobs. Toward the end of the nineteenth century, many school districts adopted policies that barred the hiring of married women, and some even authorized firing those who married during their academic terms. The justification was that a woman's place was in the home. It was not until 1941 that several state Supreme Court rulings put an end to these policies, known as marriage bars.

Title IX of the Education Amendment Act, passed by Congress in 1972, gave females the same opportunities that were offered to males in all educational programs receiving taxpayer dollars. Title IX stated, "No person in the United States shall, on the basis of sex, be excluded from participation in, be denied benefits of, or be subjected to discrimination under any education program or activity receiving Federal financial assistance." Title IX was the first broad federal civil rights law to explicitly prohibit sex discrimination in the educational system.

This chapter tells the inspiring stories of Olive Mann Isbell, California's pioneering teacher; Susan Mills, missionary and educator who established the first women's college; Katherine Siva Saubel, Native American scholar who preserved her Cahuilla history, culture and language; and Marilyn J. Boxer, founding mother of the nation's first women's studies program.

OLIVE MANN ISBELL (1824–1899)
CALIFORNIA'S FIRST TEACHER

After reading a circular that described a glorious land of opportunity called California, twenty-two-year-old Olive, recently married to a physician, Dr. Issac Isbell, agreed to join a group of wagon trains departing from Springfield, Illinois, for the long journey westward in April 1846. She explained, "I have all that I want here, and what more could I have elsewhere? I have tried luxury without health, and a wild mountain life with it. Give me the latter, with the free air, the dashing streams, the swinging woods, the laughing flowers and the exulting birds." The rugged, hazardous overland trip was completed in the autumn of 1846, and the group of pioneers straggled into Santa Clara County.

After their arrival, the wagon trains were met by Captain Fremont's soldiers and escorted to the Mission Santa Clara de Asis. At the time, there were approximately two hundred Americans barricaded inside the mission. The Mexican army was trying to reclaim its land, and the mission was on the verge of being attacked. Along with the other able-bodied men, Dr. Isbell was promptly drafted by military leader Fremont to join the fight.

Olive Mann Isbell. *Courtesy of the Braun Research Library, Autry National Center of the American West.*

After the men's departure, those who remained inside the crumbling mission were very frightened. In order to fortify the main building, they jammed tree trunks across the big wooden gates of the compound. Aware that the children needed to receive attention and be constructively occupied, Isbell proposed a work project. Together with a

few others, she and the children cleaned a dilapidated former adobe stable and built a rickety table and some benches from scraps of wood.

Olive Isbell was born on October 8, 1824, in Ohio, one of a family of fifteen and a niece of the famous educator Horace Mann. Her uncle believed that "a common school education benefited both the individual and the community at large." Under his influence, Isbell began a teaching career. In December 1846, recognizing the importance of learning to read and write, she established the first American school in California on the grounds of the Santa Clara Mission. Twenty children attended her class. The rickety table and benches, previously built with their own hands, served as the classroom's minimal furniture. The tile roof leaked, and the earthen floor was often damp and wet. When heat was needed, a fire was made on a stone platform stationed in the center of the room. A hole in the roof sometimes provided for the smoke's escape.

Isbell's limited school supplies consisted of five McGuffey Readers, half a dozen spellers and three arithmetic and geography books. In order to teach the basics of English without a slate, a blackboard or paper, Isbell wrote the alphabet on the palms of her pupils' hands with charcoal. Lacking pencils, lessons were written on a dirt floor with a long, pointed stick. Concerned about protecting her students, Isbell made sure to keep a rifle handy and soon became known as Aunt Olive.

Shortly after he joined Fremont and his men, Dr. Isbell was stricken with typhoid pneumonia and forced to return to the mission. Isbell tended to her sick husband and others who suffered from so-called "emigrant fever." The mission was attacked, and in the midst of nursing her husband back to health, the couple had to withstand a daily exchange of gunfire. Many of the mission's residents became gravely ill, and some died. Following the instructions of her physician husband, Isbell handed out more than one hundred doses of medicine to arrest sickness and prevent infection. When she was not busy ministering to the sick, she assisted in getting ammunition to the soldiers.

On January 1, 1847, marines from Yerba Buena (now San Francisco) arrived with a small cannon and supplies. Following a brief skirmish, the Mexican army laid down its arms and agreed to stop fighting. The only campaign in Northern California during the Mexican-American War ended, and a truce was declared on January 3, 1847. Two months after the fighting ended, the Isbells, along with five other families, moved to Monterey.

On their very first night in the new city, Thomas O. Larkin, United States consul, who had learned of her previous school at the mission, invited Mrs. Isbell to establish a similar school in Monterey. She accepted and opened a

school, which was located in the old adobe customs house. Books, pencils and paper were made available, and Isbell was guaranteed a salary of $200 a month. Parents were charged $1 a month for their children to attend, and the initial enrollment of twenty-five students quickly doubled. Since Mrs. Isbell spoke no Spanish and only two of her students were English speaking, she was able to teach with the assistance of a couple of bilingual students.

Although the Monterey school was successful, Dr. Isbell was restless, and the couple relocated in French Camp, near present-day Stockton, and bought a ranch. They had barely settled when gold was discovered at Sutter's Mill. Dr. Isbell and others organized the Stockton Mining Company and headed to the gold fields. While her husband was away mining, Isbell stayed behind and tended to their ranch. The couple had no children, and her only assistance was provided by a nine-year-old boy. After Isbell learned that the local people admired her clothing, she was able to earn extra money by making calico gowns and petticoats.

After three years, Dr. Isbell returned home with eighty pounds of gold. In 1850, the Isbells sold their property at French Camp, moved back to Ohio and later moved again to Texas. Using the fortune made in the California gold mines, the couple purchased another ranch. By mid-1865, the couple had returned to California and settled in Santa Paula in Ventura County.

After a tragic horse-and-buggy accident, Dr. Isbell died in 1886. Olive Isbell lived out her last years in Santa Paula and died in 1899. The City of Santa Paula recognized her contribution to education by naming a local school in her honor. Audrey Youngs, who has researched Isbell's life, stated, "Mrs. Isbell not only nurtured education in California, she exemplified the courage, persistence, and zeal of the pioneer woman."

SUSAN MILLS (1825–1912)

ESTABLISHED FIRST WOMEN'S COLLEGE IN CALIFORNIA

The mid-1800s brought significant changes for women in education. There was a rapid growth in secondary education, and the development of collegiate education for women followed. Schools that offered women an education equal to that of men, called "seminaries," began to flourish.

Susan Tolman Mills was born in Enosburg, Vermont, to John Tolman and Elizabeth Nichols Tolman in 1825. Her father operated Gilbert's

Tannery out of their homestead. He wanted to expand his tanning business, and by the time Susan was ten, the family had moved to Ware, Massachusetts. Susan's mother, who wanted her six daughters to get an education, died in 1837, but all the girls eventually attended the Mount Holyoke Female Seminary. Susan Mills graduated from there in 1845, and for the next three years, she taught classes under the leadership of Mary Lyon, the seminary's inspirational leader. Mills later commented, "Not a day of my life passes that I do not put into practice something I learned from her."

Susan Mills. *Courtesy of the Special Collections, F.W. Olin Library, Mills College.*

In 1848, she married a Presbyterian missionary, Cyrus Taggart Mills, who had been educated at Williams College and Union Theological Seminary. Cyrus chose a missionary career, and immediately after their marriage, the couple sailed to Ceylon (now Sri Lanka). Cyrus became principal of a seminary for boys while Susan Mills taught domestic skills to girls from the local schools. The climate did not agree with them, and they both developed health problems. Sick and exhausted, the couple returned to Boston in 1854.

In 1860, fully recovered, they relocated to Honolulu and took over the Punahou School (then known as Oahu College). Susan Mills taught geography, geology, chemistry and botany and introduced calisthenics to the female students. She also became an expert horsewoman and is credited with improving the food and providing other amenities to the school. In 1864, the couple moved to California, where they hoped to run a school of their own.

The following year they bought the Young Ladies Seminary that had been founded in 1852 and was located in Benicia, just east of Vallejo in Solano County. At that time, the University of California and Stanford had yet to exist. Miners, farmers and merchants who wanted to educate their daughters without sending them on the perilous journey to East Coast schools enrolled their children. With a vision of equal education and opportunity for women,

the Mills purchased the seminary for $5,000 and renamed it Mills Seminary. The school had only thirty-eight boarding students and a small number of inexperienced teachers.

The Mills improved the school by increasing the number of course offerings and recruiting qualified teachers. During the next five years, the school prospered and expanded. In 1871, the Mills sold the property and relocated their school to open country in the foothills of Oakland, on the east shore of the San Francisco Bay. A long four-story building with a high central observatory named Mills Hall became the college's new home. The structure provided homes for faculty and students, as well as classrooms and dining halls, and was long considered the most beautiful educational building in the state. The student body quickly grew, with students of diverse faiths and backgrounds enrolled from many states and countries.

While her husband served as head of the seminary, Mills held the title of "lady principal." In addition to teaching, she shared in all of the school's administrative duties. Through shrewd real estate investments before his death in 1884, Cyrus succeeded in repaying all the debts incurred in building the Oakland campus. Through all their years together, the couple had planned to build a school and then to transform it into a college. Determined to realize this goal, Susan Mills successfully carried through the school's shift to college status. In 1885, Mills College, the Pacific Coast's first women's institution of higher learning, was founded.

After her husband's death, Susan Mills served as acting president, but the trustees selected Homer Sprague, headmaster of the Girls' High School in Boston, to serve as the college's permanent president. After Sprague resigned in 1887, he was succeeded by Dr. Charles Carroll Stratton. In January 1890, three faculty women complained to Mrs. Mills and then to the board that President Stratton had pressed "amatory attentions" upon them. After this scandal, most of the students refused to attend church when Dr. Stratton preached. Seminary girls, forgetting they were ladies, poured into a mob, made a little coffin, tacked a picture of President Stratton on the lid, marched it around and then carried it to the trash gate and burned it. On May 8, Stratton resigned.

Following his resignation, the position was briefly filled by another man, the president of nearby University of the Pacific. Meanwhile, Mills continued as the college's lady principal and managed the school's business affairs. In 1890, Susan Mills, who was then sixty-four years old, was elected president of the first women's college on the Pacific Coast. The story of the two male presidents became a sealed chapter in the college's history.

While serving as president, she constantly worked to raise standards and secure recognition for the college, and under her leadership, the college obtained accreditation. Mills never lost her gift for selecting competent teachers and winning their loyalty. In 1904, architect Julia Morgan was just beginning her career. Wishing to be supportive of a female architect, Mills hired her to design six buildings for the campus. One of Morgan's structures, El Campanil, is believed to be the first bell tower built on a United States college campus. In addition, during the nineteen years Mills served as president, a science building, auditorium, library and gymnasium were added to the campus.

In 1901, Mills received an honorary doctorate from Mount Holyoke, her alma mater. When the still-active college president was eighty, the academic world united in sending congratulations. The trustees of Punahou testified, "She met and overcame obstacles with equanimity; she accomplished a great work with poor facilities; she drew her inspiration from the dull routine of a busy life." Even the American ambassador in London sent a personal message: "When I saw you at Mills College last spring, I understood the secret of your escape from the benumbing spell of old age."

Mills retired from the presidency in 1909 at the age of eighty-four. She died three years later in the house that she and her husband built on the campus, a Vermont cape house that today serves as the college president's home. Mills is buried beside her husband in a cemetery on the campus. The college art gallery is maintained by the endowment from the estate of Susan Mills.

KATHERINE SIVA SAUBEL (1920–2011)

NATIVE AMERICAN SCHOLAR

Katherine Saubel was a Native American activist, educator and author whose efforts focused on preserving the language and culture of her Cahuilla people. Her numerous awards include being the first Native American woman inducted into the National Women's Hall of Fame; first recipient of the Smithsonian Institution National Museum of the American Indian Art and Culture Award; and first recipient of the California Indian Heritage Preservation Award by the Society for California Archaeology. In 2002, she received an honorary doctorate in philosophy from La Sierra University in Humanities and Philosophy and was awarded the Chancellor's Medal, the highest honor bestowed by the University of California at the University of California–Riverside.

Katherine Siva Saubel. *Courtesy of Ira Nowinski, photographer.*

Saubel was raised on the Agua Caliente Reservation in Palm Springs, the eighth of eleven children. Her mother could only speak Cahuilla. In addition to the tribe's native language, her father also learned Latin, Spanish and English. When she was about five years old, she saw a white person for the first time. "I thought they were just painted that white. I didn't know, really, that it was their regular skin," she told Deborah Dozier, author of *The Heart Is Fire*, a history of the Cahuilla Indians.

When Saubel was a young girl, some children at school made fun of her, and she asked her father, "Why are they saying this to me?" Her father explained, "From the beginning, when they came here, they stole everything of ours; and now they refuse to know us. They don't really want to know us. That is why they are calling you those names." He went on to say, "The Cahuillas were great people, and the people that are making fun of you don't want to face it." The Cahuillas were in fact once among the largest Indian tribes that inhabited California. From her father, Saubel learned to take pride in her cultural heritage and native language while her mother, a Cahuilla medicine woman, taught her to take care of the earth "because it takes care of you, and if you destroy it, you are destroying yourself."

Saubel entered public school at the age of seven at a time when many Indian children caught speaking their native language were punished. "I would speak to them in the Indian language," Saubel later told an interviewer, "and they would answer me in English." After finishing primary school, she wanted to go to high school, but at the time there was none in Palm Springs. Her only option was to take a bus to Banning with white students until Palm Springs High School was completed. Saubel transferred and is believed to be the first Native American woman to graduate from Palm Springs High School.

While attending high school, Saubel had to wait at a bus stop on the reservation in front of a small restaurant that had a sign in the window that said "Whites Only." Never one to fear standing up for her people and their rights, she went into the restaurant and told the owner to take it down because his restaurant was on reservation land and he had no right to keep Indians out of a restaurant on their own land. According to the Malki Museum archives, the owner did not say a word when she told him this. Saubel thought he was shocked to have an Indian teenage girl confront him, but the next time she passed the restaurant, the sign had been removed.

In 1940, at the age of twenty, she married Mariano Saubel, who lived on the Morongo Reservation near Banning. Only a year and a half after they were married, their son, Allen, was born, and Mariano was drafted for World War II. During the three years that he served overseas, Saubel wrote to him every day. Her mother-in-law, a well-known Cahuilla basket maker, watched the baby while Saubel worked in the fields and orchards with her father-in-law. The couple remained married for forty-five years until Mariano passed away in 1985.

Concerned that the Cahuilla people were in danger of being forgotten, Saubel resolved to dedicate her life to preserving her culture. She memorized sacred songs that traditionally were performed only by Cahuilla men and wrote down the names of the plants and herbs she had learned from her mother while gathering with her. In 1958, Saubel was introduced to Lowell Bean, a student of ethnology and anthropology at UCLA. They worked together for ten years and coauthored *Temalpakh (From the Earth): Cahuilla Indian Knowledge and Usage of Plants.* Saubel was an expert on the unique Cahuilla uses of such plants as mesquite, screw bean, oak, acorn and others.

In 1962, Bean introduced her to Dr. William Bright, professor of linguistics and anthropology at the University of California–Los Angeles, and they collaborated on studies of the Cahuilla language. The Kennedy Scholarship

for Native Americans allowed Saubel, at the age of forty-two, to travel to the University of Chicago and the University of Colorado–Boulder, where she studied the fundamentals of ethnology, anthropology and linguistics. Under the direction of Dr. Bright, she became a lecturer at UCLA and served as coauthor with Professor Pamela Munro of a book about the Cahuilla language. Two years later, Saubel continued her language research with linguist Professor Hansjakob Seller at the University of Cologne in Germany, and they produced an authentic written translation of the Cahuilla language that had previously existed only in spoken form. Saubel also published her own dictionary and several authentic transcriptions and English translations of Cahuilla tribal lore.

In 1964, she and others co-founded the Malki Museum on the Morongo Indian Reservation in Banning, the first nonprofit museum on a Native American reservation, and served as its president. The museum displays artifacts dating from prehistoric to recent times and also publishes scholarly works on Native Americans from the region.

Saubel was appointed to numerous commissions and agencies. She served as a member and chairwoman of the Los Coyotes tribal council and the Riverside County Historical Commission, which selected her County Historian of the Year in 1986. In 1987, she was recognized as Elder of the Year by the California State Indian Museum. Governor Jerry Brown appointed her to the California Native American Heritage Commission in 1982. In this position, she worked to preserve California Indian culture and historical sites. She also testified as an expert on Native American culture and history to the California legislature and the United States Congress and was an acclaimed public speaker. In 1998, Saubel successfully brought electricity to the Los Coyotes Reservation in San Diego County, where she later served as tribal chairwoman.

Katherine Siva Saubel, preserver of Cahuilla culture, was instrumental in sharing the oral histories of her people with the rest of the world. She helped others to discover the culture and heritage of her own people and worked diligently to bridge the two worlds. In her own words, "Nobody wanted to know we were here. We were swept under the rug by non-Indian people who felt guilty about what had been done to us. So we were just a forgotten people, and now we can say we are still here and were here a thousand years ago." Saubel died in 2011 at the age of ninety-one.

Marilyn J. Boxer (1930–Present)
Founding Mother of Women's Studies

Marilyn Boxer has blazed her fair share of trails. She served as chair of the nation's first women's studies program, established at San Diego State University in 1970, and is the author of several books about women's history, including the first comprehensive account of a field that has become part of American higher education, *When Women Ask the Questions: Creating Women's Studies in America*. According to Boxer, women's history is not just a form of social history to be dismissed as the history of trivial things, such as how people dressed or furnished their houses. It is political history and fundamental to the major issues with which historians traditionally have been concerned.

Boxer was born in Kansas City, Missouri. Her father died when she was nine. "When I was about five, he had said one day, Marilyn will be a scholar. I had no idea what that meant; but it must have sounded good, for I remembered it all my life. And of course, he was right," she recalled. Boxer attended the highly regarded Southwest High School. The school prided itself on each year sending a few students east to the Ivy League. During her sophomore year, she was called into a counselor's office and told that she had been selected for what was called the Hundred Girls' Club, a group selected from all the high schools in Kansas City to be encouraged to go to college.

Boxer did succeed in winning a Seven Sisters scholarship to Wellesley College but dropped out

Marilyn Boxer. *Courtesy of the Special Collections, San Diego State University Library.*

prior to graduation "when told by a man that he couldn't live without me." By the beginning of the 1950s, she was a pregnant teenager, and by the 1960s, Boxer was in her second marriage and a mother of three, living in suburban comfort. "Raised by mothers who voted, we were encouraged by coeducation to expect equal opportunities, then we went home to produce the baby boom and fancy Jell-O molds," Boxer recalled.

In the mid-1950s, Simone de Beauvoir's book *Second Sex* helped Boxer to keep her "intellectual flame alive" and demonstrated that a woman's mind was capable of serious work in history and philosophy. A decade later, she was also influenced by Betty Friedan's bestselling book *The Feminine Mystique*. The year after Friedan's book appeared, Boxer's youngest child entered first grade, and she decided to return to college and complete her bachelor's degree. In 1964, the term "re-entry woman" had not yet appeared. At the advanced age of thirty-four, Boxer pleaded with a dean at the University of Redlands for readmittance as an undergraduate, and "fourteen years late and with three children in attendance," she earned her bachelor's degree "with distinction" in history.

Boxer viewed 1970 as the first year of her "self-definition." When she heard about a regional meeting of the National Organization for Women (NOW) being held in Los Angeles, she traveled there with a small group to attend her first organized feminist event. She was impressed that approximately four or five hundred women attended the meeting, and she heard presentations about lawsuits waged, often unsuccessfully, for equal employment opportunities and against unequal application of laws in matters ranging from education to prostitution. Included among the lessons that Boxer learned was that she was not alone in her dissatisfaction; women constituted a group or collectivity of some sort to which she belonged; and women were worthy of attention and assertive action on their own behalf.

Recently divorced, in a precarious financial situation and at the then unheard-of age of forty, Boxer decided to begin her doctoral studies. "Happily for me, one serendipitous effect of not starting doctoral studies until 1970 was that I caught a swelling wave of feminism," she later wrote. Among the limited choices of advisers at the nearby University of Riverside that she decided to attend, so as not to dislocate her children, was one who worked on French socialism. Boxer had the determination to reject dissertation topics that lacked her intrinsic interest and found her way to women's history. She traveled to Europe in 1972 and spent fifteen months gathering research for her dissertation topic, the relationship between socialism and feminism in France.

While still a graduate student, Boxer taught her first course as a "women's studies" instructor called women in history that was offered under the rubric of interdisciplinary studies at San Bernardino Valley College. The course syllabus stretched across the centuries from the Hebrew Bible to the contemporary women's liberation movement. "It was great learning and teaching such interesting—no fascinating—material to students who shared my passion for learning what had been missing from our education and mattered so much to our lives," she explained.

In 1974, Boxer was hired to teach women's history at San Diego State University (SDSU), appointed to the women's studies program and chosen to be the chair. In addition to her position, the faculty consisted of one other full-time professor and several part-time lecturers. As chair, she was responsible for all the student-related, curricular, personnel, financial and other activities of an academic program. In an edited book, *The Politics of Women's Studies: Testimony from 30 Founding Mothers*, Boxer described her early years as chair: "The SDSU program in its first four years had suffered almost continual conflict, internal and external, surviving ultimately both the mass resignation of its faculty and a recent vote by the administration on whether to terminate its existence or to try again."

Between fall semester 1974 and spring semester 1975, under Boxer's leadership, enrollment in women's studies rose 40 percent. Greater resources were invested in the program, and by 1980, faculty positions increased from 2.4 to 8.1. One day when she was running short on letterhead, Boxer asked her secretary to order new stationery inscribed "Department of Women's Studies," and the following year, the program's status was officially changed to the new name.

By 1983, Boxer moved from departmental to university leadership, first becoming associate dean and then, from 1985 to 1989, dean of the SDSU College of Arts and Letters. In 1989, she accepted a position as professor of history and vice-president for academic affairs at San Francisco State University. When asked why she left SDSU, she sometimes answers, "Tree hunger." "I love walking in the woods which are in short supply in San Diego but abundant in the Bay Area." A scholar trained primarily in modern European women's history and secondarily in modern American history, she is the author or coauthor of four books and has published numerous essays on women's history and women's studies, often crossing disciplinary lines in her research and writing.

Since 2003, Boxer has been professor emeritus at San Francisco State. She continues to be busy professionally, reading women's history with as much interest as she brought to it in 1970, attending conferences and writing.

Chapter 9

ARCHITECTS

California has a rich history of diverse architectural landscape and design styles. Throughout the meandering Pacific coast, there are unadorned adobe homes of early Spanish colonists, Arts and Crafts houses, mansions of entertainment moguls, innovative modernist architecture, weird futuristic structures and many other interesting building types. We live and work in them; we go to parks and sports arenas; we enjoy pubic gardens. But we probably do not take the time to reflect about the creative thinkers and designers who were responsible for these structures.

Until the early twentieth century, the building of California was left to the imagination of men. It was the rare woman who dreamed of designing residences and commercial buildings and creating communities. Apparently the hostility to women that was commonplace in the professions of lawyers and doctors was not as deeply ingrained in the fields of architectural design and urban planning. Although it was most unusual to see women architects, landscape designers, drafters and urban planners, it was not too difficult to get into the schools and earn degrees in their specialties. Quotas existed until after World War II, but it did not take lawsuits and years of court actions to gain admission.

When women entered these occupations, they did it with a flourish and achieved major commissions early in their careers. Julia Morgan, the first woman architect in California, designed the Hearst Castle and all the surrounding structures. For a young woman to have secured the confidence of William Randolph Hearst is an amazing accomplishment. Following Morgan at Berkeley was Lilian Rice, an early environmentalist and

Sketch of residence for Mr. D.M. Richards, Lilian Rice, architect. *Courtesy of the San Diego History Center.*

proponent of the "original architecture ideal" and the importance of planned communities. She was responsible for the total design and construction of the famous Rancho Santa Fe community in San Diego County. Then there is Florence Yoch, one of the first woman landscape architects in California chosen to design the gardens for five major movie sets, including *Gone with the Wind*, plus create the gardens of many famous Hollywood celebrities. It took Norma Merrick Sklarek, an African woman, until 1954 to become the first black woman licensed architect in California and New York. She founded one of the largest all-female-owned architectural practices in the United States. With this company, she had the distinction of being the first African American woman to own an architectural firm.

JULIA MORGAN (1872–1957)
FIRST WOMAN ARCHITECT

At the mere mention of the world-renowned Hearst Castle in San Simeon, California, images of magnificent architecture, pools and gardens come into the mind's eye. Another structure that also conjures a lovely vision is the detailed and intricately designed Fairmont Hotel in San Francisco. If one were asked to picture the architect who designed the castle and restored the hotel, most likely it would be a male figure. That assumption is incorrect. The *woman* who is responsible for the design of these structures and seven hundred more is Julia Morgan, the first woman architect in California, first woman graduate in the University of California–Berkeley civil engineering program and first woman permitted to attend the influential art school École

Berkeley City Club, Julia Morgan, architect. *Courtesy of the Landmark Heritage Foundation/Berkeley City Club Image Archive.*

des Beaux-Arts in Paris. Morgan was one of the most significant architects in the early twentieth century and a trailblazer for women in civil engineering and architecture. She was a legend unto herself in California structural design history.

Born in San Francisco in January 1872 to Eliza and Charles Morgan, she was the second of five children. Her parents, originally from New England, moved to California to ensure their children received quality educations. As a child, Morgan's family described her as being headstrong in addition to ambitious and intelligent. While growing up, she expressed an interest in building design and construction. Fortunately, her parents were open-minded and of upper-middle-class status and had the means to encourage her curiosity. A major influence during her youth was Pierre LeBrun, a cousin by marriage and a well-known New York architect, whom she visited may times on the East Coast and who encouraged her interest.

After graduation from Oakland High School in 1890, Morgan attended the University of California–Berkeley. Berkeley, however, did not have a school of architecture; consequently, Morgan enrolled in the College of Engineering to pursue her architect and design interests. Since she was the first woman to attend the school, she was unfortunately the target of taunting and discrimination from fellow male students. Morgan, however, was confident enough not to be disturbed by their boorish behavior, and she knew she had the support of many admiring professors.

In her senior year, Morgan met Bernard Maybeck, a luminary of American architecture who was to become her mentor and close colleague. She was captivated by his designs and philosophy of architecture, and her

future work reflected his concept that "houses should look as if they grew on the land." Maybeck recognized her exceptional talent and encouraged her to apply to the École des Beaux-Arts. After graduation, Morgan applied but was denied entrance because the school did not accept women. She applied a second time but failed the entrance exam. In a letter, she claimed that the school had deliberately failed her because she was a woman. Two years later, she passed the entrance exam and was admitted to the architecture program, placing 13th out of 376 applicants. Morgan was the first woman to graduate with a degree in architecture from this internationally celebrated school.

Training with Maybeck in the Arts and Crafts design, combined with the traditional training in classical styles and designs at the École, gave her the skills to eclectically develop and create expert work in many styles. To her advantage, her engineering degree provided her with the ability to determine whether her creative designs would work. Others recognized her immense talent, and at the age of thirty-four, she was commissioned to reconstruct the Fairmont Hotel that had been destroyed in the earthquake in 1906.

Upon graduation from the École des Beaux-Arts in 1901, Morgan returned to the Bay area and went to work for architect John Galen Howard, who was supervising a project commissioned by Phoebe Apperson Hearst. Howard assigned Morgan to work on drawing the elevations and designing the decorative details for the Mining Building built in memory of George Hearst. She also designed the Hearst Greek Theater on the Berkeley campus. This was Julia Morgan's introduction to three generations of the Hearst family.

Morgan aspired to establish her own company, so she took the state licensing exam in 1904 and became certified to practice. One of her first residential commissions was to remodel Phoebe Hearst's Hacienda del Pozo de Verona. Using the Arts and Crafts style that became her defining technique, she exposed support beams, used horizontal lines that blended with the landscape, made extensive use of shingles and incorporated the California redwood and earth tones.

During the fifty years of her long and brilliant career, Morgan designed over seven hundred structures, including the bell tower on the campus of Mills College in Oakland, a structure that withstood the great 1906 San Francisco earthquake; the Asilomar Conference Center; and hundreds of residences, churches, clubs, banks, schools, hospitals and large retail stores. Some of her residential projects may be categorized as ultimate bungalows and express the Arts and Crafts movement in the American Craftsman style of architecture. However, her signature commission is the Hearst

Castle in San Simeon. Ms. Hearst introduced Morgan to her son William Randolph Hearst. One day while speaking with Morgan, Mr. Hearst made an unpretentious request: "Miss Morgan, we are tired of camping out in the open at the ranch in San Simeon, and I would like to build a little something that would be more comfortable than the platform tents" that he previously used at the ranch. With these few words to Julia Morgan, history was made.

For the next twenty-eight years, Morgan supervised nearly every aspect of construction at Hearst Castle, including the purchase of "everything from Spanish antiquities to Icelandic Moss to reindeer for the Castle's zoo." She was responsible for most of the structures, grounds, pools, animal shelters and workers' camp, down to the smallest feature. Morgan and Hearst worked closely during the almost three decades of construction, and Morgan was forever designing and redesigning. Hearst would decide on one design for a room and change his mind so that Morgan had to revamp completely around his new specifications. During his travels, he would send home complete walls and ceilings to be used in particular rooms. She continued working on this project until Hearst encountered financial problems in the mid-1940s and production on the castle came to an end. Although Julia Morgan's work was completed at the castle, the castle itself was never fully finished the way William Randolph Hearst had envisioned it. Today, the official name of the 90,080-square-foot estate is the Hearst San Simeon State Historical Monument.

Morgan was an exceptionally versatile designer and was able to move effortlessly from project to project and style to style, a talent her clientele appreciated. It was not unusual to see Morgan climbing scaffolds and descending into trenches in her skirts to ensure each detail's perfection. She would spend weekends at San Simeon and during the week work on the numerous projects for which she was commissioned. Gifted with an incredible eclectic talent, it was easy for her to work from an immense repertoire of architectural styles to produce unique designs. Morgan had a very specific philosophy: design a structure that works well with its surroundings and pleases the client. Her structures are noted for her client-centered approach to design, her use of indigenous available materials and her integration of diverse styles. Julia Morgan was a "client's architect," admired for detailed artisanship and her ability to shape a project to meet the emotional and financial needs of the client. She was tireless. A young staff member noted, "All her life was work—morning, day and night." She worked harder and longer than any of them and still was able to endure. Having no close relatives, her staff and their families became her family.

She was a generous and kind boss who did not hesitate to help when one of them needed something. When she closed her office, Morgan shared all her profits with her staff.

Morgan received an honorary doctorate from her alma mater, the University of California–Berkeley. One of the few honors she accepted, the degree states:

> *Distinguished alumna of the University of California; Artist and Engineer; Designer of simple dwellings and stately homes, of great buildings nobly planned to further the centralized activities of her fellow citizens; Architect in whose works harmony and admirable proportions Bring pleasure to the eye and peace to the mind.*

She carefully preserved all of her papers, sketches, architectural plans and drawings. These were donated by her family to Cal Poly–San Luis Obispo and are housed in the Special Collections Department of the Robert E. Kennedy Library. Julia Morgan died on February 2, 1957, and is buried in the Mountain View Cemetery in the hills of Oakland, California. In December 2008, she was inducted into the California Hall of Fame, located at the California Museum for History, Women and the Arts in Sacramento.

As California's first woman architect, Julia Morgan triumphed over gender barriers at home and abroad and has been a model and inspiration to generations of young women to pursue their dreams.

LILIAN JEANETTE RICE (1889–1938)

REGIONAL ARCHITECTURE PIONEER

Lilian Rice's official biographer described her as the model modern woman one hundred years ago. Although she developed the internationally renowned community of Rancho Santa Fe in San Diego County, California, she was not a widely recognized architect until she was "rediscovered" by writer and biographer Diane Welch. During her lifetime, Rice was well known in San Diego for her interpretation of Spanish Revival architecture, and several of her structures are listed as national or local historic landmarks, including ten homes in Rancho Santa Fe. In her University of California yearbook, she was described as "the very model of serious young womanhood fulfilling the promise of education and professional status so long denied her sex."

Lilian Jeanette Rice. *Courtesy of the Rancho Santa Fe Historical Society.*

Lilian Jeanette Rice was born in 1889 in National City, California, to Laura and Julius Rice, parents who valued education and creative thinking and design. Julius Rice was an educator in the San Diego and National City school districts. He and Laura Rice, an artist, encouraged their daughter to seek a career outside the realm of the of accepted "women's" professions of that era. Rice was characterized as a determined woman with a warm and vivacious personality. Her eyes best described her nature: "Their large, downward slant evoked a visionary quality that foreshadowed the dreamer inside."

Influenced by her parents, Rice enrolled at the University of California–Berkeley for a degree in architecture. She was extremely fortunate to have attended Berkeley while it was under construction and, thus, was able to experience the entire design development under the direction of John Galen Howard, director of the School of Architecture. He combined eastern and European designs with the rugged Northern California landscape to produce an original architecture fitting to its environment. Rice's exposure to this new style of architecture deeply influenced the evolution of her philosophy. After graduating in 1910, she spent the following year earning a teaching certificate to supplement her architectural work.

Rice returned to San Diego and started work as a draftswoman for Hazel Waterman, a local well-respected designer who trained with Irving J. Gill, perhaps the foremost architect of that era. During this period, the Waterman firm worked on projects where Rice learned about the adobe brick building methods of the 1830s. This design influenced her throughout her professional career, and she developed a deep respect for Southern California's heritage, landscape and diversity of topography.

While working as a draftswoman, Rice taught math at the high school level and later mechanical drawing and descriptive geometry at San Diego State Teacher's College, now known as San Diego State University. She also had a great affection for the theater and enjoyed performing. She was obviously talented since she received recognition as an actor in local San Diego productions.

In 1920, Richard Requa, a celebrated architect, recruited Rice to join his firm, Requa and Jackson, as a part-time associate. Requa, who had traveled extensively throughout Spain, was enamored with Mediterranean architectural styles and believed these designs were very suitable to the Southern California landscape. It was through her association with Requa that Rice again discovered the ideal of an "original architecture." She valued the romantic tradition built around California's mission days and the vast ranchos that dotted the Southwest.

Not long after Rice started working with the firm, the company received a commission to design and supervise the construction of a nine-thousand-acre tract of land for a planned development in north San Diego County. Requa selected Rice to lead the project that eventually came to be known as Rancho Santa Fe. Rancho Santa Fe began as the San Dieguito Land Grant and from its founding in the 1830s was recognized for its great beauty and historic tradition. In 1906, the Santa Fe Land Improvement Company, a division of the Santa Fe Railroad, purchased the San Dieguito Land Grant and changed the name to Rancho Santa Fe. After a failed experiment to grow eucalyptus trees and use the wood for the rail ties, the vice-president of the railroad decided to subdivide the area into several hundred tracts for country homes and orchards. He was adamant that the Spanish colonial heritage of the area be maintained and that a permanent horticultural development be created. It was up to Rice to carry out this wish and preserve the area's character and design it as a monument to California's history.

From 1922 through 1927, Rice worked the fourteen-mile expanse as city planner, landscape architect and construction supervisor, creating an environmentally sensitive community. It was a complete village composed of the famous The Inn at Rancho Santa Fe, a school, shops, a library and many lovely residences and service buildings. Rice had her own office in the covenant under her own name, and she eventually built a permanent home at The Inn at Rancho Santa Fe called the Wisteria Cottage. One of her first challenges occurred in 1923, when the truckers went on strike. Without the trucks, construction would have halted. Rice was not about to let this happen, so she and other women who were working on the property drove

the trucks and kept the building materials moving. From all accounts of Lilian Rice, this was typical of her character.

An exceptional sense of artisanship and attention to detail were indicative of Rice's skills as an architect. The exterior designs illustrate her desire for a building's appearance to always "conform to the setting of nature." In a 1928 architectural journal, she wrote, "I found real joy at Rancho Santa Fe. Every environment there calls for simplicity and beauty—the gorgeous natural landscapes, the gently broken topography, the nearby mountains." The environment and the preservation of natural beauty were of utmost importance to her. As an early environmentalist and a proponent of architecturally controlled communities, she believed that "without control, the heritage of natural charm that nature gave…was further disfigured, instead of being enhanced."

Being completely involved with every aspect of the community, her clients appreciated her sensitivity and wanted their homes to reflect the warmth and simplicity of her designs. Rice believed as a woman architect she had a unique advantage in being more attuned to the needs of her clients and was therefore able to reflect these needs in their living spaces. In 1928, the Rancho Santa Fe Association was formed with the express purpose to ensure the protection of the community and preserve the natural landscape and environment. This was a testimony to Rice's belief in architecturally controlled communities and her vision that Rancho Santa Fe would be a model for future developments. Rice was selected as a member of the first board of directors of the association, which remains active today and controls all building and landscaping activity related to property within the covenant. Her mark on Rancho Santa Fe is indelible.

In 1929, Rice left Requa and Jackson and established her own thriving architecture firm. She designed some outstanding residential and commercial structures outside Rancho Santa Fe, including the Arnberg House and Zlac Rowing Club, both of which received design awards by the San Diego Chapter of the American Institute of Architects. She worked until her sudden death in December 1938 at the young age of forty-nine.

From newspaper accounts and interviews with former colleagues and students, there was consistent praise for her craftsmanship and teaching techniques, and they also praised Lilian Rice the person as having a sparkling personality and enjoying life. She combined both work and fun and was a master at both. Her biographer Welch noted, "Rice's life is important because she was a pioneer as a female architect, not only surviving but thriving in a male dominated profession during the Great Depression."

FLORENCE YOCH (1890–1972)

LANDSCAPER OF AMERICAN DREAMS

The images of landscape architecture elicit pictures of lovely gardens and fragrant blooms with a feminine touch. In the early twentieth century, however, many talented men dominated this occupational field. Then there was Florence Yoch, an outstanding and highly respected garden designer and one of the few female professionals. She was one of the most original and imaginative American landscape architects of the century. As a distinct figure in the history of American landscape design, Yoch's gardens were widely acclaimed in the western United States. When she established her professional garden design business in 1918, she probably never thought she would be designing homes for celebrity figures and movie sets for some of the most memorable movies in Hollywood's history.

Yoch, born in 1890, grew up in an affluent family in Santa Ana, California, a suburb of Los Angeles. She studied at the University of California–Berkeley, Cornell University and the University of Illinois–Urbana-Champaign, where she completed a degree in landscape architecture. Over a span of more than fifty years, Yoch created 250 projects from Coyoacan, Mexico, to Carmel, California. With a passion for travel, she made annual visits to Europe to study the formal gardens. As a student of these European gardens, she expertly adapted their decorum of the traditional to the casual southwestern environments. Her gardens reflected the lifestyle of her Southern California clients and ranged from the conventional Pasadena homes to the more

Florence Yoch. *Courtesy of Dr. James Yoch.*

flamboyant Hollywood estates. Yoch's work encompassed a broad range of landscape types from botanical gardens, magnificent estates and public courtyards to parks and movie sets.

As she was establishing herself in this male-dominated profession, Yoch met and hired Lucille Council, another female landscape architect. They developed a professional and personal relationship that lasted until Council's death in 1964. Although it was not an openly acknowledged lesbian relationship, it did pose a risk to their professional careers. However, their talent was so sought after that their personal life never inhibited or interfered with their success. As life partners, they created magnificent gardens including the Howard Huntington Estate, the Getty House, Rancho Los Alamitos and what is now the campus of Cal Poly–Pomona. One of their most popular California garden designs is the Il Brolino estate garden, which epitomizes their style of bringing an elegant look to contemporary California gardens. Yoch was devoted to ensuring that her designs reflected the individual lifestyles of her clientele. She preferred that gardens suit their owners' lives. She wanted her plans to accommodate modern restraints on labor, space and water and to serve as models for the late twentieth century.

James Yoch, a professor of English at the University of Oklahoma, documented his cousin's work in *Landscaping the American Dream: The Gardens and Film Sets of Florence Yoch, 1890–1972*. An exhibit that he assisted to curate at the Huntington Library in 1997, titled "Personal Edens: The Gardens and Film Sets of Florence Yoch," noted that Yoch's practice and the shared distinction of owning one of her gardens "united a network of friends and clients across Los Angeles by overcoming divisions of geography and social background." The communities of Los Angeles and Pasadena were very different in their living styles, but Yoch was able to work in both, one of the only designers to have the talent and personal style to achieve this. Many of these gardens were designed for "settlers," those who moved west for the lure of the climate and the lovely hills. As Professor Yoch noted, "She transformed desert hills and plains into the places of dreams of beloved homes left behind or those that had always been wished for."

Yoch genuinely liked many of her clients, and they in turn felt the same about her. Many successful women commissioned Yoch to design their gardens, such as Dorothy Arzner, the first female movie director, for whom she designed a Greek temple garden. Arzner introduced Yoch to the movie industry, and thus she became the first woman landscape architect to design movie set gardens. Her clients included Hollywood figures such as producers Jack Warner and David O. Selznick and director George Cukor.

Yoch created the landscape designs for Tara in *Gone with the Wind* and the Capulet garden set in *Romeo and Juliet*. As noted in the Huntington Library exhibit, "The films on which Yoch worked were all derived from literary sources. Rejecting flamboyant individualism, her designs suited movie themes emphasizing the redemptive power of a well-organized domestic world." To ensure the originality of the desert oasis of Algiers for *The Garden of Allah*, she traveled to Africa to do research and spent time in Georgia for *Gone with the Wind*. For *The Good Earth*, she transformed the San Fernando Valley hills into rice fields, and in *How Green Was My Valley*, she made ten thousand daffodils bloom for the filming of the hero's recovery. James Yoch wrote, "Her gardens and film sets seem simple and photogenic at first glance, yet her landscape pictorialism fulfilled the movie maker's call for stunning visual effects." The budget for the garden design for Tara, created on a studio set and not on location, was an amazing $16,000 at the end of the Depression era.

After the Depression and World War II, Yoch simplified her designs and made gardens easier to maintain for the workers who were installing and caring for them. She took great pride in her designs and wanted her gardens to remain healthy and beautiful. Therefore, she would often include a detailed set of instructions and gardening calendar for her clients to follow. As times changed and suburbs grew, she began to emphasize pools and tennis courts and had a more American architectural quality to her work. She replaced lawns with fields of barley, alfalfa and African grass. She once admonished a friend, "Do not work against local conditions and spoil the genuine desert-country-ranch look."

Yoch and Council settled in the Monterey Peninsula in 1960. After Council's death in 1964, Yoch continued to work until 1971, one year before she died at age eighty-two. James Yoch wrote of Florence Yoch, "The complex harmonies of her personal Edens bridge divisions in city and state and join their owners to larger communities, new cultures, and venerable times. In each landscape, she told many stories to enlarge American dreams."

NORMA MERRICK SKLAREK (1928–2012)

ROSA PARKS OF ARCHITECTURE

Norma Merrick Sklarek, celebrated as the "Rosa Parks of Architecture," broke the glass ceiling of a white male–dominated industry when, in 1954, she passed the New York State examinations to become the first African

Norma Sklarek. *Courtesy of the UCLA Charles E. Young Research Library Department of Special Collections, Los Angeles Times Photographic Archives, © Regents Courtesy of the University of California, UCLA Library.*

American woman licensed architect in New York and the United States. There were many firsts for this spectacularly gifted and entrepreneurial spirited woman. Sklarek would be the first to say it was not an easy road on which to start a career. She said, "Until the end of World War II, I think there was strong discrimination against women in architecture. The schools had a quota, it was obvious, a quota against women and a quota against blacks. In architecture, I had absolutely no role model. I'm happy today to be a role model for others that follow."

Sklarek was born in April 1928 in New York City to Amy Merrick and Dr. Walter Merrick, both of West Indian heritage. The country was in the midst of the Great Depression, and she remembers her father working for little or no pay tending to his patients in their neighborhood. Growing up in this economically difficult environment helped Sklarek develop a sense of responsibility and individualism that became the building blocks to her successful career. Being an only child, she reaped the benefits of having devoted parents who encouraged her passion for the visual arts. She would draw whatever was available. She painted murals, sketched her relatives, decorated her room and refinished and painted furniture. In an interview for the book *No Mountain High Enough: Secrets of Successful African American Women*, she told author Dorothy Ehrhart-Morrison, "I did lots of things with my father that ordinarily girls did not do—like going fishing, painting the house, and doing carpentry work."

Most of Sklarek's education was in predominantly white elementary and high schools attended by highly intelligent and competitive students. With her excellent skills in mathematics and science, she could have chosen from

numerous professions. Nothing really seemed to spark her curiosity until her father suggested architecture, a profession about which she knew very little except that it incorporated her interests. His suggestion led her to enter Barnard College, part of Columbia University. In her freshman year, she took courses in preparation for applying to the Columbia University School of Architecture. It was not a secret that the School of Architecture had quotas and only admitted a few women each year. Sklarek noted, "The school did not want to waste space on women. They felt that women would get married and return home to have children." Sklarek, the youngest in the class, was competing with older mature students who were veterans and others who had already earned their bachelor's and master's degrees. However, four years later, she graduated and passed the grueling four-day licensing exam on her first try. Thus, Norma Sklarek became the first African American female licensed to practice architecture in the United States.

Degree in hand, she was about to embark on one of the biggest challenges of her life: finding a job. She began to apply for jobs, many jobs. Twenty different firms rejected her applications before she was finally hired for an entry-level position. In a video interview, she was gracious to say she did not know if she was rejected because she was a black person, a young woman or because the economic conditions at that time were very dire. It was in the 1950s, before equal-opportunity legislation, and was a difficult time for her.

Finally, Sklarek was hired by Skidmore, Owens, Merrill, one of the preeminent architecture firms in the country. She spent four very productive years there and was respected and acknowledged for her talent. Her professional life was going well, but her personal life was falling apart. Sklarek married, had two children, was divorced and became a single working mother of two young boys.

Deciding she needed to move on to another phase in her personal life and career, she relocated to Los Angeles and joined the prestigious architectural firm of Gruen and Associates. She became the first African American woman licensed in the state of California, and it would take another twenty years until another black female achieved that status. Sklarek flourished at Gruen and, six years later, was named the first female director of architecture, a position in which she supervised dozens of other architects. She remained at Gruen for twenty years and during that time headed many award-winning projects. Sklarek left Gruen in 1980 and joined Weldon Becket and Associates, where she was appointed vice-president and oversaw the design and development of Terminal One at the Los Angeles International Airport. It was a tremendous accomplishment, and the timely completion

of the terminal for the 1984 Olympics was attributed to her professional expertise and tenaciousness.

A defining moment in her career was when she co-founded Siegel-Sklarek-Diamond, one of the largest all-female-owned architectural practices in the United States. With this company, she had the distinction of being the first African American woman to own an architectural firm. After four years, she left the firm, not happy with the small size of the projects and worried about the liability of owning such a large company. She became a principal at Jared Partnership in 1989 and remained until 1992.

Sklarek was involved in comprehensive architectural pursuits in addition to her office practice. She taught architecture at both the University of California–Los Angeles and the City College of New York. She was named a fellow of the American Institute of Architects (AIA), becoming the first woman in the organization's Los Angeles chapter and the first black woman to achieve that honor nationally. Sklarek authored several articles, including "Women in Architecture" for the *Encyclopedia of Architecture & Construction*, and has an architecture scholarship in her name at Howard University. She was featured in a video presentation, *I Dream a World, Portraits of Black Women Who Changed America*, and *African American Architects in Current Practice*, where she talks about her training and career.

Sklarek chose architecture as her life's career at a time "when racism and sexism reigned with impunity in the organizations and institutions of the nation." She was able to overcome this discrimination with her exceptional talent and has had an incredibly successful career as the first African American women in her field. She spoke candidly about the challenges and discrimination she encountered early in her career. During an interview for *No Mountain High Enough*, she recalled learning that her former supervisor gave her a scathing evaluation. "He said that I was lazy, that I knew nothing about design and architecture, that I socialized, and that I was late every day…It taught me that it is possible to work next to somebody and not know that they hated you. It had to be personal. He was not a licensed architect, and I was a young kid. I looked like a teenager, and I was black and a licensed architect." Norma Sklarek became successful in spite of the prevalent discrimination she faced.

Of the approximately 120,000 licensed architects in the United States, about 1,814 of them are African American. Only 274 of the 1,814 are women. Sklarek has helped cultivate that transformation, but there is still a long road ahead for more African American women to become architects. Norma Sklarek passed away in early 2012, leaving her mark as a trailblazer and model.

Chapter 10

ENTERTAINERS

From the early gold rush era to the present day, entertainment was a venue for women to shine. Female entertainers were the first group of successful women to capture the public eye, taking to the stage in vaudeville and film and redefining their place in society. As June Sochen notes in her book *From Mae to Madonna: Women Entertainers in Twentieth-Century America*, women did whatever it took, from dancing on Broadway and falling on bananas in silent films to wisecracking in smoky clubs, as well as becoming the modern icons of today's movies and popular music, to get their names in lights. These many talented women have entertained millions of people in the United States and the world in all genres from burlesque to the silent films, talkies, the stage and television. Women entertainers not only defined themselves through performance, but they also defined our culture in whatever medium they have chosen, including directing, acting, writing and studio ownership.

During the last half of the nineteenth century, concurrent with the gold rush was the advent of the entertainment industry. With the gold miners came the actors, and saloonkeepers who realized the value of entertainment for the lonely miners installed theaters in saloons for their patrons. Eventually, real theaters were opened in Sacramento and San Francisco where traveling players who were the backbone of entertainment were able to perform. The paragon of the gold rush theater was little Lotta Crabtree, the spirited redheaded six-year-old sprite who performed all over the West and was the first American superstar.

At the turn of the century, filmmaking as an industry started to flourish. Female actors played a critical part in the development of early film and in

Dancers in front of Lyceum Theatre. *Courtesy of the San Diego History Center.*

the Hollywood star and studio systems. Because they were more popular and more in demand than male actors, early female stars were a significant force in the growth of this nascent industry. Their popularity translated into greater control of their acting roles, as well as what occurred in the creative and business components of the industry.

Three of the women in this chapter were closely associated with the burgeoning film industry in Hollywood, the locale made famous with the establishment and growth of movie film production. Hollywood is the historical center of movie studios and stars, and the word "Hollywood" is synonymous with the American film and television industry. In 1853, one adobe hut stood on the site that became Hollywood, but by the early 1900s, it had become a popular setting for the major film industries from the East. The weather and natural sunlight were most conducive for filming, along with open spaces and a wide variety of natural scenery. In early 1910, D.W. Griffith was sent by the Biograph Company to the West Coast with his acting troupe to shoot the first movie in Hollywood. He was a major force in the development of the movie production studios and is associated with several of the women in this chapter. Along with Griffith on this trip was Mary

Pickford, soon to be the most famous star in the country and also the first female owner of a film production company. Also associated with Griffith was Madame Sul-Te-Wan, the first African American female actor to sign a contract with a major movie studio and to be a featured performer.

Directing was an aspect of the industry that was more challenging for a female in the early years of Hollywood, but Dorothy Arzner learned how to fit in and overcame that barrier to become one of the most prolific and talented directors of the golden era of Hollywood. Arzner, unfortunately, was all but forgotten until she was rediscovered in the 1970s in a project of feminist film studies.

There were many women entertainers who excelled in their area of expertise, and it was difficult to select the four presented in this chapter. However, it is hoped the reader will agree that Crabtree, Sul-Te-Wan, Arzner and Pickford were trailblazers who opened up new opportunities for women to be involved in all aspects of entertainment and were sought out not only for their appearance but also for their work as actors, directors and executives.

LOTTA CRABTREE (1847–1924)

FIRST AMERICAN SUPERSTAR

Lotta Crabtree, the original golden girl of the emerging entertainment industry, was known by many terms of endearment, including the nation's darling, the eternal child, the fairy star of the gold rush and the California diamond. To the early residents of the gold rush era, however, she was just "our Lotta," one of the most beloved entertainers of the last half of the nineteenth century. Lotta was introduced to dancing and performing by none other than the infamous Lola Montez, inventor of the "spider dance" and courtesan of Ludwig I of Bavaria and Franz Liszt, among others.

Crabtree was born in New York City in November 1847 to British immigrant parents. Her father, John Ashworth Crabtree, a bookseller, went to California in 1851 in search of gold, and a year later, Crabtree and her mother, Mary Ann, followed him. When they arrived in San Francisco, John Crabtree was nowhere to be found, so they stayed with friends. It was during this time that Crabtree was introduced to the theater and took her first dancing classes.

A year later, the family moved to Green Valley, California, where John Crabtree was living and had a boardinghouse for gold miners. It was here

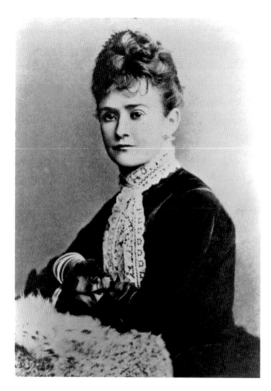

Lotta Crabtree. *Courtesy of the Searls Historical Library.*

that Lotta Crabtree met Montez, who, as legend has it, took her to a local tavern to perform. Crabtree was an instant success with the mining crowd, and thus began the official career of America's first superstar, the Shirley Temple of her day. Mary Ann Crabtree, a classic stage mother, managed Lotta Crabtree's career and finances until the day she died.

Crabtree and her mother toured the gold-mining cities, with Crabtree entertaining the miners who adored this six-year-old redhead frolicking, dancing, singing and playing the banjo. They showed their appreciation by showering her with gold nuggets, coins and gold watches that Mary Ann Crabtree quickly amassed in her apron. The gold eventually became too heavy to carry, so they put it in a steamer trunk that they took with them as they traveled from town to town. Mary Ann Crabtree, clever entrepreneur that she was, used this gold to purchase real estate, horses and bonds wherever they toured. She would walk the streets dressed in all black looking for investments. Lotta Crabtree was on her way to becoming a millionaire with a fortune eventually worth more than $4 million. Today, that would be equivalent to $46 million.

In 1856, the family moved back to San Francisco, and by the age of nine, Crabtree was affectionately known as "Miss Lotta, San Francisco's Favorite." She developed a devoted following as she continued touring the gold fields, often performing exhausting one-night stands. The people of San Francisco were so enchanted with this exceptionally talented, barely five-foot-tall beauty that they presented her with a solid gold wreath and a package of twenty-dollar gold pieces before she left for a cross-country tour in 1864.

Crabtree's debut in New York was only moderately successful, but upon return a year later, she was a tremendous sensation. She performed in many shows and was the belle of the ball. The *New York Times* described her as having the "face of a beautiful doll and the ways of a playful kitten." With her petite size, she became a favorite for her portrayals of children and famous for her endearing, infectious joviality and occasionally risqué manner. She was a bit of a rebel and quickly learned that being bolder would appeal to her audiences. When she said "damn it" on the stage, the New York clergy objected, the media loved it and she was off to being a superstar.

During the next two decades, Crabtree became the highest-paid entertainer and a household name throughout the United States. Theaters were sold out, she was mobbed wherever she performed and the people could not get enough of this vivacious, giggling personality. At a standing room–only performance in London, there was such a clamor to see her that a riot broke out. Since her plays were written solely for her, she had the liberty to interpret and improvise as she wished. Not only were the audiences always laughing, but so was Crabtree. Lotta's performances were always played for laughs—the unbelievable plots were only frameworks by which amusing scenes, songs and dances were combined into an evening's entertainment. She became well known for her thin black cigars, dressing in men's clothing and tomboyish demeanor.

Although Crabtree had many admirers, she never married. She was one of the most sought-after women in America, and smitten young men would unhitch the horses from her carriage and pull her to the theater. However, from her adolescent years on, her mother kept the suitors at bay, earning her the not-so-flattering title of "Lotta the Unapproachable." So intriguing was the love life of Crabtree that the *New York Times* devoted a front-page story to it in 1883. Her admirers included General William T. Sherman, the Grand Duke Alexis of Russia and President Ulysses Grant, who first saw her perform in the 1850s in Eureka. All were enamored of her girlish style, magnetism, disarming naiveté and reputed "most beautiful ankle in the world," which she would poke out of the curtain at the end of shows.

Amazingly, to the end of her performing days, Crabtree was able to maintain her youthful appearance and was still able to play children's parts. She retired at the age of forty-three, apparently because of an injury, and went to live in New Jersey in a twenty-two-room house purchased by her mother. However, living among millionaires was not her style, and she was never accepted by them. They eschewed her black cigars and short skirts and did not consider her a "proper" lady for the society clubs, much to the

chagrin of her mother. Crabtree found this existence utterly boring and, after her mother's death in 1905, did not return to the estate. She became very despondent and lived as a recluse. Her mother was so central to her life that she unsuccessfully sought to have her sainted.

Crabtree spent the remaining years of her life at the Brewster Hotel in Boston that she had purchased and often was seen painting seascapes in Gloucester and Rockport, Massachusetts, with a cigar in her mouth and a dog at her feet. Although she lived as a recluse, she shared her wealth. Money was central to her existence, but she was a serious philanthropist and held many deep convictions. She advocated for women's rights, aging actors and animal rights and became a vegetarian before the word was commonly used. She was one of the first women to own and drive her own car and was quite a sight driving it. She called her car the "Red Rose" and was quite a spectacle when seen driving it around. Crabtree was a modern woman and a trailblazer in the true meaning of the word.

Lotta was very particular when making out her will and made a lot of "friends and relatives" unhappy by giving about half of her fortune to charities for things as "anti-animal experimentation," "trust to provide food, fuel and hospitalization for the poor," "help for released convicts," "support for poor, needy actors," "aid to young graduates of agricultural colleges" and "relief for needy vets of WWI," as well as instructions to place beautiful drinking fountains for animals and people throughout the country. Many of her funds and trusts are still operating today. Her will was contested by no fewer than seventy-seven persons and was eventually settled with great fanfare and much coverage in all the local newspapers.

Crabtree died in 1924 and was buried next to her mother in the family plot in Woodlawn Cemetery in New York City. She was the undisputed sweetheart of the California gold rush, a pioneer in the art of burlesque and had been the "cause of more merriment than almost any other entertainer of her time."

MADAME SUL-TE-WAN (1873–1959)

PIONEER BLACK ACTRESS

Madame Sul-Te-Wan, known as the "mysterious black actress," had a career that spanned more than five decades. She played a pioneering role in the early history of cinema by becoming the first black performer—male or female—to

Madame Sul-Te-Wan. *Courtesy of the Margaret Herrick Library.*

sign a contract with a major movie studio and to be a featured performer. Although her name is not that familiar to film aficionados, she played alongside such stars as Mammy Beulah, Lucille Ball, Claudette Colbert, Rock Hudson, Harry Belafonte and Sidney Poitier, to name a few. Wan was the first black woman contracted to appear in a feature film in one of the most controversial movies in American cinematic history, *Birth of a Nation.*

Madame Sul-Te-Wan, née Nellie Crawford, was born in Louisville, Kentucky, in 1873 to Cleo De Lonsa and Silas Crawford, former slaves. Her preacher father, whom Wan described as having "the Bible in one hand and all the women he could get in the other," abandoned Wan and her mother when she was a young child. Cleo De Lonsa supported her family by working as a laundress for performers in Louisville's Buckingham Theatre, employer of famous actors of that era. Wan knew early on that

she wanted to be on stage and act. She would carefully watch the actors performing, and the following day, she would rehearse the act at school in front of classmates. At the age of six, she made her own debut with a "buck and wing" dance and even won a granite pot and spoon for her adorable performance. Precocious describes her well. At eight years old, she was so bold that she tried to run away and join the circus. That, of course, did not work. When she was older, she moved to Cincinnati, billed herself as "Creole Nell" and joined a troupe called Three Black Cloaks. She later formed her own musical performing companies, the Black Four Hundred, which had sixteen performers and twelve musicians, and then the Rare Black Minstrels. Both companies were well received as they toured the East Coast Negro vaudeville circuit.

Wan married Robert Reed Conley in 1910, gave birth to three sons and moved her family to Arcadia, where she hoped to break into California's mushrooming film industry. Real estate was affordable and work plentiful, and the Negro press was encouraging black Americans to relocate to the West Coast. Within two years of arriving in California and shortly after the birth of her third son, Conley deserted the family, leaving them penniless. It was not easy to support her family with sporadic dancing and singing jobs, so Wan supplemented her income with domestic work and never gave up on her dream of being an actor. It was during this difficult time that she decided to reinvent herself as Madame Sul-Te-Wan and tried to resurrect her acting career.

In 1915, she heard the famous director D.W. Griffith, a native of her hometown, was making a movie based on the bestselling novel *The Clansman* about the antebellum South and Reconstruction. The movie was the famous *Birth of a Nation*. Wan personally begged him for a job, and Griffith was so impressed that he hired her on the spot, paying her three dollars a day. After one day's work, he raised her salary to five dollars a day and eventually gave her a contract for twenty-five dollars a week whether she did any acting or not. She was the first black actor to be hired as a stock player in Hollywood. Griffith even wrote a special scene for her where she played a wealthy black woman who depicted the new Negro class before the Civil War. It was out of character for Griffith to let her appear in the movie, for he was known to have preferred white actors in blackface to play the roles. Most of her role, however, was deleted and did not make the final cut. To this day, *Birth of a Nation* is considered to be one of the most racially charged movies in the history of the industry, and it is ironic that this was the movie that had the first black actor in a role.

After the completion of the film, Wan was discharged from Griffith's film company for allegedly stealing a book from a white actor and inciting blacks to protest the film. She hired a well-known African American attorney, E. Burton Ceruti, to successfully defend her against the charges, and Wan was reinstated in the company. Wan and Griffith remained lifelong friends, and she went on to perform in several of his other films. He was also very helpful in finding her other acting roles in the industry. Although there were rumors and questions about a possible illicit relationship between them, nothing was ever authenticated.

Her stamina to continue performing is a testimony to her character. For years she played uncredited roles as servants, nannies, criminals and natives—stereotypical characters who appeared in the scripts only as occupations rather than names. This continued for most of the 1920s with the exception of two credited performances as "Mammy" in *The Lighting Rider* and "Easter" in *The Narrow Street*. While playing these supportive roles, she had the opportunity to work with outstanding actors, producers and directors, including Cecil DeMille. Toward the end of the decade, she had two memorable performances working with Buster Keaton in *College* and Gloria Swanson in *Queen Kelly*.

Unlike so many silent-era players, Madame Sul-Te-Wan successfully made the transition to sound, and she was the first black actor to do so. However, her roles did not change in the more than fifty films she acted in during her career. During the 1930s, '40s and '50s, she continued working, an achievement that was unusual for someone of color. After forty years in films, she finally landed a speaking role as Hagar, Carmen's grandmother, in the 1954 musical drama *Carmen Jones* with a nearly entirely African American cast, including Harry Belafonte, Dorothy Dandridge and Diahann Carroll. Her last screen appearance came in 1958 in the adventure film *The Buccaneer*, starring Yul Brynner and Charlton Heston.

At the age of eighty, and the oldest black actor in the world, she was honored at a Hollywood banquet attended by more than two hundred actors and movie personalities. Wan died on February 1, 1959, at the Motion Picture Country home and is interred in Hollywood, California. In 1986, almost three decades after her death, Madame Sul-Te-Wan was inducted into the Black Filmmakers' Hall of Fame, a tribute to a trailblazer who, though never a big star in her own right, paved the way for so many who would follow.

DOROTHY ARZNER (1897–1979)

NOTED FILM DIRECTOR DURING HOLLYWOOD GOLDEN AGE

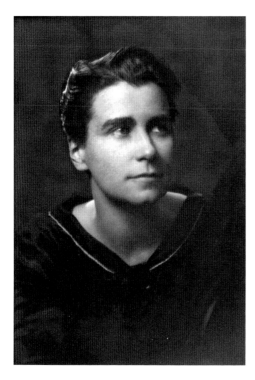

Dorothy Arzner. *Courtesy of the Library of Congress.*

Sexism was a dominant feature in the film industry when Dorothy Arzner decided to embark on a career in editing and script writing. In spite of this environment, she became the only female director during the post-silent boom of Hollywood filmmaking and the first female member of the Directors Guild of America. Although she established the largest oeuvre by a woman director, her work has been practically excluded in accounts of film history. Not until the 1970s and the rediscovery of her work in a project of feminist film studies did she finally receive the critical acclaim she deserved. During her career as a director from 1928 to 1943, Arzner was able to make a smooth transition from directing three silent movies to fourteen "talkies." She was not a typical Hollywood luminary; she did not fit. Her life, her persona and her films were not the expected norm for that era.

Arzner was born in San Francisco and grew up in Los Angeles, where her parents owned a Hollywood restaurant patronized by many Hollywood celebrities. Upon finishing high school in 1915, she enrolled in the University of Southern California to study medicine. After two years of study, she realized this was not a good career choice, and she dropped out of school. After volunteering as an ambulance driver during World War I, she became interested in pursuing a career in the film industry. The ambulance director introduced her to William DeMille, a major director at the Famous Players–

Lasky Corporation, the parent company of Paramount Studios. DeMille hired her to type scripts for twenty dollars per week. Reportedly, her typing was not too good, so she asked if she could assist with some of the synopses of the studio's current productions. Arzner moved quickly to film cutter, scriptwriter and editor within three years. She was the first Hollywood editor to be given a screen credit, and by 1922, as chief editor for Realart Studio, she had edited fifty-two films. Arzner's talent as a filmmaker came to the forefront while editing the Rudolph Valentino epic *Blood and Sand*. In the famous bullfighting scene, she combined stock footage with original material and saved the studio thousands of dollars.

Director James Cruze was so impressed by Arzner's skills that he employed her as a writer and editor for several films. He gave her the opportunity to demonstrate her ability as a screenwriter in *Old Ironsides*, a magnificent movie, part of which was filmed with the very earliest widescreen technology.

By the mid-1920s, Arzner knew it was her time to become a director. Paramount partially obliged by promoting her to assistant director, but she realized this was not going to vault her into the director's chair. Being determined and shrewd, she threatened to jump to Columbia Pictures, where she had already been offered a director's position. Paramount executives ceded to her demands and let her direct *Fashions for Women*, an extremely profitable hit. Arzner noted, "My philosophy is that to be a director you cannot be subject to anyone, even the head of the studio. I threatened to quit each time I didn't get my way, but no one ever let me walk out."

She made history by directing Paramount's first sound movie, *Manhattan Cocktail*, and then launched Frederick March as a screen star in *The Wild Party*, starring Clara Bow. During this filming, Arzner made a significant contribution to sound technology. It was Bow's first foray into the "talkies," and she was extremely self-conscious of her deep Brooklyn accent. Arzner rigged a microphone onto a fishing rod, essentially creating the first boom mike, and thus was able to control the tone quality of Bow's voice. This production was also Arzner's first attempt at using coded lesbian themes in her films.

Arzner directed eleven feature films for Paramount between 1927 and 1932 and then left to work on her own. RKO hired her to direct Katharine Hepburn, its new star, in *Christopher Strong*. Theirs was a strained relationship, as both of them were intensely independent and obstinate. Aside from Hepburn, Arzner worked well with many other female actors, including Lucille Ball in her outstanding performance of *Dance Girl Dance*, also starring Maureen O'Hara. She directed Joan Crawford in two 1937 films, *The Last Mrs. Cheney* and the *Bride Wore Red*, and Rosalind Russell in *Craig's Wife*.

Arzner retired from filmmaking after suffering from a bout with pneumonia in 1943 while directing *First Comes Courage*. Although most of her films were box office successes and the studios profited, the culture of the industry was changing. Arzner was on the politically incorrect side of the transformation, and most likely, the more conservative studio executives were responsible for ending her directing career. She reportedly commented that twenty-five years in the business (with business partners like that) were simply enough.

In 1943, Arzner joined several of her Hollywood colleagues making training films for the United States Army's Women's Army Corps. She started teaching filmmaking at the Pasadena Playhouse and then taught directing and screenwriting at the first Film School Generation at University of California–Los Angeles until her death in 1979.

It was no secret that Arzner was a lesbian and lived for more than four decades with dancer and choreographer Marion Morgan, who appeared in some of her movies. Dressed in suits, ties and short hair combed tightly back, she emitted an authoritarian demeanor. This may have been her way to portray herself as "the man in charge" and to fit into the Hollywood boys' club. Most of her films featured strong female characters, and though she was recognized as a director of "women's films," she actually succeeded in challenging the accepted tenets of Hollywood from within, posing viewpoints that challenged the prevailing order. She was not hesitant to articulate class rivalries, focus on relationships and institutions and critically examine forms of solidarity.

During the rise of the feminist movement in the 1960s and '70s, when Arzner's career and works were "rediscovered," the younger feminist film scholars described her films "as challenging the dominant, phallocentric mores of the times." Arzner, however, did not want be boxed and labeled as a gay or woman director. She was a director. For women who wanted a career in film, she became a role model. For feminist film scholars, she was the subject of much debate. These younger women wanted to give Arzner the recognition that had eluded her and believed she deserved from her generation.

Arzner received several important honors in her lifetime, including the First International Festival of Women's Films in 1972. The Directors Guild in 1975 honored her with a "Tribute to Dorothy Arzner." Katharine Hepburn sent a telegram that read: "Is it wonderful that you've had such a great career, when you had no right to have a career at all." Arzner's noted quote is "When I went to work in a studio, I took my pride and made a nice little ball of it and threw it right out the window." This quote perfectly described Arzner and how she became an acclaimed director in a predominantly male industry.

MARY PICKFORD (1892–1979)

AMERICA'S SWEETHEART

As a child, Mary Pickford was exceptionally curious, questioning and always looking for more answers. In an interview later in life, she said, "I was always older than my years." A tough and perceptive businesswoman, she lived life on her own terms and, by the age of thirty, realized many of her ambitions. Pickford remembers eating roses when she was young, thinking that their aroma, beauty and color would be absorbed by her body. Roses or not, Pickford became a legend in her time and an international star beloved for her stunning beauty and charming personality.

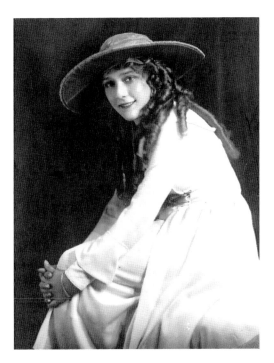

Mary Pickford. *Courtesy of the Library of Congress.*

Mary Pickford was born Gladys Marie Smith in April 1892 in Toronto, Canada, to Charlotte Hennessey and John Smith. In the early years of Pickford's life, the family struggled with finances and her alcoholic father. Her parents eventually separated, and shortly thereafter, her father died. Struggling to make ends meet, her mother worked as a seamstress and rented rooms to provide the family with extra money. Fortuitous for Pickford, one of the boarders was a local theater stage manager. He arranged for her to appear at Toronto's Princess Theatre for her acting debut at the age of six. Then known as "Baby Gladys," Pickford and her family spent the next nine years touring in shows throughout the country. In 1907, she adopted the family name Pickford and made her Broadway debut in the successful *The Warrens of Virginia.*

In 1909, Pickford appeared in her first film with the American Mutoscope & Biograph Company, the first motion picture company in the United States

devoted entirely to film production. Working under D.W. Griffith, Pickford embarked on a career that would see her become the most renowned female star of the silent era and the most famous female actor in the world. Most Biograph actors earned five dollars a day, but after a single day in the studio, Griffith agreed to pay her ten dollars per day against a guarantee of forty dollars a week. During that year, Pickford played in fifty-one films, both bit parts and leading roles. Pickford was determined to stand out among the many other actors and noted, "I played scrubwomen and secretaries and women of all nationalities…I decided that if I could get into as many pictures as possible, I'd become known, and there would be a demand for my work." That is exactly what happened. Although actors were not listed in the credits, it was not long before the audiences noticed Pickford. In the film promotions, she was dubbed "The Girl with the Golden Curls," "Blondilocks" or "The Biograph Girl" and quickly became "America's Sweetheart."

As her fame grew, Pickford asserted her authority over the creative and financial aspects of her career, dictating the provisions of her productions. Her popularity extended onto the world scene, and early films like 1909's *The Little Darling* were copied in Russia and distributed throughout the European underground market. Biograph suffered an astounding loss of income because of this piracy, but it made Pickford an international superstar. Her mother, Charlotte, tutored her about parlaying her fame into wealth. Thus, Pickford learned to negotiate lucrative financial contracts. Seeking more independence, she left Griffith in 1913 and joined Adolph Zukor's Famous Players Company, later the forerunner to Paramount. The studio capitalized on her fame and charged theaters a payment to show her films, a first in the industry.

At her mother's urging, Pickford began to demand unprecedented larger salaries. Zukor paid her an astonishing $10,000 per week and a $30,000 signing bonus, plus a percentage of all profits from her films. She was the first female actor to receive a share of a film's earnings, and by 1919, she was earning $350,000 per movie, making her Hollywood's first millionaire. As one of silent film's most significant performers and producers, her contract demands were pivotal to shaping the film industry. Pickford undoubtedly became a defining figure in the history of modern celebrity.

The Hollywood studios could not meet her demands. Therefore, in 1919, she and Charlie Chaplin, another top star, decided to form their own studio. They were joined by Douglas Fairbanks and D.W. Griffith in forming the independent film production company United Artists Pictures, a studio that was responsible for many great films for the next sixty-plus years. In 1920, her film *Pollyanna* grossed about $1.1 million. The following

year, *Little Lord Fauntleroy* would also be a success, and in 1923, *Rosita* grossed over $1 million as well.

Tired of her America's sweetheart roles, Pickford struggled to transform her film image. To the dismay of her fans, she decided to cut her famous ringlets. Her hair had become a symbol of her feminine mystique, and when she cut it, the *New York Times* carried the story on the front page. Shortly after, she starred in her first talking movie, *Coquette*, for which she won an Academy Award for best actress. The audiences, however, did not take to her in the more sophisticated roles, and she was never able to achieve the extraordinary success she had in the silent pictures.

For some reason, Pickford did not fully appreciate the magnitude of talking films. She said, "Adding sound to movies would be like putting lipstick on the Venus de Milo." Pickford faced new challenges and had difficulty incorporating her voice into her screen acting. However, her greatest challenges were not related to the technology. Her problems were her fans, who associated her with old-fashioned roles and wanted younger, sexier stars. She was in her late thirties and was unable to play the children, moody teenagers and spirited young women for which her fans adored her, but neither could she play the elegant heroines of early sound. Finally, at the age of forty-three, Pickford retired after making her last film, *Star Night at the Cocoanut Grove* in 1934. However, she continued to produce films for United Artists, and her partnership with Chaplin continued for decades until he left the company in 1955. Pickford followed in 1956, selling her remaining shares for $3 million.

During her lifetime, Pickford was married three times. In 1911, she married Owen Moore, an Irish-born silent film star whom she divorced in 1920 to marry the very handsome and debonair Douglas Fairbanks. Their marriage was hailed as "the marriage of the century," and they immediately became Hollywood's first virtual royal couple. Together they lived a fairy-tale life in their Beverly Hills estate, a spacious former hunting lodge the press dubbed "Pickfair." Over the years, the home served as a gathering place for politicians, artists, journalists and foreign diplomats. The two of them were the first actors to officially place hand- and footprints in the cement at Grauman's Chinese Theatre on April 30, 1927.

As early as 1925, the marriage showed signs of trouble, and tension increased as both their careers were fading. Fairbanks also had trouble adjusting to sound films, and his age made him incompatible with the types of roles for which he had grown famous. To boost their careers, the couple starred in a film together, *The Taming of the Shrew*, which, unfortunately, was

a flop. Pickford was unable to cope with the pressure and during this time succumbed to her family's addiction to alcohol. She divorced Fairbanks in 1936 after learning he was having an adulterous affair and married Buddy Rogers, a former co-star twelve years younger. They remained together until her death.

In 1976, Pickford was awarded an Oscar for lifetime achievement from United Artists, the very organization she had started years earlier. However, her later years were absorbed by her alcoholism and depression. It appears she was not able to cope with the loss of Fairbanks, the love of her life, and the cruel reality of her lost stardom. Pickford died of a cerebral hemorrhage in 1979 at the age of eighty-seven.

Pickford's career lasted from 1908 to 1935, encompassing 236 films throughout the 1910s and 1920s. She was believed to be the most famous woman in the world or, as a silent-film journalist described her, "the best known woman who has ever lived, the woman who was known to more people and loved by more people than any other woman that has been in all history." As a testimony to her impact on the film industry, there is a picture of her with her famous golden ringlets hanging in the Library of Congress in Washington, D.C.

BIBLIOGRAPHY

CHAPTER 1. PIONEERS

Introduction

Bouvier, Virginia M. *Women and the Conquest of California*. Tucson: University of Arizona Press, 2004.

Cutter, Donald. "Sources of the Name California." *Arizona and the West* 3, no. 3 (Autumn 1961): 223–35.

Ibanez, Vincente Blasco. *Queen Calafia*. New York: E.P. Dutton, 1924.

Nancy Kelsey

Chartier, JoAnne, and Chris Enss. *With Great Hope: Women of the California Gold Rush*. Guilford, CT: Two Dot, 2000.

Holland, Cecelia. *An Ordinary Woman: A Dramatized Biography of Nancy Kelsey*. New York: A Tom Doherty Associates Book, 1999.

Levy, Jo Ann. *They Saw the Elephant: Women in the California Gold Rush*. Norman: University of Oklahoma Press, 1992.

Luzena Wilson

Collins, Gail. *America's Women*. New York: HarperCollins, 2007.

Fischer, Christiane, ed. *Let Them Speak for Themselves: Women in the American West 1849–1900*. Hamden, CT: Shoe String Press, 1977.

Furbee, Mary R. *Outrageous Women of the American Frontier*. New York: John Wiley & Sons, 2002.

Henry, Fern. *My Checkered Life: Luzena Stanley Wilson in Early California*. Nevada City, CA: Carl Mautz Publishing, 2003.

Levy, Jo Ann. *They Saw the Elephant: Women in the California Gold Rush*. Norman: University of Oklahoma Press, 1992.

Wilson, Luzena Stanley, *Luzena Stanley Wilson: '49er: Memories Recalled Years Later for Her Daughter, Correnah Wilson Wright*. Mills College, CA: Eucalyptus Press, 1937.

Mary Ellen Pleasant

Hudson, Lynn M. *The Making of "Mammy Pleasant": A Black Entrepreneur in Nineteenth Century San Francisco*. Urbana: University of Illinois Press, 2003.

Smith, Jessie, ed. *Notable Black American Women*. Detroit: Gale Research Inc., 1992, 858–62.

Zauner, Phyllis. *Those Spirited Women of the Early West*. Yountville, CA: Zanel Publications, 2001.

Charlotte "Charley" Parkhurst

Brennan, Linda C. *Women of the Golden State: 25 California Women You Should Know*. Bedford, NH: Apprentice Shop Books, 2009.

Furbee, Mary R. *Outrageous Women of the American Frontier*. New York: John Wiley & Sons, 2002.

Hill, Fern. *Charley's Choice*. West Conshohocken, PA: Infinity Publishing, 2008.

Moody, Ralph. *Stagecoach West*. Lincoln: University of Nebraska Press, 1967.

CHAPTER 2. SETTLERS

Introduction

Fisher, Christine, ed. *Let Them Speak for Themselves: Women in the American West, 1849–1900*. Hamden, CT: Shoestring Press, 1977.

Hayden, Delores. "Biddy Mason's Los Angeles." *California History* 68, no. 3 (Fall 1989).

Jensen, Joan M., and Gloria Ricci Lothrop. *California Women: A History*. San Francisco: Boyd & Fraser Publishing Company, 1987.

Levy, Jo Ann. *They Saw the Elephant: Women in the California Gold Rush.* Norman: University of Oklahoma Press, 1992.

Louise Amelia Knapp Smith Clappe

Brennan, Linda C. *Women of the Golden State: 25 Women You Should Know.* Bedford, NH: Apprentice Shop Books, 2009.

Rawls, Jim. *Dame Shirley and the Gold Rush.* New York: Steck-Vaughn Company, 1993.

Smith-Baranzine, Marlene, ed. *The Shirley Letters: From the California Mines, 1851–1852.* Berkeley, CA: Heyday Books, 2001.

Zauner, Phyllis. *Those Spirited Women of the Early West.* Yountville, CA: Zanel Publications, 2001.

Bridget "Biddy" Mason

Beasley, Deliliah L. *The Negro Trail Blazers of California.* Los Angeles, CA: Times Mirror Printing and Binding House, 1919.

"Biddy Mason biography." Women in History. www.lkwdpl.org/wihohio/maso-bid.htm.

Brennan, Linda C. *Women of the Golden State: 25 Women You Should Know.* Bedford, NH: Apprentice Shop Books, 2009.

Hayden, Delores. "Biddy Mason's Los Angeles." *California History* 68, no. 3 (Fall 1989).

Levy, Jo Ann. *They Saw the Elephant: Women in the California Gold Rush.* Norman: University of Oklahoma Press, 1992.

Smith, Jessie, ed. *Notable Black Women.* Detroit: Gale Research Inc., 1992, 732–34.

Williams, Jean K. *Bridget "Biddy" Mason: From Slave to Businesswoman.* Minneapolis, MN: Compass Point Books, 2005.

Toby "Winema" Riddle

Bales, Rebecca. "Winema and the Modoc War: One Woman's Struggle for Peace." *Prologue Magazine* 37, no. 1 (Spring 2005).

Chartier, Jo Ann, and Chris Enss. *She Wore a Yellow Ribbon: Women Soldiers and Patriots of the Western Frontier.* Guilford, CT: Two Dot, 2004.

Meacham, Alfred B. *Wi-ne-ma the Woman Chief and Her People.* Hartford, CT: American Publishing Company, 1876.

Murray, Keith A. *The Modocs and Their War.* Norman: University of Oklahoma Press, 1959.

"Toby Riddle." New World Encyclopedia. www.newworldencyclopedia. org/entry/Toby_Riddle.

"Winema, Peacemaker." History Channel Club. www.thehistorychannelclub. com/articles/articletype/articleview/articleid/251/wine.

Elizabeth "Lillie" Hitchcock Coit

Bowlen, Frederick J. "Elizabeth Wyche 'Lillie' Hitchcock Coit." Virtual Museum of the City of San Francisco. www.sfmuseum.org/hist1/h-coit.html.

Holdredge, Helen. *Firebelle Lillie.* New York: Meredith Press, 1967.

"Lillie Hitchcock-Coit." Virtual Museum of the City of San Francisco. www.sfmuseum.org/hist1/h-coit2.html.

Zauner, Phyllis. *Those Spirited Women of the Early West.* Yountville, CA: Zanel Publications, 2001.

CHAPTER 3. SUFFRAGISTS

Introduction

Chartier, JoAnn, and Chris Enss. *With Great Hope: Women of the California Gold Rush.* Guilford, CT: Two Dot, 2000.

Gullett, Gayle. *Becoming Citizens: The Emergence and Development of the California Women's Movement, 1880–1911.* Urbana: University of Illinois Press, 2000.

Jensen, Joan M., and Gloria Ricci Lothrop. *California Women: A History.* San Francisco: Boyd and Fraser Publishing Company, 1987.

Laura de Force Gordon

Bakken, Gordon Morris, and Brenda Farrington. *Of Women in the American West.* Thousand Oaks, CA: Sage Publications, 2003.

Eagle, Mary Kavanaugh Oldham, ed. *The Congress of Women Held in the Woman's Building World's Columbian Exposition.* Kansas City, MO, 1894.

Gordon, Laura de Force. "Women's Sphere from a Woman's Standpoint." digital.library.upenn.edu/women/eagle/congress/gordon.html.

"Guide to the Laura Gordon papers [ca. 1856–1882]." Online Archive of California. www.oac.cdlib.org/findaid/ark:/13030/tf4p300407.

Harper, Ida Husted. *The Life and Work of Susan B. Anthony*. Vol. 3. Indianapolis: Hollenbeck Press, 1908.

"How We Won the Vote in California." www.archive.org/stream/howwewonvoteinca00solo#page/4/mode/2up.

James, Edward T., Janet Wilson James and Paul S. Boyer, eds. *Notable American Women 1607–1950, A–F Volume I*. Cambridge, MA: Belknap Press of Harvard University Press, 1971.

"Laura de Force Gordon." andrejkoymasky.com/liv/fam/biod1/deforc01.html.

"Laura De Force Gordon." www.history.com/topics/laura-de-force-gordon.

Silver, Mac, and Sue Cazaly. *The Sixth Star: Images and Memorabilia of California Women's Political History 1868–1915*. Canada: Ord Street Press, 2000.

Ellen Clark Sargent

Brower, Maria E. *Nevada City*. Charleston, SC: Arcadia Publishing, 2005.

Chartier, JoAnne, and Chris Enss. *With Great Hope: Women of the California Gold Rush*. Guilford, CT: Two Dot, 2000.

"Ellen Clark Sargent Historical Essay." Found SF. www.foundsf.org/index.php?title=Ellen_Clark_Sargent.

"How We Won the Vote in California." www.archive.org/stream/howwewonvoteinca00solo#page/4/mode/2up.

Noy, Gary. "Area Couple Fought for Women's Rights." TheUnion.com. www.theunion.com/article/20040619/TODAYSFEATURE/106190116.

"The Picket Line." sniggle.net/Experiment/index5.php?entry=24May10.

"The Sargents of Nevada City." Sierra Nevada Virtual Museum. www.sierranevadavirtualmuseum.com.

Maud Younger

James, Edward T., Janet Wilson James and Paul S. Boyer, eds. *Notable American Women 1607–1950, P–Z Volume III*. Cambridge, MA: Belknap Press of Harvard University Press, 1971.

Jensen, Joan M., and Gloria Ricci Lothrop. *California Women: A History*. San Francisco: Boyd and Fraser Publishing Company, 1987.

"Maud Younger." Women of the West Museum. theautry.org/explore/exhibits/suffrage/maudyounger_full.html.

"Maud Younger." www.answers.com/topic/maud-younger.

"Maud Younger." www.novelguide.com/a/discover/ewb_0002_0026_0/ewb_0002_0026_0_00181.html.

Clara Shortridge Foltz

Babcock, Barbara. "Alma Mater: Clara Foltz and Hastings College of the Law." *Hastings Women's Law Journal* 21, no. 1 (2010): 99–106.

———. "Clara Shortridge Foltz: 'First Woman.'" Valparaiso University Law Review. wlh.law.stanford.edu/wp-content/uploads/2010/10/babcock-28VULR1231.pdf.

———. "On Her Book 'Woman Lawyer.'" Rorotoko. www.rorotoko.com/index.php/article/barbara_babcock_book_interview_woman_lawyer_trials_clara_foltz.

———. *Woman Lawyer: The Trials of Clara Foltz*. Stanford, CA: Stanford University Press, 2011.

Flaherty, Kristina Horton. "A Hundred Years Later, a Trailblazer Gets Her Due." California Bar Journal. www.calbarjournal.com/June2011/TopHeadlines/TH1.aspx.

Gullett, Gayle. *Becoming Citizens: The Emergence and Development of the California Women's Movement, 1880–1911*. Urbana: University of Illinois Press, 2000.

James, Edward T., Janet Wilson James and Paul S. Boyer, eds. *Notable American Women 1607–1950, A–F Volume I*. Cambridge, MA: Belknap Press of Harvard University Press, 1971.

Schwartz, Mortimer D., Susan L. Brandt and Patience Milrod. "Clara Shortridge Foltz: Pioneer in the Law." Hastings Law Journal. www.countyofsb.org/uploadedFiles/defender/HastingsFoltz.pdf.

Silver, Mac, and Sue Cazaly. *The Sixth Star: Images and Memorabilia of California Women's Political History 1868–1915*. Canada: Ord Street Press, 2000.

Chapter 4. Reformers and Activists

Introduction

Elinson, Elaine, and Stan Yogi. *Wherever There's a Fight: How Runaway Slaves, Suffragists, Immigrants, Strikers, and Poets Shaped Civil Liberties in California*. Berkeley, CA: Heyday Books, 2009.

Jensen, Joan M., and Gloria Ricci Lothrop. *California Women: A History*. San Francisco: Boyd & Fraser Publishing Company, 1987.

Donaldina Cameron

Martin, Mildred Crowl. *Chinatown's Angry Angel: The Story of Donaldina Cameron.* Santa Barbara, CA: Pacific Books, 1977.

Rutter, Michael. *Upstairs Girls: Prostitution in the American West.* Helena, MT: Far Country Press, 2005.

Wilson, Carol Green. *Chinatown Quest: The Life Adventures of Donaldina Cameron.* Stanford, CA: Stanford University Press, 1950.

Katherine Philips Edson

Braitman, Jacqueline R. "The Public Career of Katherine Philips Edson." *California History* 65, no. 2 (June 1986).

Eichelberger, Eunice. "Hearts Brimming with Patriotism." In *California Women and Politics*, edited by Robert W. Cheney, Mary Irwin and Ann Marie Wilson. Lincoln: University of Nebraska Press, 2011.

Hundley, Norris C. "Katherine Philips Edson and the Fight for the California Minimum Wage, 1912–1923." *Pacific Historical Review* 29, no. 3 (August 1960).

Rose Pesotta

"Labor Activist Rose Pesotta Organizes in Akron, Ohio." Jewish Women's Archive. jwa.org/thisweek/feb/25/1936/rose-pesotta.

Laslett, John. "Gender, Class, or Ethno-Cultural Struggle? The Problematic Relationship Between Rose Pesotta and the Los Angeles ILGWU." *California History* 72, no. 1 (Spring 1993): 20–39.

Leeder, Elaine. *The Gentle General: Rose Pesotta, Anarchist and Labor Organizer.* Albany: State University of New York Press, 1993.

Schofield, Ann. "Rose Pesotta." Jewish Women's Archive. jwa.org/encyclopedia/article/pesotta-rose.

Sicherman, Barbara, and Carol Green, eds. *Notable American Women: The Modern Period.* Cambridge, MA: Belknap Press of Harvard Press, 1980, 541–42.

Dolores Huerta

"Dolores Huerta Biography." Las Culturas. www.lasculturas.com/aa/bio/bioDoloresHuerta.htm.

"Dolores Huerta." Discover the Networks. www.discoverthenetworks.org/individualProfile.asp?indid=2074.

Garcia, Mario T., ed. *A Dolores Huerta Reader*. Albuquerque: University of New Mexico Press, 2008.

Garcia, Richard A. "Dolores Huerta: Woman, Organizer, Symbol." *California History* 72, no. 1 (Spring 1993): 56–71.

Rose, Margaret. "Traditional and Nontraditional Patterns of Female Activism in the United Farm Workers of America, 1962–1980." *Frontiers: A Journal of Women's Studies* 11, no. 1 (1990): 26–32.

CHAPTER 5. ENVIRONMENTALISTS AND CONSERVATIONISTS

Introduction

Barriga, Joan. "Survival with Style: The Women of the Santa Cruz Mountains." Mountain Network News. www.mnn.net/women.htm.

Costle, Douglas M. "Women and the Environment." EPA Journal. epa.gov/aboutepa/history/topics/perspect/women.html.

"Ecofeminism: Women and the Environment." feministcampus.org/fmla/printable-materials/Women_Environment.pdf.

Josephine Clifford McCrackin

"Best Kept Secrets of Santa Cruz County." www.santacruzbnb.com/secret.places.html.

"Clifford McCrackin, Josephine—Writer, Conservationist." germanamericanpioneers.org/ClifordMcCrackinJosephine.htm.

Foote, Cheryl J. *Women of the New Mexico Frontier*. Albuquerque: University of New Mexico Press, 2005.

James, Edward T., and Janet W. James. *Notable American Women 1607–1950, G–O Volume I*. Cambridge, MA: Belknap Press of Harvard University Press, 1971.

James, George Wharton. "The Remarkable History of a Remarkable Woman: Josephine C. McCrackin." *National Magazine*, July 1912.

"Josephine Clifford McCrackin (1839–1920), The Valley Still Verdant." California Legacy Project. californialegacy.org/radio_anthology/scripts/mccrackin.html.

Payne, Stephen Michael. "Josephine Clifford McCrackin." Santa Cruz Public Libraries. www.santacruzpl.org/history/articles/236.

Swift, Carolyn. "1899 Fire Sparked Conservation Movement." *Santa Cruz Sentinel,* January 2, 2000.

Minerva Hamilton Hoyt

LA History Archive. www.lahistoryarchive.org/resources/LA_Women.

"Minerva Hamilton Hoyt." Historical Society of Southern California. socalhistory.org/biographies/minerva-hamilton-hoyt.html.

"Minerva Hoyt—Southern Belle to Desert Lady." Wandering Not Lost. www.wanderingnotlost.org/2011/04/minerva-hoyt-southern-belle-to-desert-lady.

"A Park for Minerva." National Park Service. www.nps.gov/jotr/historyculture/mhoyt.htm.

Lupe Anguiano

Doyle, Alicia. "Women's Group Will Honor Local Activist Lupe Anguiano." *Ventura County Star*, August 12, 2008.

"Lupe." Las Mujeres de la Caucus Chicana. www.vocesprimeras.com/profilela.html.

"Lupe Anguiano Archive Event." UCLA Chicano Studies Research Center. www.chicano.ucla.edu/center/events/anguiano.htm.

"Lupe Anguiano—Protector of the Earth and Activist for the Poor." Stewards of the Earth. stewards-earth.org/Leadership/National_Women's_History.htm.

Saillant, Catherine. "Activist's 60-Year Fight for Justice." *Los Angeles Times*, March 19, 2007.

"2007 Honorees, Lupe Anguiano." Women's History Month. nwhp.org/whm/anguiano_bio.php.

Williams, Jasmin. "Lupe Anguiano—A Tireless Warrior Woman." *New York Post*, March 12, 2007.

Alice Waters

"Alice Waters, Executive Chef, Founder and Owner." Chez Panisse. www.chezpanisse.com/about/alice-waters.

Apple, R.W. "On the Left Coast, a 30th to Remember." *New York Times*, August 20, 2009.

"The Edible Schoolyard: Alice Waters' Chez Panisse Foundation." justcauseit.com/articles/edible-schoolyard-alice-waters-chez-panisse-foundation.

"The Evolution of Chez Panisse." www.whitings-writings.com/essays/chez_panisse.htm.

"Foodies Can Eclipse (and Save) the Green Movement." TIME. www.time.com/time/health/article/0,8599,2049255,00.html.

Martin, Andrew. "Is a Food Revolution Now in Season?" *New York Times*, March 22, 2009.

McNamee, James. *Alice Waters and Chez Panisse*. New York: Penguin Press, 2007.

Shriver, Jerry. "Waters Goes Sour on Biography". *USA Today*, March 23, 2007.

Slow Food. www.slowfood.com.

"Women and Food: Alice Waters." Star Chefs. starchefs.com/features/women/html/bio_waters.shtml.

CHAPTER 6. DOCTORS AND DENTISTS

Introduction

Agnew, Jeremy. *Medicine in the Old West 1850–1900*. Jefferson, NC: McFarland, 2010.

Brown, Adelaide, MD. "The History of the Development of Women in the Medicine in California." *California and Western Medicine* 23, no. 5 (1925): 579–582.

James, Edward T., and Janet W. James. *Notable American Women 1607–1950. A–F Volume I*. Cambridge, MA: Belknap Press of Harvard University Press, 1971.

"Pioneers that Shaped Medicine in San Francisco." San Francisco Medical Society. www.sfms.org.

Lucy Maria Field Wanzer

"First Woman Graduate." UCSF. support.ucsf.edu/files/pdfs/medicine/medicalalumni09fa.pdf.

Pierce, Frederick C. *Field Genealogy*. Chicago: Hammond Press: W.B. Conkey Co., 1901.

Scully, A. Lois, MD. "Medical Women of the West." Women and Medicine. www.ncbi.nlm.nih.gov/pmc/articles/PMC1026634/pdf/westjmed00136-0117.pdf.

Volkman, Kate. "Six Women Who Did UCSF Proud—First Women." *Medical Alumni* 50, no. 2 (Fall 2009).

Wanzer, William David. *The History of the Wanzer Family in America, from the Settlement in New Amsterdam, New York, 1642–1920.* Medford, MA: Medford Mercury Press, 1920.

"Women Pioneers in San Francisco Medicine." www.sfms.org/AM/Template.cfm?Section=Home&template=Home/CM/HTMLDisplay.

June Hill Robertson McCarroll

"The 'Guy' Who Invented Pavement Markings." The Journey. kirchmanassociates.blogspot.com/search/label/%22Dr.%20June%20McCarroll%22.

"June McCarroll's Lasting Legacy." American Countryside. americancountryside.com/2010/10/18/june-mccarrolls-lasting-legacy.

"Let's Start with the Road." The Journey. kirchmanassociates.blogspot.com/2008/03/lets-start-with-road.html.

"Pavement Marking History." http://a1pavementmarkingllc.com/Striping_history.html.

Rasmussen, Cecelia. "'Doc June' Drew the Line on Safety." *Los Angeles Times*, October 12, 2003.

Nellie E. Pooler Chapman

Brower Maria E. *Nevada City*. Charleston, SC: Arcadia Publishing, 2005.

Enss, Chris. *The Doctor Wore Petticoats: Women Physicians of the Old West*. Guilford, CT: Globe Pequot Press, 2006.

Millard, Bailey. "1899–1918 Early Academic Programs and Teaching." John M. Hyson Jr., DDS, MS, MA, "Women Dentists: The Origins." Copyright 2002, *Journal of the California Dental Association*.

"Nellie Chapman." www.virtualcities.com/ons/ca/g/as/cag95a29.htm.

"Nellie Chapman: The People of Nevada County." www.nevadacountygold.com/goldrushtown/nelliechapman.html.

"Women Dentists: The Origin." www.cda.org/library/cda_member/pubs/journal/jour0602/hyson.htm.

Margaret "Mom" Chung

"Dr. Margaret 'Mom' Chung." West Adams Heritage Association. www. westadamsheritage.org.

"Guide to the Margaret Chung Papers, 1880–1958." oac.cdlib.org/findaid/ark.

Wu, Judy Tzu-Chun. *Doctor Mom Chung of the Fair-Haired Bastards: The Life of a Wartime Celebrity*. Berkeley: University of California Press, 2005.

CHAPTER 7. LAWYERS

Introduction

Babcock, Barbara. "Alma Mater: Clara Foltz and Hastings College of the Law." *Hastings Women's Law Journal* 21, no. 1 (2010): 99–106.

Epstein, Cynthia. *Women in Law*. Chicago: University of Illinois Press, 1993.

Morello, Karen. *The Woman Lawyer in America: 1638 to the Present*. Boston: Beacon Press, 1986.

Mossman, Mary Jane. *The First Woman Lawyers*. Portland, OR: Hart Publishing, 2006.

Rowe, Peter. "Jurist Finds History Out of Order During Re-Enactment of 1872 Case." *San Diego Union Tribune*, August 19, 2011, A1.

Annette Abbott Adams

"'Girl' Lawyer Makes Good: The Story of Annette Abbott Adams." Women's Legal History. http://wlh.law.stanford.edu/biography_search/biopage/?woman_lawyer_id=10005.

Jenson, Joan. "Annette Abbott Adams, Politician." *Pacific Historical Review* 35, no. 2 (May 1966): 185–201.

Sicherman, Barbara, and Carol Green, eds. *Notable American Women: The Modern Period*. Cambridge, MA: Belknap Press of Harvard University Press, 1980, 3–5.

Georgia Bullock

"Bobbed-Haired Portia Takes the Bench; Judge Georgia Bullock and Her Campaign for the Los Angeles Superior Court." Women's Legal History. http://wlh.law.stanford.edu./biography-search-results/biopage?woman_lawyer_id=10138.

Drachman, Virginia G. *Sisters in Law: Women Lawyers in Modern American History*. Cambridge, MA: Harvard University Press, 1998.

Grace, Roger M. "Three History Making Women Judicial Officers of L.A. Superior Court Are Now Joined by a Fourth." *Metropolitan News*, September 11, 2008, 4.

Gladys Towles Root

"The 'Lady in Purple': Gladys Towles Root." Women's Legal History. wlh. law.stanford.edu/biography_search.

Noe, Denise. "The Life of Gladys Towles Root." www.trutv.com/library/ crime/notorious_murders/classics/root/1.html.

Rasmussen, Cecilia. "Lady in Purple Took L.A. Legal World by Storm." *Los Angeles Times*, February 6, 1995.

Rice, Cy. *Defender of the Damned: Gladys Towles Root*. New York: Citadel Press, 1964.

———. *Get Me Gladys!: The Poignant Memoirs of America's Most Famous Lady Criminal Lawyer*. Los Angeles: Holloway House Publishing Co., 1966.

Rose Elizabeth Bird

Chiang, Harriet, and Joan Ryan. "Bird's Passion for Principles Recalled." *San Francisco Chronicle*. December 6, 1999, A1.

Levin, Eric. "The New Look in Old Maids." *People*, March 31, 1986, 28.

"The Rise and Fall of Rose Bird: A Career Killed by the Death Penalty." Women's Legal History. wlh.law.stanford.edu/biography_search.

"Rose Elizabeth Bird: Choosing to Be Just (Erin Adrian)." Women's Legal History. wlh.law.stanford.edu/biography_search.

Stolz, Preble. *Judging Judges: The Investigation of Rose Bird and the California Supreme Court*. New York: Free Press, 1981.

CHAPTER 8. EDUCATORS

Introduction

"The Early Days of Education in Los Angeles." kids.lausd.net/treasures/ lausd-earlydays.html.

Enss, Chris. Frontier Teachers: Stories of Heroic Women of the Old West. Helena, MT: Two Dot, 2008.

"The History of Women and Education." National Women's History Museum. www.nwhm.org/online-exhibits/education/introduction.html.

Reyhner, Jon, Joseph Martin, Louise Lockard and Gilbert W. Sakiestewa, eds. *Learn in Beauty: Indigenous Education for a New Century.* Flagstaff: Northern Arizona University: 2000.

Olive Mann Isbell

Enss, Chris. *Frontier Teachers: Stories of Heroic Women of the Old West.* Helena, MT: Two Dot, 2008.

Levy, Jo Ann. *They Saw the Elephant: Women in the California Gold Rush.* Norman: University of Oklahoma Press, 1992.

"Olive Mann Isbell: The First Teacher." www.fortunecity.com/millennium/sesame/258/omh.html.

Wood, Will C. "Early History of California Public Schools." www.sfmuseum.org/hist3/schools.html.

Youngs, Audrey. "The First American School Teacher." *Paradise California Newsletter*, April 24, 1981.

Susan Mills

James, Edward T., ed. *Notable American Women: A Biographical Dictionary, 1607–1950.* Cambridge, MA: Belknap Press, 1971, 546–47.

James, Elias O. *The Story of Cyrus and Susan Mills: A Biography of the Founders of Mills College.* Stanford, CA: Stanford University Press, 1953.

"Mills, Susan Lincoln Tolman." universalium.academic.ru/279185/Mills,_susan_Lincoln_Tolman.

"Mission & History." Mills College www.mills.edu/about/mission_and_history.php.

Katherine Siva Saubel

Bean, Lowell J. *Mukat's People: The Cahuilla Indians of Southern California.* Berkeley: University of California Press, 1974.

Dozier, Deborah. *The Heart Is Fire: The World of the Cahuilla Indians of Southern California.* Berkeley, CA: Heyday Books, 1998.

Malki Museum. www.malkimuseum.org.

Saubel, Katherine S., and John Bean Lowell. T*emalpakh (From the Earth): Cahuilla Indian Knowledge and Usage of Plants*. Banning, CA: Malki Museum Press, 1972.

We Are Still Here. www.violethillsproductions.com.

Marilyn J. Boxer

Boxer, Marilyn J. *When Women Ask the Questions: Creating Women's Studies in America*. Baltimore, MD: Johns Hopkins Press, 1998.

———. "Women's Studies as Women's History." In "Women's Studies Then and Now," edited by Cheryl J. Fish and Yi-Chun Tricia Lin. *Women's Studies Quarterly* 30 (Fall/Winter 2002): 42–51.

Howe, Florence, ed. *The Politics of Women's Studies*. New York: Feminist Press, 2000.

CHAPTER 9. ARCHITECTS

Introduction

Craven, Jackie. "Architecture in California, USA." architecture.about.com/od/usa/p/california.htm.

Simpson, Lee M.A. *Selling the City: Gender, Class, and the California Growth Machine, 1880–1940*. Stanford, CA: Stanford University Press, 2004.

Stoutland, Sarah. *Neither Urban Jungle Nor Urban Village: Women Family and Community Development*. New York: Garland Publishing, 1997.

Julia Morgan

Allaback, Sarah. *The First American Women Architect*. Champaign: University of Illinois Press, 2008.

Alter, Judy. *Extraordinary Women of the American West*. Connecticut: Children's Press, 1999.

Boutelle, Sara Holmes. *Julia Morgan, Architect*. New York: Abbeville Press, 1988.

Craven, Jackie. "Julia Morgan, Designer of Hearst Castle." architecture.about.com/od/greatarchitects/p/juliamorgan.htm.

James, Cary. *Julia Morgan: Woman of Achievement*. New York: Chelsea House Publication, 1990.

"Julia Morgan: Architect." Encyclopedia of San Francisco. www.sfhistoryencyclopedia.com.

"Julia Morgan, Early Architect." web.archive.org/web/20070623083708/http://capitolmuseum.ca.gov/english/remarkable/panel4.html.

"Julia Morgan: Legacy." Cal Poly. lib.calpoly.edu/specialcollections/architecture/juliamorgan/legacy.html.

McNeill, Karen. "Julia Morgan: Gender, Architecture, and Professional Style." *Pacific Historical Review* (May 2007): 229–68.

Lilian Jeanette Rice

Allaback, Sarah. *The First American Women Architect*. Champaign: University of Illinois Press, 2008.

"Discovering the 'Lost' Architect of Rancho Santa Fe: Lilian Rice." San Diego Metro. sandiegometro.com/2010/09/discovering-the-%E2%80%98lost%E2%80%99-architect-of-rancho-santa-fe-lilian-rice.

Eddy, Lucinda L. "Lilian Jeanette Rice: Search for a Regional Ideal, the Development of Rancho Santa Fe." *Journal of San Diego History* 29, no. 4 (1983): 262–85.

"Famous Female Architect Finally Gets a Biography." Coast News. thecoastnews.com/pages/full_story/push?articleFamous+female+architect+finally+gets+a+biography%20&id=3901797.

"Lilian Rice, Architectural Master of Rancho Santa Fe." www.kenyonrealty.com/lillian-rice-c17334.html.

Welch, Diane Y. *Lilian Rice: Architect of Rancho Santa Fe*. Atglen, PA: Schiffer Publishing, Ltd., 2010.

Florence Yoch

"Florence Yoch and the Gardens of Gone with the Wind." Garden History Girl. gardenhistorygirl.blogspot.com/2009/08/florence-yoch-and-gardens-of-gone-with.html.

"Hollywood Landscapes." Design Slinger. designslinger.com/2009/03/18/hollywood-landscapes.aspx.

"The Landscape Architects." Athenaeum. athenaeum.caltech.edu/Yoch.html.

"Personal Edens: The Gardens and Film Sets of Florence Yoch." www.curatorial.org/archive/P_exhibPersonalEdens.html.

Smaus, Robert. "Gardens: California Essence: Seventy Years Ago, Florence Yoch Brought Us European Landscape Design." *Los Angeles Times*, August 20, 1989.

Yoch, James. *Landscaping the American Dream: The Gardens and Film Sets of Florence Yoch, 1890–1972*. Sagaponack, NY: Sagapress, 1989.

Norma Merrick Sklarek

Ehrhart-Morrison, Dorothy. *No Mountain High Enough: Secret of Successful African American Women*. Berkeley, CA: Conari Press, 1997.

No Mountain High Enough. books.google.com/books?id=utiqvRo0oZAC &pg=PA150&lpg=PA150&dq=dorothy+ehrh.

"Norma Sklarek." African American Registry. www.aaregistry.org/historic_ events/view/norma-sklarek-pioneered-black-women-architect.

"Norma Sklarek." www.greatbuildings.com/architects/Norma_Sklarek. html.

"Normal Sklarek: The First African American Woman Architect." www. suite101.com/article.cfm/african_american_history/45832/4.

Summers, Barbara, ed. *I Dream a World: Portraits of Black Women Who Changed America*. New York: Harry N. Abrams, 1989.

CHAPTER 10. ENTERTAINERS

Introduction

"The Birth of Film." National Women's History Museum. www.nwhm.org/ online-exhibits/film/1.html.

Sochen, June. *From Mae to Madonna: Women Entertainers in Twentieth-Century America*. Louisville: University of Kentucky Press, 1999

"Women on Screen: The Rise of Female Stars." National Women's History Museum. www.nwhm.org/online-exhibits/film/14.html.

Zauner, Phyllis. *Those Spirited Women of the Early West*. Yountville, CA: Zanel Publications, 2001.

Lotta Crabtree

"Charlotte Mignon 'Lotta' Crabtree." Virtual Museum of the City of San Francisco. www.sfmuseum.org/bio/lotta.html.

"Did Lotta Crabtree Make Abe Lincoln Smile?" hornytimetraveler. wordpress.com/2009/02/12/did-lotta-crabtree-make-abe-lincoln-smile.

James, Edward T., and Janet W. James. *Notable American Women 1607–1950 A–F Volume I.* Cambridge, MA: Belknap Press of Harvard University Press, 1971.

"Lotta's Many Conquests." New York Times. query.nytimes.com/mem/ archivefree/pdf?res.

Pandey, Swati. "Gold Rush Child Star." The Daily. www.thedaily.com/ page/2011/03/31/033111-opinions-history-lotta-crabtree-pandey-1-3.

Rourke, Constance. *Troupers of the Gold Coast or the Rise of Lotta Crabtree.* New York: Harcourt Brace and Company, 1928.

Tynan, Trudy. "Lotta's Legacy." *Los Angeles Times*, February 15, 1998.

Madame Sul-Te-Wan

Bogle, Donald. *Bright Boulevards, Bold Dreams: The Story of Black Hollywood.* New York: OneWorld/Ballantine. 2005.

"Conley, Nellie [Madam Sul-Te-Wan]." Notable Kentucky African Americans Database. www.uky.edu/Libraries/nkaa/record.php?note_ id=40.

Jet Magazine. "First Negro Movie Actress." February 19, 1959.

"Lasting Legacies—Madame Sul-Te-Wan." Legacy.com. www.legacy.com/ ns/FullStory.aspx?StoryType=1&StoryID=26.

"Madame Sul-Te-Wan: A Persistent Pioneer." Classic Film Union. fan.tcm. com/_Madame-Sul-Te-Wan-A-Persistent-Pioneer/blog/501318/66470. html.

"Madame Sul-TeWan, Pioneering African American Actress, Born Today in 1873." Nashua Telegraph. www.nashuatelegraph.com/news/911516- 196/daily-twip-madame-sul-te-wan-pioneering.

Dorothy Arzner

"Biography for Dorothy Arzner." IMDb. www.imdb.com/name/ nm0002188/bio.

"Dorothy Arzner." Film Museum. www.filmmuseum.at/jart/prj3/ filmmuseum/main.jart?rel=en&content-id=1219068743272&schienen_ id=1294826066329&reserve-mode=active.

"Dorothy Arzner Films/Dorothy Arzner Filmography/Dorothy Arzner Biography." Film Directors Site. www.filmdirectorssite.com/dorothy-arzner.

"Dorothy Arzner." Senses of Cinema. www.sensesofcinema.com/2003/great-directors/arzner.

Mayne, Judith. *Directed by Dorothy Arzner (Women Artists in Film)*. Bloomington: Indiana University Press, 1994.

Mary Pickford

"Biography for Mary Pickford." IMDb. www.imdb.com/name/nm0681933/bio.

"Mary Pickford." AMC. movies.amctv.com/person/56706/Mary-Pickford/details.

"Mary Pickford: A Life 1892–1979." www.mybestgirl27.com/A_Life.

"Timeline: Mary Pickford Chronology." PBS. www.pbs.org/wgbh/amex/pickford/timeline/timeline2.html.

Whitfield, Eileen. *Pickford: The Woman Who Made Hollywood*. Louisville: University of Kentucky Press, 1977.

INDEX

About the Authors

Dr. Gloria G. Harris began her career as a psychologist in the early 1970s after receiving her doctorate from the University of Washington. She coauthored the groundbreaking book *Assertive Training for Women* and taught assertiveness training and management training for women in over sixty federal agencies throughout the United States from 1974 to 1980. Dr. Harris is also coauthor of *Surviving Infidelity*, a self-help book that has sold more than 150,000 copies. Her academic appointments include the University of Washington, School of Medicine; American University, department of psychology; and San Diego State University, department of women's studies.

Dr. Harris has been appointed to numerous boards and commissions and previously served as chair of the San Diego County Commission on the Status of Women. In 2010, she was inducted into the San Diego Women's Hall of Fame, and she currently serves as a board member of the Women's Museum of California.

Hannah S. Cohen has a master's of science degree in library and information sciences and an advanced diploma in educational administration. Early in her career, she worked in the public library system in New York and was then director of communications and media, where she was responsible for the development of library media centers in a large public school system.

For most of her career, Ms. Cohen worked as a public affairs consultant for numerous nonprofit organizations assisting in capacity building, fund development and advocating for policy changes for the underserved. She worked closely with business and government officials to develop policy and legislation.

Ms. Cohen has been deeply involved in advocating for women's equality and the rights of the underprivileged, and she serves on numerous boards promoting awareness of these issues. She is currently a board member of the Women's Museum of California and chairperson of the museum's fund development committee.